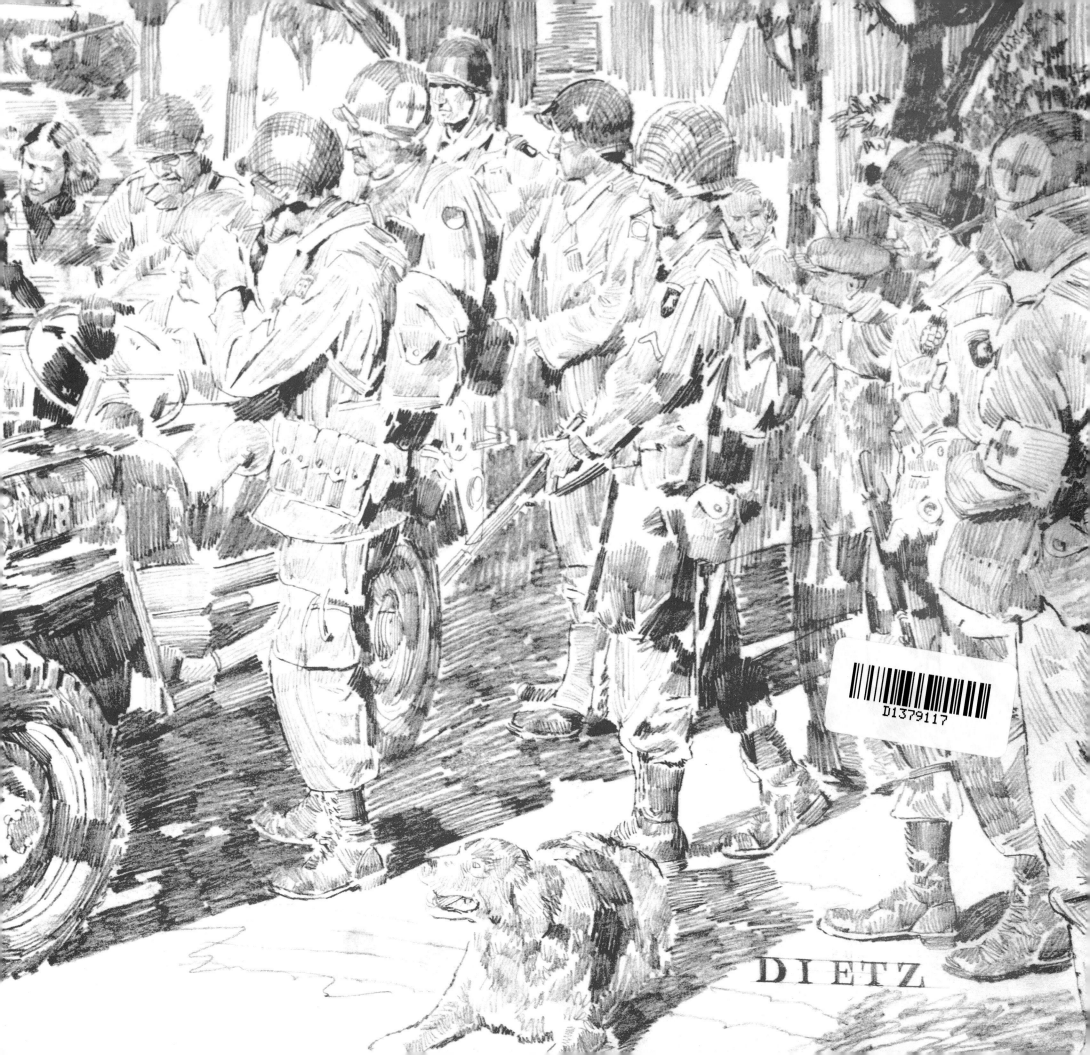

DIETZ

PORTRAITS OF COMBAT

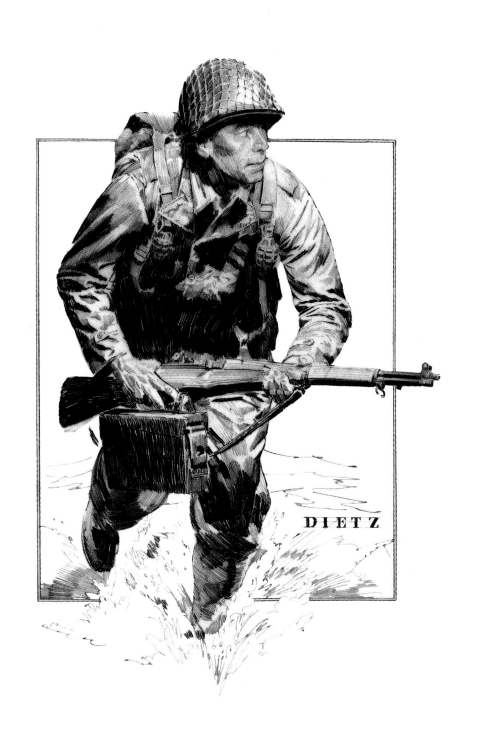

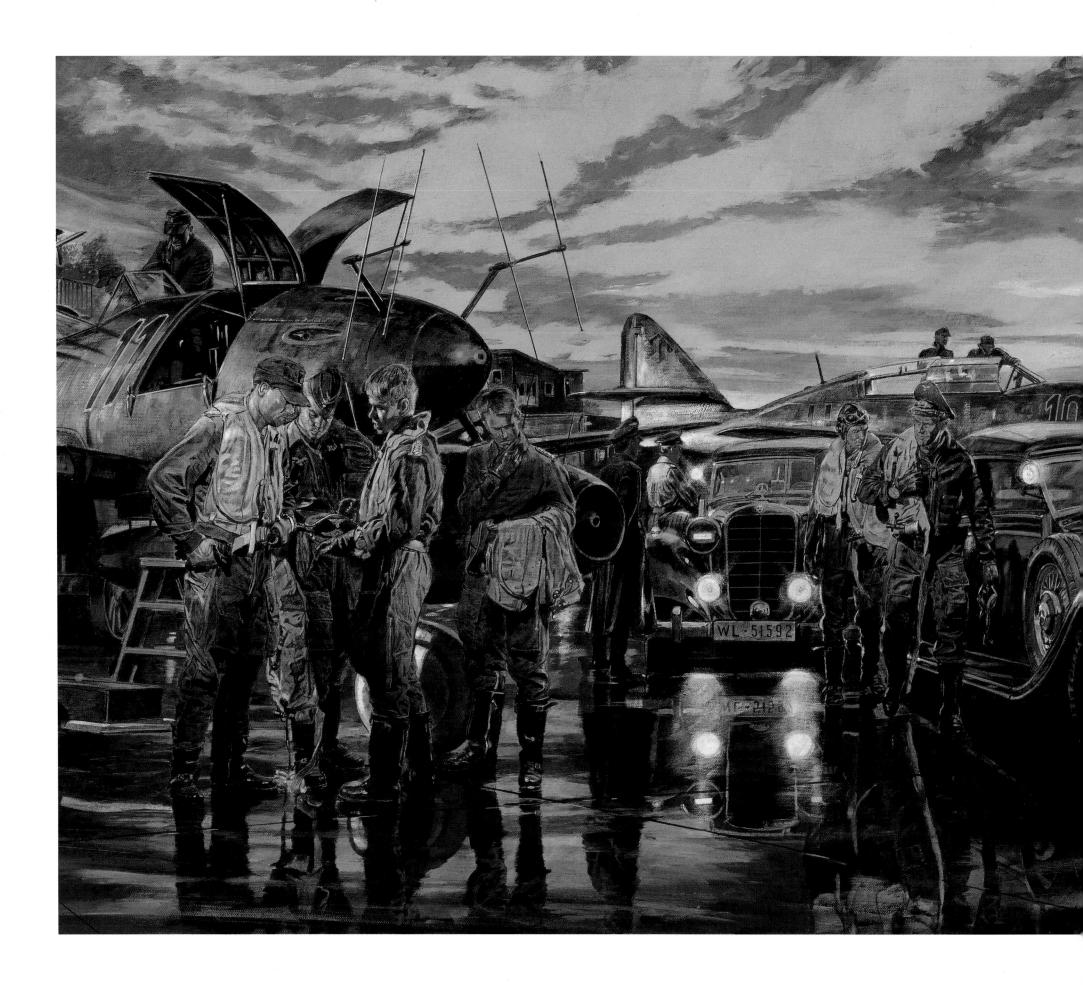

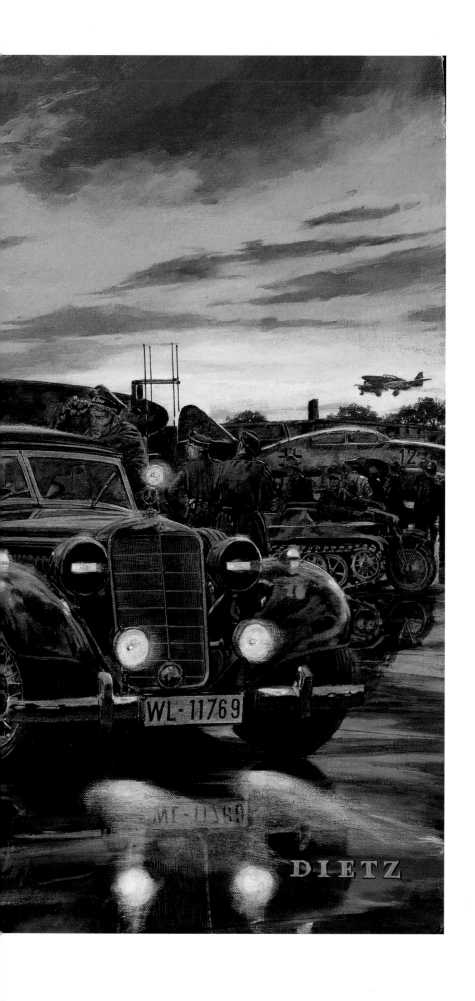

PORTRAITS OF COMBAT

The World War II Art of James Dietz

JAY BROZE

FRIEDMAN/FAIRFAX
PUBLISHERS

A FRIEDMAN/FAIRFAX BOOK
Please visit our website: www.metrobooks.com

© 2001 by Michael Friedman Publishing Group, Inc.

Library of Congress Cataloging-in-Publication Data available upon request.

ISBN 1-58663-080-6

Editors: Nathaniel Marunas and Betsy Beier
Art Director: Kevin Ullrich
Photo Editor: Jami Ruszkai
Production Manager: Rosy Ngo

Color separations by Bright Arts
Printed in Singapore by KHL Printing Co Pte Ltd

1 3 5 7 9 10 8 6 4 2

Distributed by Sterling Publishing Company, Inc.
387 Park Avenue South
New York, NY 10016
Distributed in Canada by Sterling Publishing
Canadian Manda Group
One Atlantic Avenue, Suite 105
Toronto, Ontario, Canada M6K 3E7
Distributed in Australia by
Capricorn Link (Australia) Pty Ltd.
P.O. Box 6651
Baulkham Hills, Business Centre, NSW 2153, Australia

When I was first asked to provide some kind of dedication and/or acknowledgments list for this book, I demurred, reasoning that it would probably wind up sounding like an overlong, gratuitous Academy Award thank-you speech, beginning with my wife, Patti, and son, Ian (for all their love, support, and help over the years); my dog, Tazzy (who is great company around the studio and poses almost willingly for dog biscuits); friends (who have been roped into posing for seemingly ridiculous situations); art reps; Tom Lippert, Barbara, and Elliott Gordon (friends, advisors, educators in "lifemanship," and people who showed a great deal of faith in my questionable ability); parents (they paid for college bills for an "iffy" career choice); teachers (Joe Henninger, Reynold Brown, Don Putman, and others at the old campus of Art Center); publishers who have spent time and money publishing my various prints (Kathleen and Greg Weber, Larry Smith of Somerset House, and especially the Shueys at American Art & Antiques) as well as the galleries who have sold those prints; illustrators and role models (Pyle, Parrish, Rockwell, Cornwell, Lovell, Leyendecker, Leynnwood, Wyeth, etc.), from whom I have stolen technique, style, and composition; Jay Broze, who deserves a dedication all to himself, not just for his Herculean efforts in writing the text of this book and making some sense of all the information that he required from me, but for his friendship, help (not always asked for), advice (again, occasionally unsolicited), support, trivial questions asked and answered, long lunches, wonderfully forgettable conversations, and of course, free Mariners tickets; the authors who have written all the new marvelous reference books on military subjects; the men and women in our country's armed forces (especially in the 82nd and 101st Airborne, the 75th Ranger Regiment, the First Division Museum, and others who I can't mention, who invested in artistic renditions of their units' modern history); the reenactment groups who have given so freely of their expertise as research consultants and their time as models); the inventors of the VCR, who made it possible to watch old movies (those by Michael Curtiz, Howard Hawks, Busby Berkeley, Alfred Hitchcock, Preston Sturges—for research purposes, natch)....

Such a list would have to include the doubters, too, in spite of whose nay-saying I have (more or less) succeeded: teachers who predicted abject failure (thanks, Harvey Thompson), skeptical friends ("you're going to try make a living as what?"), parents (they couldn't be supportive all the time), girlfriends who left when the going got tough (you know who you are, but honestly, it was probably the right decision at the time), not to mention a few art directors ("we learn from our mistakes")....

I could also ramble on and on about art stores that were open on Sundays, model agencies, pizza delivery runners, the one-hour film places that I've kept too busy, those (usually) dependable delivery people who make working in wet, rainy Seattle possible, the Mariners—the list is endless in this rags-to-slightly-better-rags story of faith being (somewhat) rewarded....

You get the idea.

So, after thinking it over, I decided this really would sound like an overlong gratuitous Academy Awards speech, so instead I'm just going to let the work included in this book speak for itself.

—Jim Dietz

CONTENTS

PORTRAIT OF THE ARTIST

The art of illustration blossomed in the United States during the first half of the twentieth century. Increasingly universal education produced widespread literacy, which in turn powered immense growth in the magazine and book publishing industries. The growing popularity of moving pictures created a huge demand for posters, and the advertising industry's appetite for artwork was insatiable. In the course of six decades, such artists as Maxfield Parrish, Howard Pyle, N.C. Wyeth, Norman Rockwell, Anton Otto Fischer, and Dean Cornwell created the canon of American illustration.

James Dietz trained as an illustrator when the business was at its height, and was a successful professional as it began a slow but steady metamorphosis. By the mid-1970s, many once-proud magazines had been excised from the new media culture, and the dominant stylistic forms in illustration were becoming both simplistic and hackneyed. There was still lots of work, but the professional community sensed that the golden age had passed. Occasionally, Jim would hear about one or another artist who had left New York or Los Angeles and moved out to Wyoming or the coast of Maine. Years later he understood that these refugees were the first painters to sense the shifting of the art markets. They were the ones who realized that great American illustration wasn't dying, it was just going through a sea change.

In the mid- to late 1970s big canvases were in demand, and the painters who had the artistic skill and technical ingenuity required to compose and fill them were leaving illustration for this new, lucrative market. They were creating what critics called interest-driven or enthusiast art; the style was often called historical realism. Gallery owners used words like "Western," "wildlife," or "maritime" to describe this art. But

no matter what it was called, collectors were buying modern originals in the 1970s, and publishers of art prints were eager for new material. Originals of Carl Evers' maritime illustrations were being snapped up. Rumor had it that the best professionals, such artists as Tom Lovell, James Bama, and Mort Kunstler, couldn't keep up with new commissions for Western and Civil War subjects.

Jim followed this demand for "gallery pieces" back to one of his favorite historical periods, the early days of aviation. As he puts it, "I had shot off my mouth about how I could really do a job on World War I flying, so I had to produce something." Comfortable painting the human form, Jim thought the relatively small size of early aircraft, as well as their frail structures, would make them ideal for compositions centered on people. These characters were so dominant in his World War I pieces that he gained a reputation as an aviation painter who didn't paint airplanes. He was also known for getting the details right, from czarist ration boxes to Austrian engine fittings. Many of his World War I paintings were reproduced as limited edi-

tion prints, but Jim's style was more attractive to collectors of original art than to print publishers.

The growing interest in historical realism allowed Jim to reconsider the artists and influences that had led him into a career in art. He went back through the body of American illustration to revisit the "why" of his pieces as well as the "how." He still refers to one or another painting as "my best Tom Lovell job" or as a story "told in a Dean Cornwell way." Jim revisited the still life as a means of exploring an historical episode too long or too complicated to be contained in a single scene. Sometime in the late 1980s he realized that he was doing the paintings he liked to do, and collectors were snapping them up.

The collectors were not limited to early aviation enthusiasts. Each year a couple of interesting World War II paintings would cross his drawing table. There had always been modern military pieces in Jim's portfolio. It was a subject that an illustrator had to have on hand, and, like most boys born in the mid-1940s, Jim had grown up with the war, if not in it. Histories, movies, comic books, magazines, family members, and friends all contributed to a mass of familiar, if not always accurate, imagery. As an illustrator, Jim added many of his own "imaginative" works to the paperback book industry in the form of book cover art. Later, his easy handling of figures began to attract clients from among museums, historical foundations, and military units who wanted to accurately commemorate specific events.

The fiftieth anniversary of World War II generated a rush of commissions. The clients of commemorative art, fifty years after the event, were different from the customers for military pieces of the prior decades. Serious collectors in the 1970s and 1980s were sensitive about

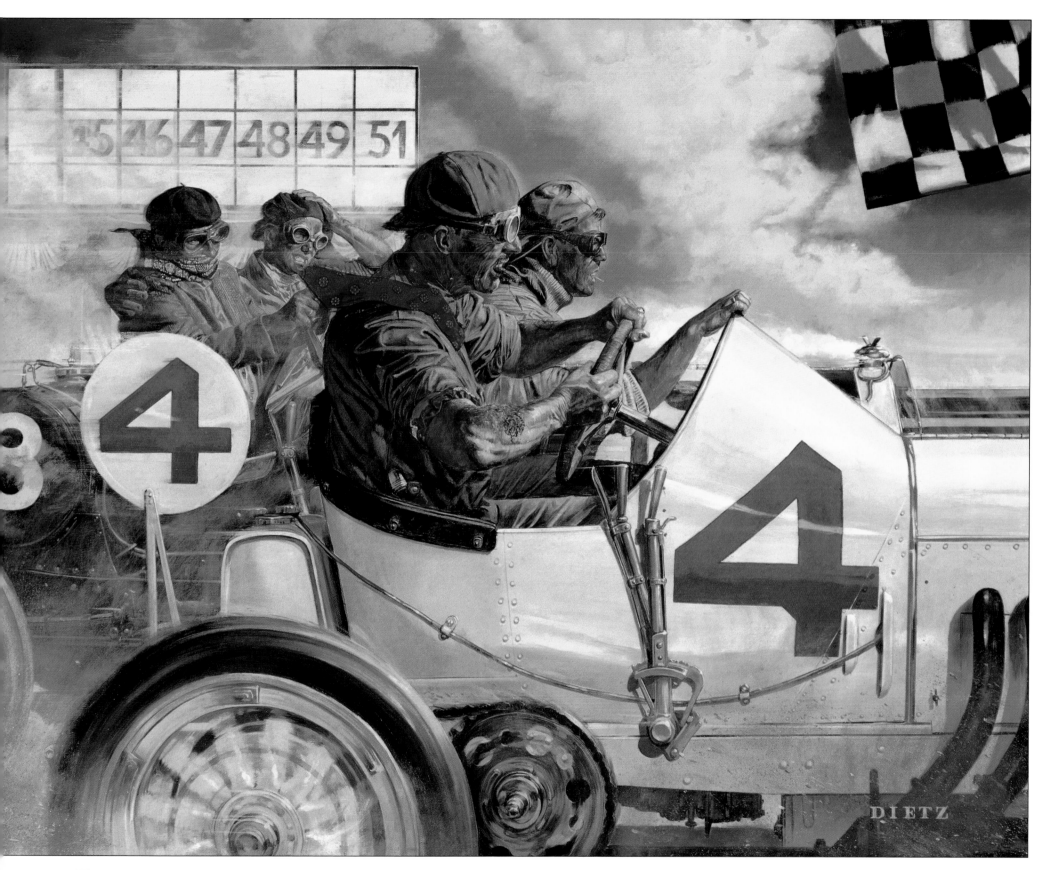

ABOVE: *Wheel to Wheel.*

glorifying violence, to the point that death and dying were all but removed from artists' palettes. By 1994, surviving veterans were demanding a different view of the time when they and their friends had been called upon to be brave in the face of terrible danger. Jim's 82nd Airborne Division paintings show this change. *In the Beginning* (see page 71), painted in the late 1980s, was purposefully devoid of combat. The scene was dedicated to discipline, devotion to duty, and leadership. *Seize the Day* (see page 92), from the mid-1990s, is a detailed portrait of World War II paratroopers in the aftermath of battle. By 1999, when *Wrath of the Red Devils* (see page 118) was commissioned, the veterans of the 82nd wanted to remind their descendants that an open-order, guns-blazing charge into enemy flak batteries had actually happened. They did not want a scene of prisoners being marched away; they insisted on a portrayal of the fight. While not looking to glorify slaughter, they needed to record the moment. It was a narrowly won day, and they thought the men who died all around them deserved to be remembered for it. In some ways, the veterans were calling for the stark images that painters had produced during the war years.

Dietz's combat work is stylistically linked to the powerful wartime sketches and paintings of Howard Brodie, Kerr Eby, and Tom Lea. Dietz may laughingly call an old book cover of his "pure Wally Wood," but a person can see the influences of Frederic Remington and Harvey Dunn in his infantry groupings, as well. There are elements of German combat art in his pieces, and Jim suggests that a viewer will also find traces of Jack Leynnwood, Dame Laura Knight, and the great Australian military painter Ivor Hele.

Dietz notes that World War II painting has become more like American Civil War painting in recent years: more classical, more popularized, and more accepting of war's brutality. As the war fades with each successive generation, it becomes almost romantic rather than industrial.

Young people already see World War II the way Jim's generation viewed the Spanish-American War or Little Bighorn—as a strange and colorful era in the nation's dim history. Though perceptions of the war change over time, the body of artwork commissioned by those who experienced it firsthand—with all its sacrifice and sadness as well as all its triumph—will exist to remind future viewers how it was witnessed by the men and women who actually lived through it.

∎

LEFT: *Tim Tyler's Luck*. BELOW: *Five Flying Ladies*. OPPOSITE TOP: *Bif Arabesque*. OPPOSITE BOTTOM: *Bon Chance*.

MAXIMUM EFFORT

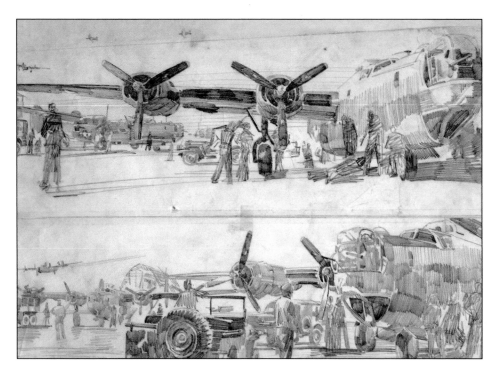

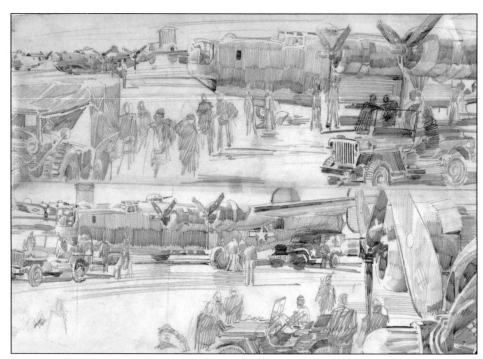

An artist who undertakes historical commissions assumes responsibility for much more than the brush strokes on his canvas. He will at different times be an investigator, a curator of artifacts, an interpreter of the historical record, a professional consultant, and possibly even the spiritual custodian of the project. One thing will always lead to another.

Maximum Effort is a definitive Jim Dietz painting. The work was originally suggested by members of the 449th Bomb Group Association, all veterans of the 15th Air Force's Italy-based strategic bombing campaign. They had seen Jim's 15th Air Force still life *Silver Wings* and thought that a commemorative painting, with a print version available for sale, would be a worthy project. There were no professional art directors or designers involved with painting and the only requirement was that it represent a B-24 that was somehow identifiable as belonging to their bomb group.

A project like the 449th's sounds like an artist's dream, a job with no publication date and few creative constraints. With no secondary

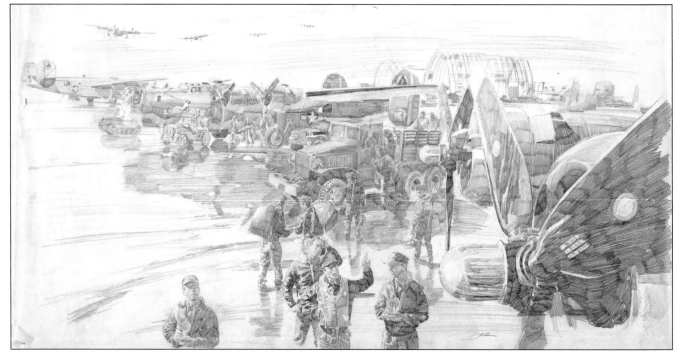

TOP LEFT AND TOP RIGHT: Thumbnail sketches are quick studies of different compositions. These four sketches of B-24 ground scenes explored different layouts for the painting. The B-24 is a massive shape compared to the human form, and these quick drawings investigated ways to integrate it into the painting.

ABOVE: This view from the cockpit had good visual movement. It led the eye along the line of planes and vehicles, then up to the bombers on final approach. The positions of the engines, men, and truck required the artist to fiddle with perspective, and he was not satisfied with the middle ground.

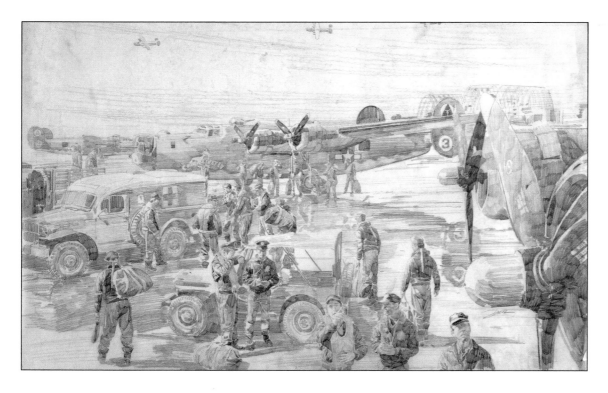

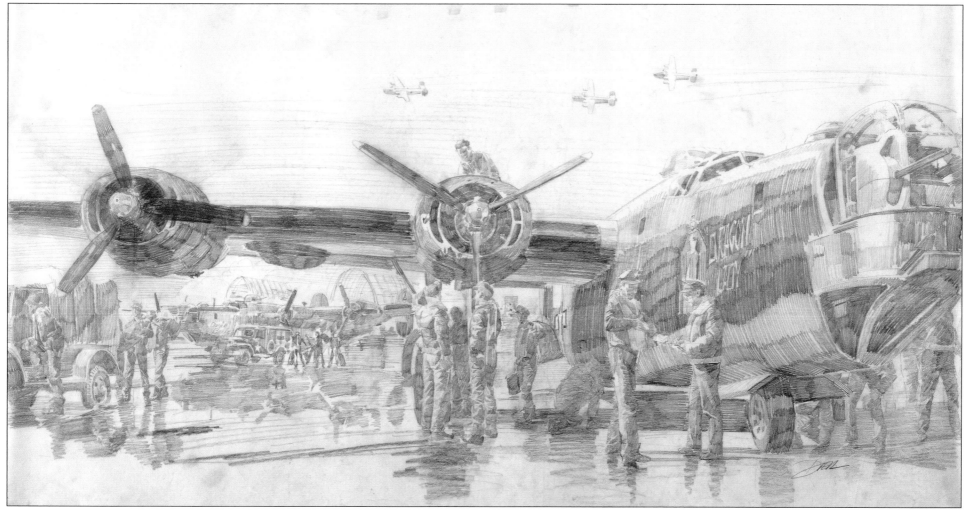

product to sell, the painting does not need retail point-of-purchase impact, Luftwaffe secret weapons, or unlikely Italian beauties. The artist is free to choose the tone of the work and be his own designer. On the downside, he may have to walk the client through the creative process, explain how each decision relates to the next, and generally spend much more time on the project than would be the case working with a publisher's art director. Also, unlike a publisher or an active duty unit such as the 82nd Airborne Division, a group of World War II veterans won't be commissioning more paintings. The artist will have only one chance to get the job right.

It was agreed in early 1990 that the painting should be a ground scene that would include many categories of the nonflying personnel in the group. Jim began working up visual ideas for the painting during breaks in his schedule. It was quickly revealed that the Consolidated B-24

would be no shrinking violet in a composition. The usual questions of perspective and height-of-eye were going to be difficult. In May 1990 Jim sent out an appeal for what he called "so many obscure and forgettable details" of post-flight operations. What vehicles met the planes, who drove the vehicles, and what standard uniform did the drivers wear? Were there bombs near the parking area? Was the tower in sight? When were the guns removed? Where and when could you smoke? How many aircraft would be visible in the pattern? How much damage could a B-24 sustain and still come home?

Don Lapham was Jim's initial contact for the painting, and he began to forward the artistic and historical input from group members. One man sent a list of his favorite airplanes' names and nose art from the three squadrons of the group. Another was able to recount step by step what happened after the propellers stopped spinning on his B-24. Letters included such details as "parachutes went right onto the truck for the 'chute shack," "You kept your own Mae West," "I always left my helmet and oxygen mask in the plane," or "You could suck a beer if you had packed any in the bomb-bay, against regs…" The author of one handwritten note recalled the

damage an inboard engine on his plane had taken. The description ended with "this was caused by a head-on pass by a Schwarm of four fighters. They had expended all their cannon shells before they reached us. Otherwise I wouldn't be here writing you this letter." Receiving a note like that gives an artist a different sense of how important such a painting might be to its audience.

In late 1991, responsibility for the 449th's painting was given to another member of the organization, and new question-and-answer sessions ensued. Jim did not expect the 449th members to be "rivet counters" in the nit-picking sense, but he knew that they would instantly spot historically false notes in the composition. This time the responses included two photographs of 8th Air Force personnel sent by a member who numbered each figure in felt pen and called out which clothing or equipment detail indicated air crew, which ones meant ground crew, and even which crew members carried each of three types of parachute. Another laundry list of facts included the news that if there were serious casualties on board a returning bomber, it would land at Bari or some other base with a hospital close by, rather than at

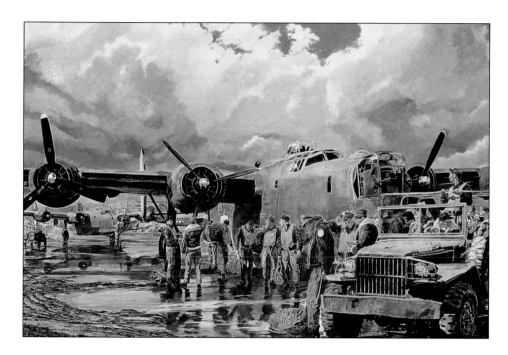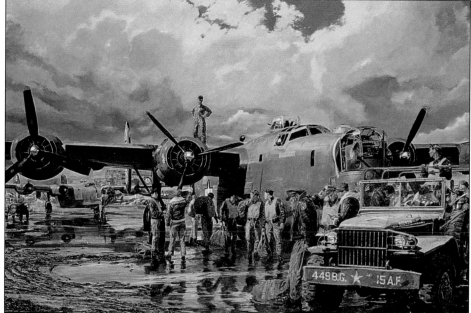

the 449th's airfield at Grottaglia. One man recalled that after the crew exited the plane "a medical orderly, white long jacket, O.D. pants, would stand by with a double shot glass of Ancient Age Bourbon."

The question of time and season became important within the group. The hardest days of the 449th were the period when the battered bomber groups based in North Africa stood down to reorganize and the squadrons based in Italy had to carry the entire load. The 449th flew twenty-one missions in January 1944, which may have been a record for a heavy bomb group. They hit Bucharest, Vienna, and Regensburg in the first four months of the year, and vets recalled seventy-two aircraft losses by July. That was a casualty rate well over 100 percent. If the painting was to commemorate that period, then the airplanes would be olive drab, the atmospherics would be gloomy, and the mode somber. If the client wanted a bright sunny day, it would be logical to include a silver airplane with colorful tail codes from late summer of 1944, when the group was riding high. It was a point of contention.

A letter arrived that detailed when the airfield at Grottaglia was improved, when paved or

oiled-gravel hardstands replaced the mud. There was a photo of a parked 449th bomber with the burned-out skeleton of the Italian dirigible hanger visible over the fuselage. That hangar was the definitive symbol of the airfield that had been Mussolini's "West Point of the Air."

All of this new information was on the plus side. The minus was the association's decision in 1992 to abandon the entire painting, despite the investment of almost three years of emotional and creative energy, because of the financial difficulties of producing the painting and selling the prints.

The 449th painting had become a labor of love for Jim. One of his first professional mentors in Southern California had flown with the 449th, and Jim had formed friendships with members of the association. He knew that the layouts and the research work would be of some use one day, but the soul of the piece was all 449th.

The project only stayed dead for a few weeks. Right after the 1992 elections, Jim received a call from a 449th veteran who had been on the fringes of the project from the beginning. Hollie Wilkes was once the senior enlisted man for maintenance in the 449th and even though he had later made it to full colonel,

ABOVE LEFT: This canvas shows the overarching skyscape in place and has more color laid down. Although there are key details still missing, the balance of tones is firming up at this stage. Problems in the relationship of shapes and colors become apparent at this stage of a painting. TOP RIGHT: In the last image the painting is nearly finished. More details have been added and further color work was been done. The details of aircraft marking have not been settled and there are no aircraft in the cloudscape.

he retained a top sergeant's attitude toward getting a job done. Hollie thought that the project was too important to give up on and told Jim that he would see it through to completion on a private basis.

The letters and layouts went back and forth that winter. The painting would be of the tough days in early 1944, and would serve as a tribute to the crews who spent their victory year in prison camps or never came back at all. The aircraft chosen were ones that were lost on or before the Bucharest raid of April 4, 1944. The bumper of the weapons carrier would carry the 449th and the 15th Air Force designations, with no squadron assigned. There would be no ambulance in the composition—the emotional wounds were deep enough without reminding viewers of the physical wounds. And because the medic in the white coat would stand out like a snowman against the plane, the men would have to get their bourbon at debrief.

RIGHT: The nose art and aircraft codes in the final version of *Maximum Effort* were selected from planes that were lost in the big March and April raids of 1944. The mechanics will repair *Paper Doll*, but neither the bomber nor the weary crew loading up for the ride to their debriefing would survive to finish their tour of duty.

Hollie Wilkes donated *Maximum Effort* to the Air Force after the prints were struck, and its display became a status symbol at the upper reaches of the Air Force organization. Today, anyone doing business with the Assistant Secretary of the Air Force sees the painted men of the 449th, and their scene brings credit to the entire 15th Air Force. The print edition sold widely outside the 449th organization. Jim still gets letters from veterans, or more commonly now their survivors, expressing thanks for the way the story was told.

Many people ask why anyone needs to paint World War II subjects. The war was photographed and filmed to a degree never before imagined. A project like *Maximum Effort* is proof that there was much more to the war than could be captured on film.

■

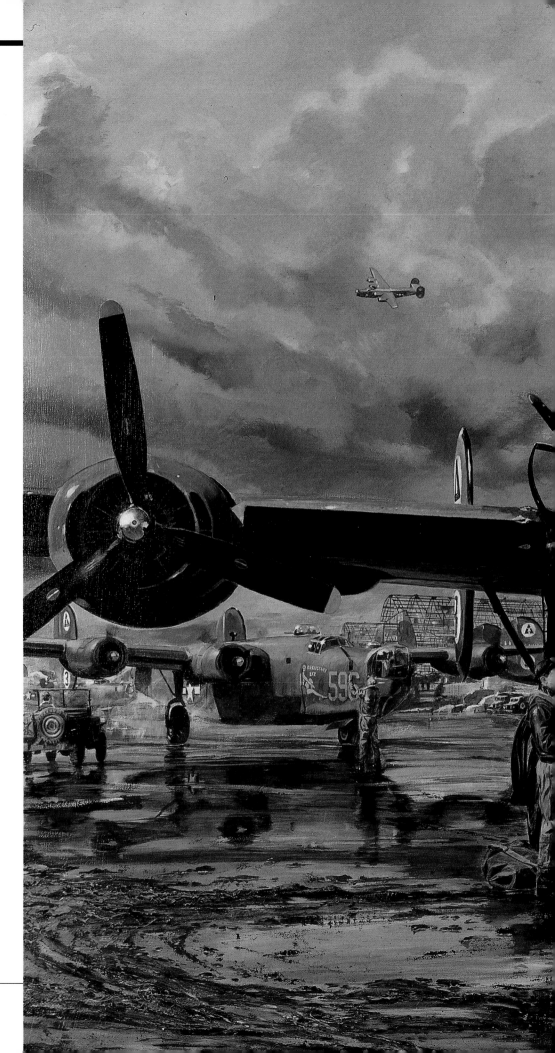

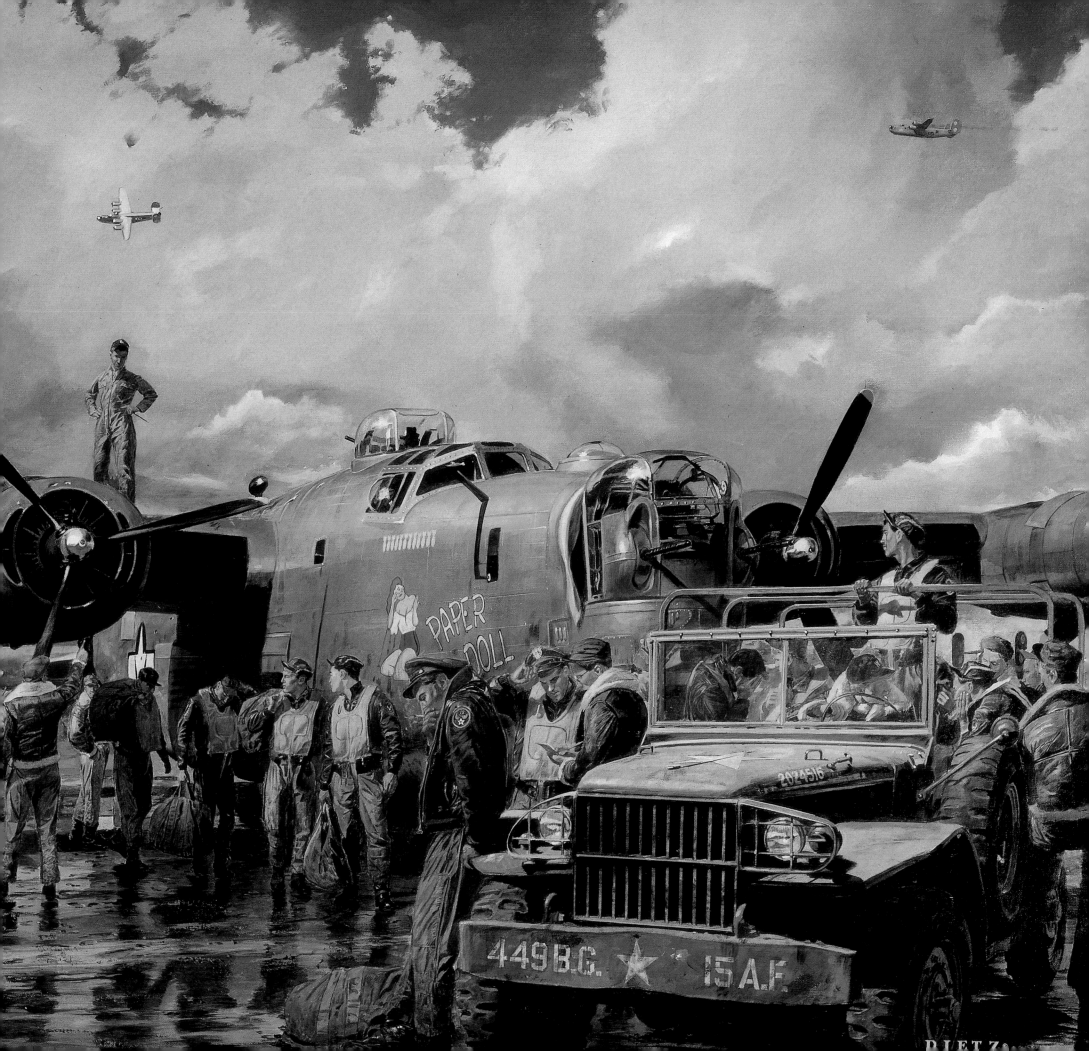

THE GALLERY

Call it Lightning!
— SAY THE PILOTS

THE INDIA
JAP AIR RA
HAWAII
EXTRA

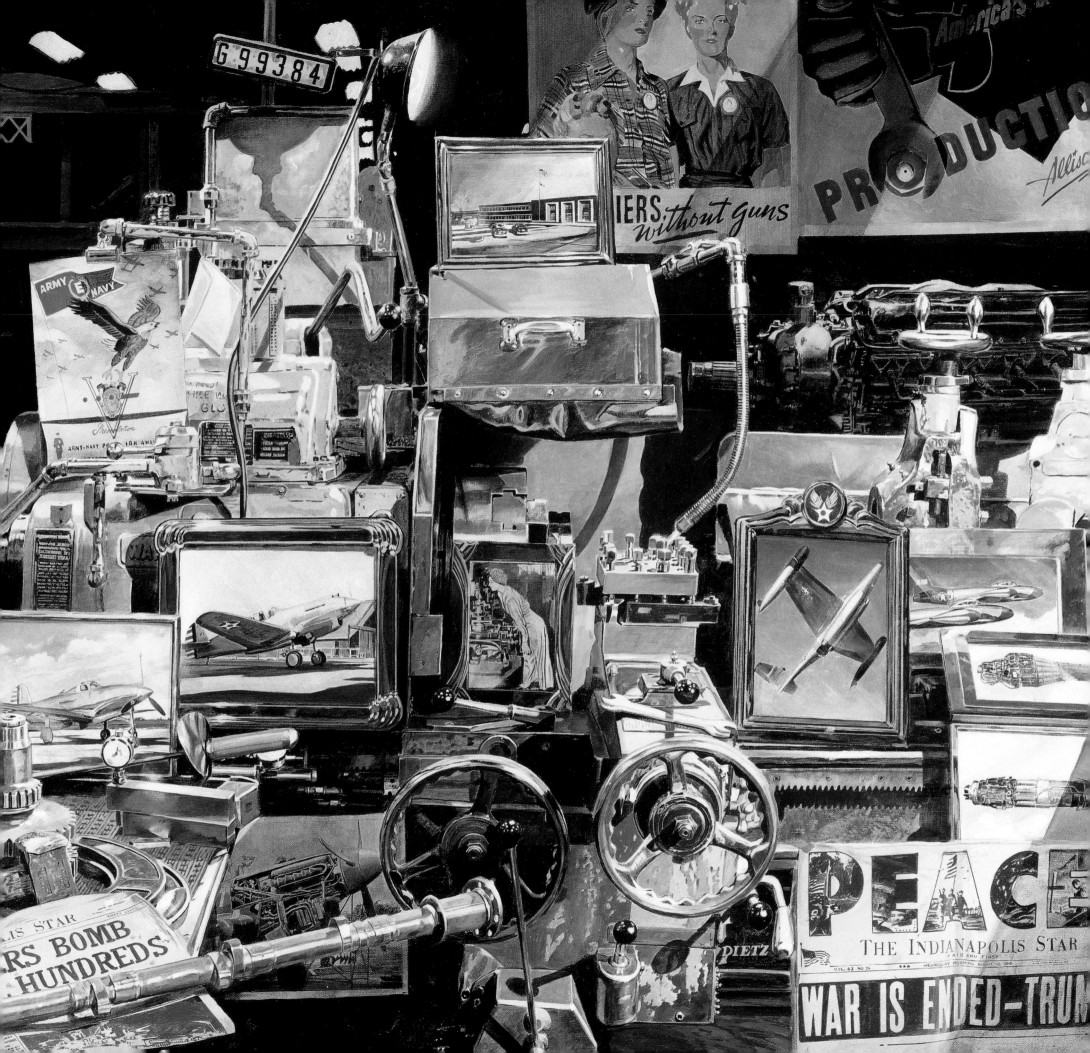

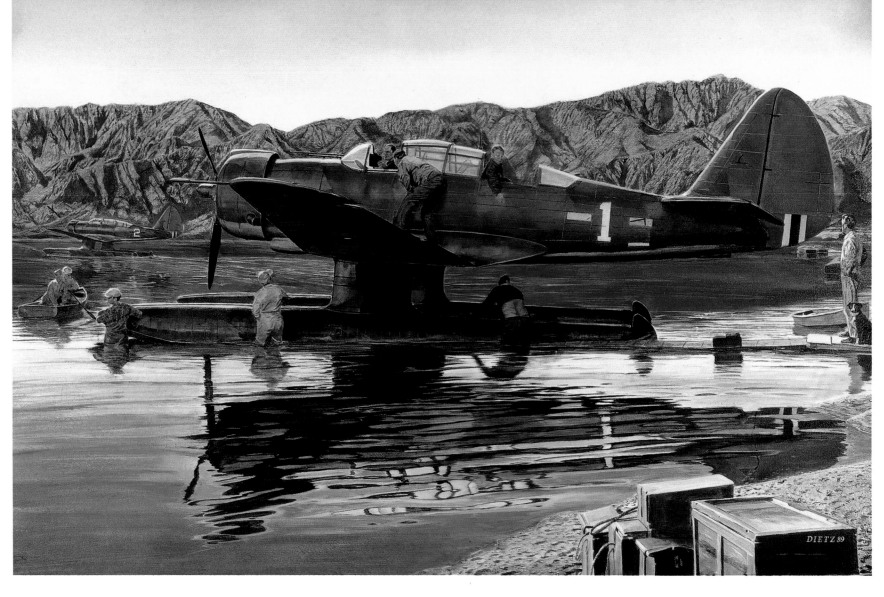

LADY OF THE LAKE

EVERY GOVERNMENT IN EUROPE UNDERSTOOD THE possibility of war in 1939, and each had to build or buy munitions and equipment for the coming conflict. Norway, which was nervously neutral in the scrum of alliances, sent representatives to the United States to find modern aircraft to patrol the country's long coastline. Northrop was developing the N3-PB as a seaplane with adequate speed, good range, and the ability to carry ordnance as large as an aerial torpedo. It perfectly fit the needs of the Norwegians, who ordered two dozen of the new planes.

Unfortunately, the war reached Norway before the Northrops did. The Norwegian govern-ment was in exile by the time the planes were ready to ship in 1940, so the aircraft were eventually delivered to a Norwegian-manned RAF squadron in Iceland. When the squadron later reequipped with Sunderlands, the few remaining Northrops were assigned to utility duties. Neither the War Department nor the Navy Department of the United States found an operational role for the plane and, after a flurry of press exposure in 1940, the N3-PB went quietly out of production.

Lady of the Lake was commissioned by a man who worked for Jack Northrop on the original design of the N3-PB. Rather than an action scene, he wanted a portrait of the aircraft in a sit-uation he could identify with more than five decades later. Dietz thought the plane showed its lines best in the water, when the mass of the twin floats was hidden beneath the surface. He placed the plane in a flight-test setting, surrounded by handlers and engineers, with peaceful dawn lighting the sky above the Southern California mountains.

■

DUNKIRK

THE EVACUATION OF BRITISH AND FRENCH DIVISIONS from the port of Dunkirk and the nearby beaches was one of the great improvisations of World War II. There were no army-sized amphibious evacuations in the combat tactics manual. In late May 1940, official opinion was divided as to whether there would be any need to remove the British Expeditionary Force at all. The French still possessed potent maneuver forces, and in London decision-makers eagerly awaited news of a crushing French counterattack against the overextended German armies.

The generals of the British Expeditionary Force were under no such delusions. Ten days after the initial German breakthrough across southern Belgium, the British faced entrapment. Pressed into a deep and narrow pocket extending along the French-Belgian border, the British had to move their most extended units north on roads just a few hundred yards behind the front lines, rolling up their flank as they went. The French were making a stand at Lille, but there was no real front to the west, and no one knew how long the Germans could be held off. These first steps of the British withdrawal were more of a steeplechase than a military movement. Rear echelon units were simply cut adrift and sent north toward the

BELOW: The inspiration for this scene of short-barreled Panzer Mk IVs was a German propaganda film on the fall of France. The M-4 Sherman was designed to defeat this tank.

huge pillars of black smoke that rose from Dunkirk's bombed oil refinery.

The Germans faced manifest difficulties, even in their triumph. Attacking from both the east and west, they had the Allies in the crease between different command organizations. The countryside was filled with unattached units. Some fought the Germans ferociously, some surrendered, some ran, and some turned out to be other German units. Hitler, too, was worried about the expected French counterattack and halted his most advanced Panzer regiments. He then allowed himself to be convinced that the trapped Allies could be more easily and economically destroyed by the Luftwaffe than by frontal assault. It seemed logical. Belgian morale was broken, the French were in disarray, and the BEF was trapped on the European shore. Why risk the depleted Panzer divisions in a desperate fight with an enemy noted for tenacity? Neither of these decisions alone could have saved the BEF, but together they gave the British just enough time to organize an escape.

By the last days of May, Admiral Sir Bertram Ramsay had the first of a vast flotilla of large and small ships lifting the troops across the Channel. First estimates suggested one division's worth of British soldiers might be saved, then perhaps forty thousand men. The estimates

increased with each passing day, as ever more ships and boats made the Channel crossing. Cloudy weather and blowing smoke obscured much of the operation from German aircraft. The first days' sea lifts removed the crowds of support personnel, and by May 28 and 29 the combat troops began arriving in Britain. Good weather arrived as well: good for small boats, good for dive-bombers.

The British withdrawal was no longer a chaotic flight to the sea. The best regiments and commanders in the British Army were undertaking a hazardous maneuver with all the professional skill and aplomb they could muster. Units that were pulled out of the line disabled their vehicles and heavy equipment before moving on to the harbor or out onto the beaches. Behind them the litter of materiel stretched for miles. In front of them was a panorama of sunken ships, bombed boats, burning buildings, blasted docks, and thousands of men. Overhead was the Luftwaffe.

The Germans had redoubled their ground attack on May 27, but the British and French defenders of Dunkirk had beaten them to the canals and rivers around the town. It was June 4 before the Wehrmacht entered Dunkirk in force. By that time, nearly 340,000 British and French soldiers had been delivered safely to Britain.

In one of his first speeches as Prime Minister, Winston Churchill proclaimed that "wars are not won by evacuations," but he certainly knew that this war could have been lost without this one.

■

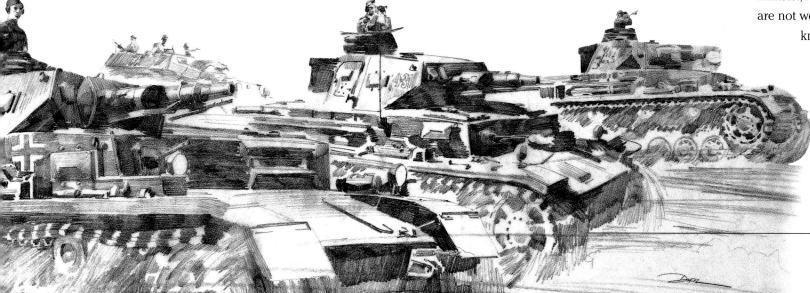

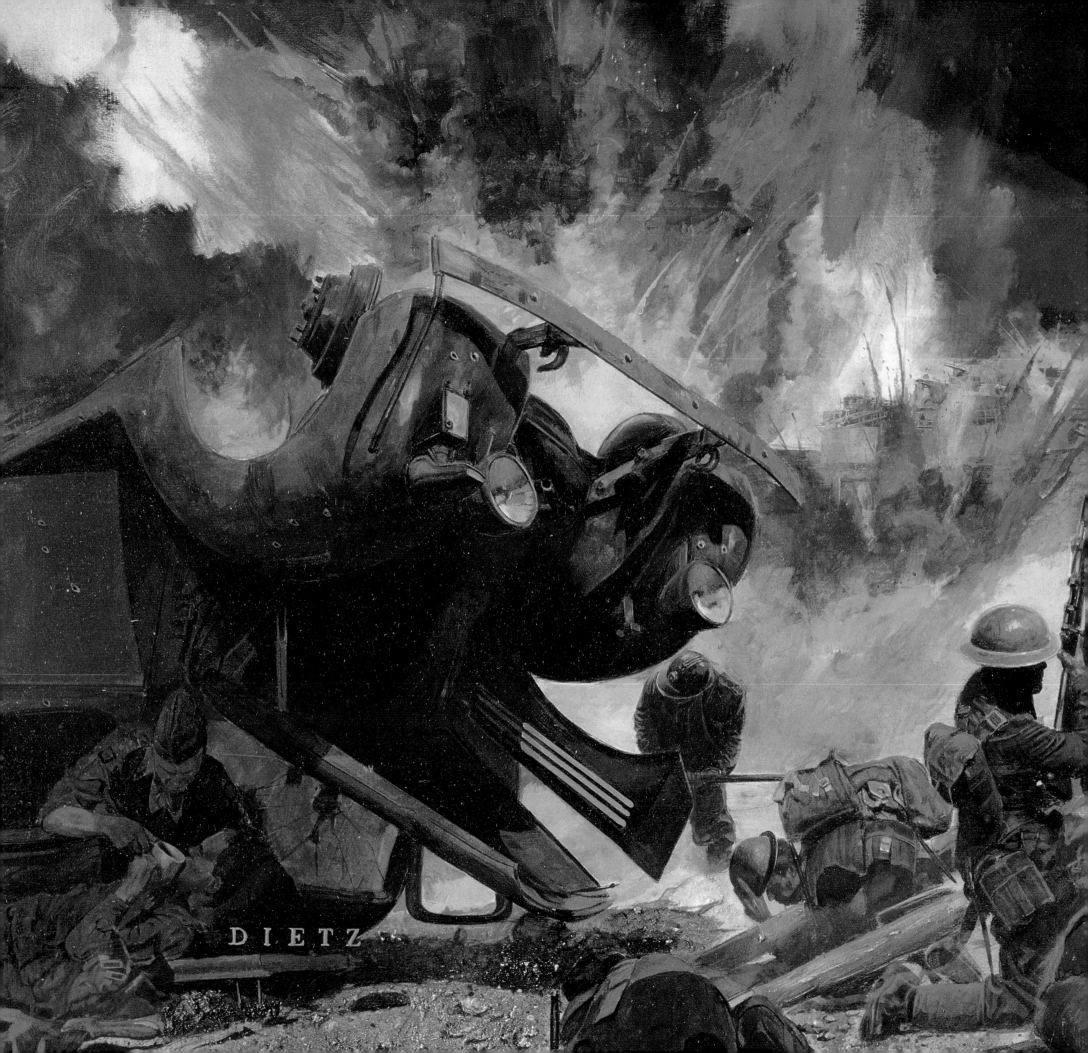

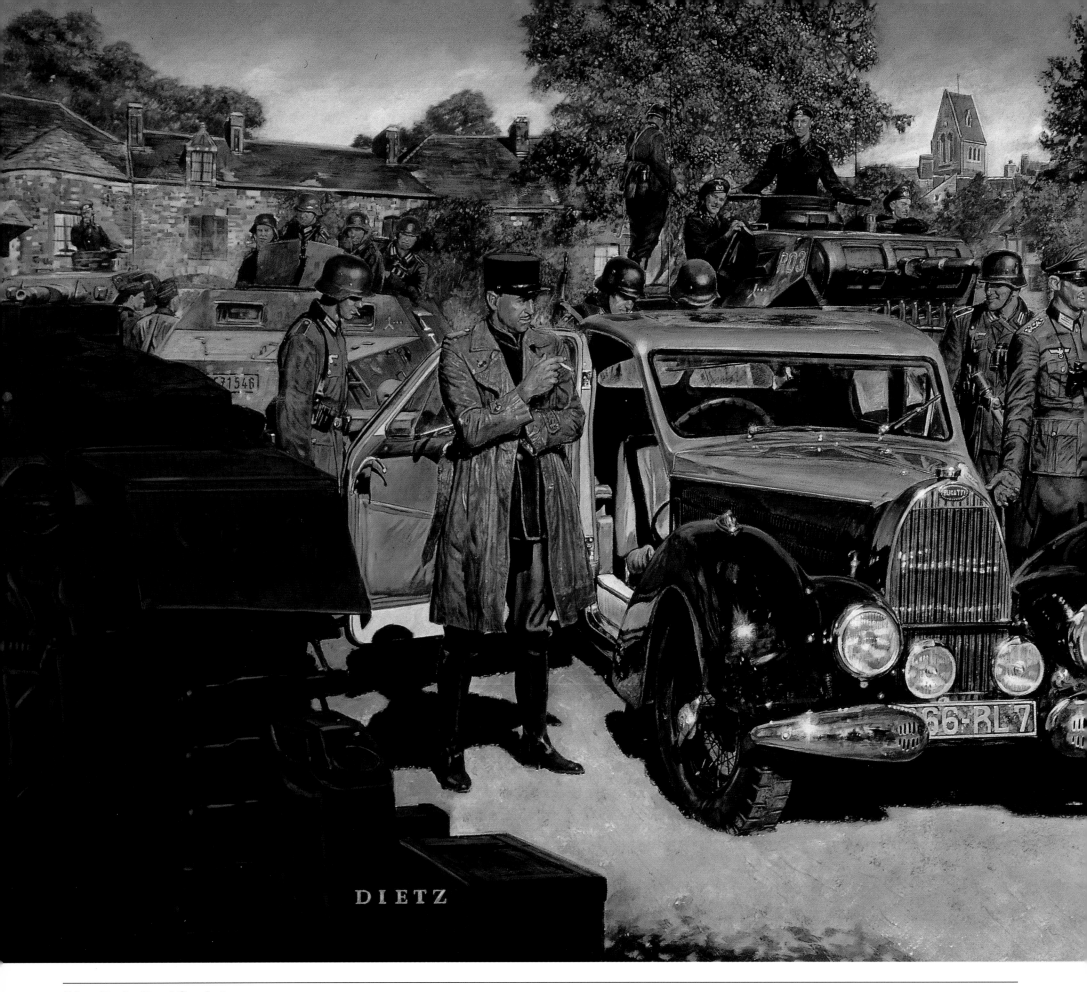

DIETZ

ROSE AMONG THORNS

EVEN WAR HAS ITS HUMOROUS MOMENTS, AND JIM'S painting of a Bugatti ensnared in an armored column portrays one of them. Robert Benoist was a French air force officer in 1940, stationed at La Bourget, Paris. He had been a notable race car driver of the late 1920s and 1930s, and when the Germans crossed the Seine, Benoist decided to secret away his private car before it became a prize of war. When his unit evacuated south, he set out to hide his Bugatti.

Benoist was stuck in the refugee stream until Poitiers, where a German Panzer unit blocked the road. A German officer with an appreciation of fine automobiles and the niceties of the Geneva Convention declared that Benoist was a uniformed prisoner of war and should travel in the safety of the tank column, under armed motorcycle escort, for the rest of the day. Nightfall found the French officer in a Wehrmacht bivouac explaining the Bugatti's technical details to a rapt audience. He also mentioned that he was nearly out of fuel for the vehicle, and if he were to continue on with the escort, he would need more. His captors readily supplied it.

The Germans were on the road early the next morning. Soon, firing broke out ahead and Benoist's guards accelerated forward to deploy. Benoist made a quick left turn onto a country lane and raced down any road that led east. By nightfall, he had his car hidden and was on his way back to the air force.

Unfortunately, Benoist was arrested during a raid on a Resistance cell later in the war. He was killed at Buchenwald in September 1944. The Bugatti that he had saved from the invaders outlived him, and is now in the hands of a collector of vintage automobiles.

∎

TO THE VICTOR

TO THE VICTOR WAS INSPIRED BY FIRST-PERSON accounts of the Battle of Britain. Anyone reading the memoirs of the British participants will be struck by how oddly civilized the conflict was in the days before the civilian population became the primary target. RAF pilots had an exciting job that entailed flying off to fight similarly employed Luftwaffe pilots. Afterward, they could slip off for tea with the girlfriend or pile into the "old bus" for a dash to the "local" for a few pints. Fighter command had a devil-may-care luster, and the war above Britain had not yet become horrific.

The golden rule during the brief aerial encounters was that you had to be the victor, or at least avoid being the vanquished. To the victor went the adoring girlfriend, the jaunty joyride, and the rejuvenating ale. The vanquished got the cockpit disintegrating all around his head, the instantaneous envelopment in exploding aviation fuel, and the long dive into a smoking hole. Great luck might mean lots of scrapes and bruises, followed by a "gong" from the air marshal. Survival could mean a promotion, a limp, and a desk job. For many, the price of failure was months of reconstructive skin grafts.

The mounting losses ground down the defending squadrons, and the horror of urban bombing shook the last nobility out of the fight. In a few cases, the wartime memoirs stop abruptly in late August or September 1940, when their exhausted writers increasingly broke the golden rule. Faithful dogs, favorite cars, and pretty girlfriends changed hands with brutal regularity. The odds did not favor a Battle of Britain fighter pilot surviving, and by war's end there were not many with firsthand memories of the hot, high summer of 1940.

∎

THE FEW

THERE IS NO AERIAL EVENT IN WORLD WAR II AS well represented in art as the Battle of Britain. Everything about the subject recommends it to the artist. It is symbolic of a beleaguered Britain standing alone against the conqueror of continental Europe, inspired by the weight and cadence of Winston Churchill's mobilizing prose. The romance of pilots alone in their fighters, facing waves of incoming bombers, is compelling. The pictures of young women in uniform moving markers representing the RAF and Luftwaffe around great game tables as the bombs fall outside completes the picture. The photographic record of these dark days might convince a person that the RAF recruited on looks; even the sleek Spitfires and stolid Hurricanes remain among the most attractive vehicles in the history of warfare. Almost every scene, whether painted or photographed from the point of view of the attackers or the defenders, depicts a sunny summer day over the pastoral landscape of the British Isles. In the face of all these possibilities, Jim's decision to treat the subject with a still life might seem unusual.

As a venerable way to expand a painting's story beyond the edge of the frame, the still life makes great sense in this case. Each element can refer the viewer to a different time and place, while working together they tell a complicated tale. Dietz devoted a portion of a family vacation in Britain to prowling the RAF Museum at Hendon in pursuit of the material on view in *The Few*. The curators may still be talking about the Yank who puttered about in the closets with his camera, pulling out and snapping photos of the little tagged artifacts from those finest hours.

■

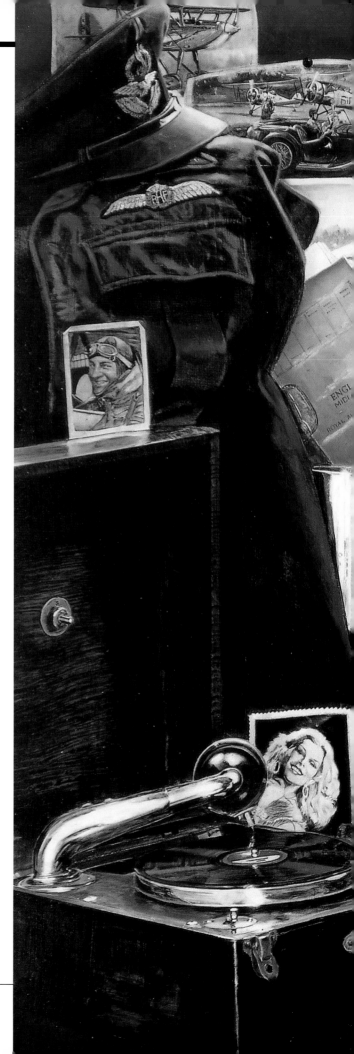

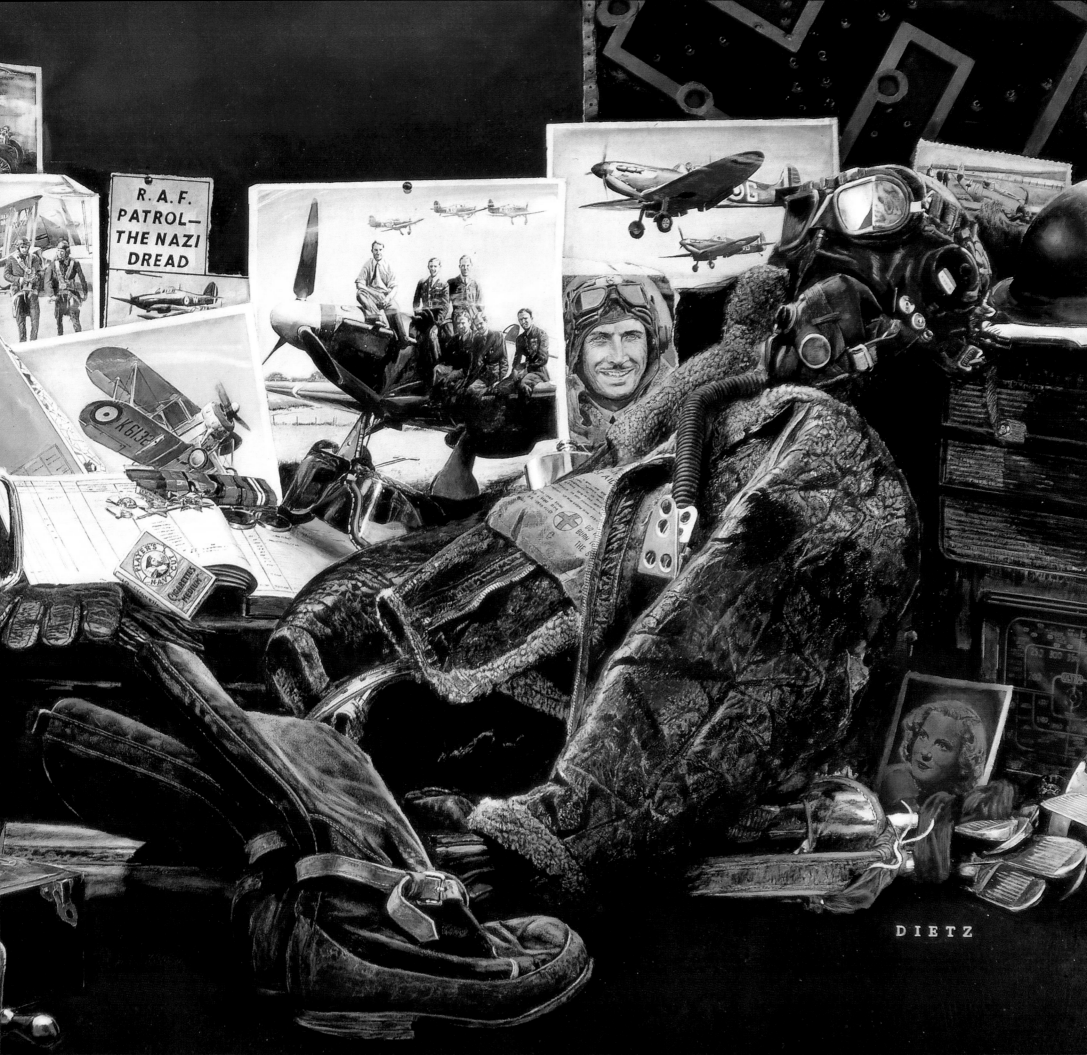

Rommel Takes Command

Lieutenant General Erwin Johannes Eugen Rommel arrived in Libya with advance elements of two Wehrmacht divisions in mid-February 1941. He was a firm believer in the efficacy of speed, striking power, and momentum. His new command had the impressive title of Deutsche Afrika Korps and the humble task of bolstering an Italian army that had just suffered military disaster. The Italians had been routed from the Egyptian frontier by an outnumbered British army, then cut off by a British armored column that had been sent, audaciously, across trackless desert. The Italian commander abandoned hundreds of armored vehicles and more than 130,000 men on the field. The front had moved more than five hundred miles (805km) west in two months.

Not content to sit in the trenches, Rommel launched a successful attack against British outposts on March 24. After assembling more of his promised battalions, he then pushed on to Mersa Brega at the base of the Gulf of Sidra. Ten days later, Rommel's tanks were at the gates of Tobruk, four hundred miles (644km) to the east, and his reputation was skyrocketing.

In hindsight, both the British advance and the British retreat seem predictable. The Italians were ill-equipped for Mussolini's war in 1940. The Italian officer corps adamantly opposed war with Britain, and Italy's most professional troops were isolated in distant East Africa. After their amazing advance into Libya, British commanders were ordered to prepare much of their desert army for service in Greece. Churchill believed that Britain had a moral obligation to support that distant ally, even if meant dangerously thinning the North African front. What could not have been predicted was how perfectly Rommel would adapt his notions of armored warfare to the terrain of the North African desert.

■

Desert Birds

In the Western Desert, any piece of flat, boulder-free space could be a landing ground. The Luftwaffe and the Desert Air Force moved back and forth along the North African littoral. Often only piles of dust-covered debris informed them that they had renewed the lease on someone else's airstrip.

The Feisler Storch pictured here was Germany's standard light utility plane throughout the war. Built in versions for reconnaissance, transport, and evacuation duties, it had superb short-field capabilities and could go virtually anywhere the troops went. Liaison pilots of all loyalties found that the little plane's ability to fly very low and very slowly was its best defense against fighters, while even the modest top speed of a spotter plane allowed it to cover much more ground than an armored patrol car. The tanks and tent in this tableau indicate that the plane is well up toward the front. Perhaps the officer under the wing has just delivered the latest gramophone record along with the day's orders.

The Stukas bearing down on this scene might be celebrating some *staffel* success, or they may just be buzzing a recognizable way point on the flight back to their own anonymous patch of desert.

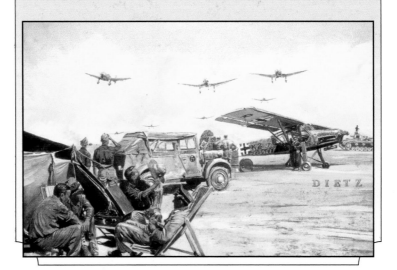

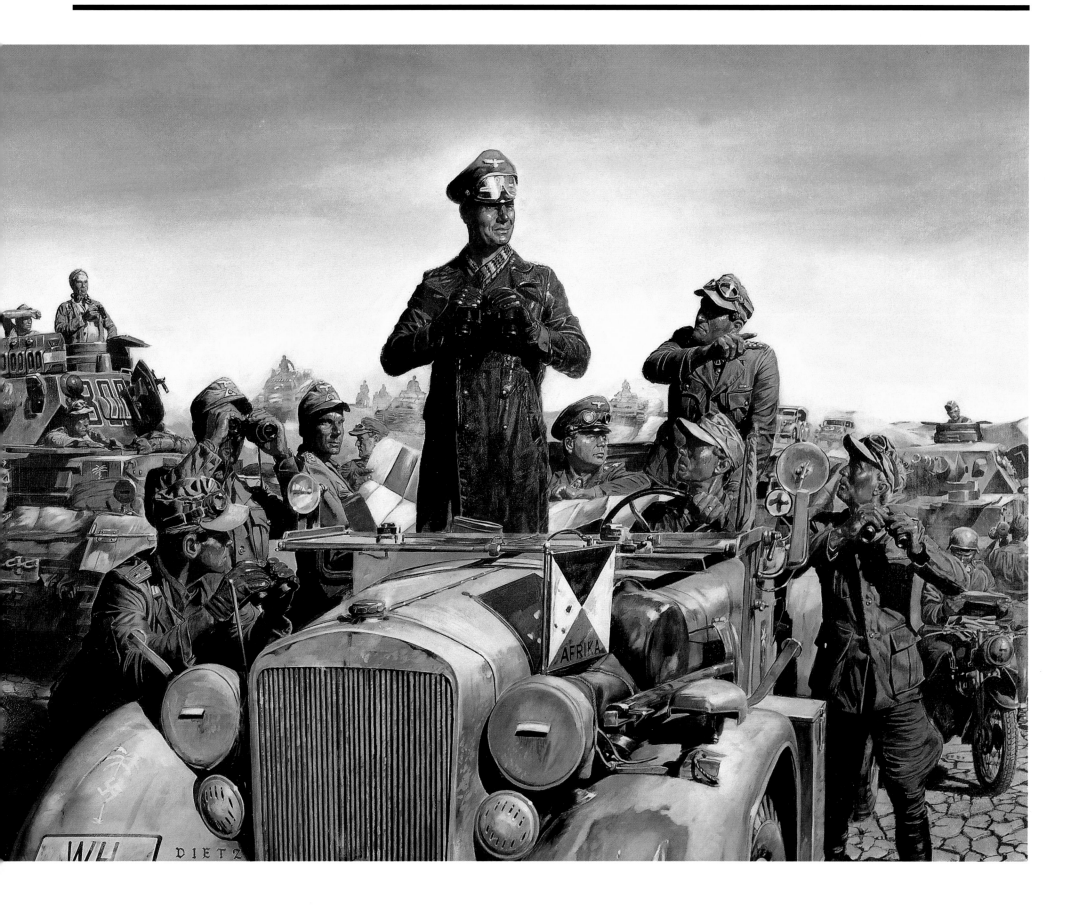

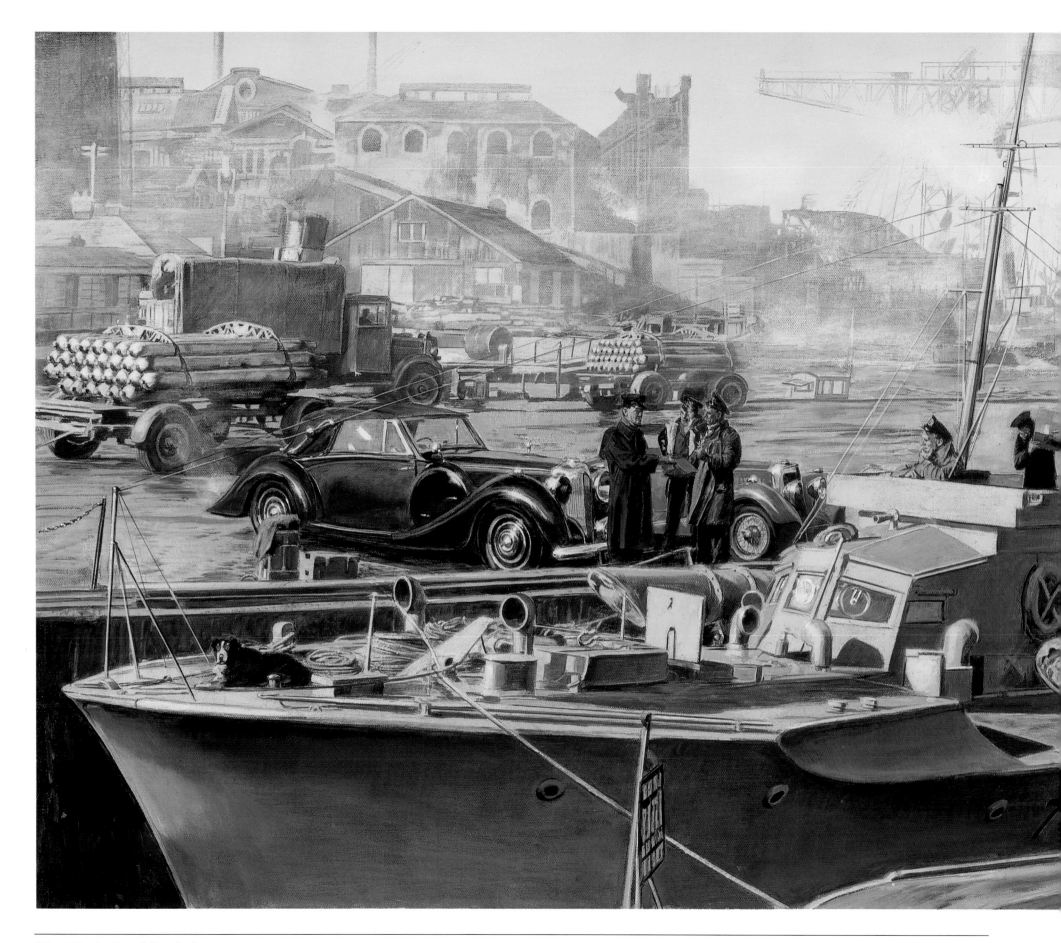

FOR YOUR EYES ONLY

BRITISH AND GERMAN LIGHT NAVAL FORCES FOUGHT a vicious, nonstop, almost private war. From the evacuation at Dunkirk to the ultimate German surrender, they clashed in the Channel, the Mediterranean, the Adriatic, and the Aegean. British boats ranged from doughty trawlers and converted fishing boats to heavily armed barges and landing craft, but the "pointy end of the spear" were high-speed torpedo and gunboats. While these boats were of numerous designs, and built by nearly every small-craft and yacht yard in the country, the Motor Torpedo Boats (MTBs) from Vosper and the Fairmile-designed Motor Gun Boats (MGBs) are symbolic of the entire small-boat war. Originally conceived as a low-cost way to launch torpedoes against important targets, the boats evolved into stealthy, high-speed platforms for large automatic weapons.

The tiny officers' quarters of the MTBs and MGBs were filled with junior officers of the Royal Navy Volunteer Reserve, mass-produced leaders whose stripes of rank on their cuffs were zigzagged rather than straight, as in the Regular Navy. For this reason, they were referred to as the "Wavy Navy" by their professional brethren. These avid amateurs went forth in unarmored but heavily armed boats to lay mines, intercept convoys, land agents, hunt submarines, escort landing craft, test weaponry, patrol harbors, and generally harass the enemy in any way possible. Some fought a semi-conventional war against similar German flotillas based in France. In North Africa and Italy the light forces were at the forefront of nearly all the amphibious operations. Things were even more colorful at the far end of the Mediterranean, where the operational diaries read like adventure fiction rather than naval history. And the Norwegian-manned vessels that raided their occupied coast faced the fury of the North Sea winter as well as the Luftwaffe and Kriegsmarine.

The boat in this painting is a typical 1940 order Vosper MTB. The offensive punch is still the torpedo, while the primary defense is the pair of .50-caliber machine guns amidships. The usual crew of the boat was ten "ratings" (non-coms) and two officers. By the look of the automobiles on the dock, the officers are very sporty, indeed. In 1937, the prototype of the Vosper boat was powered by big Italian Isotta-Fraschini engines. That source dried up when Mussolini entered the war on the wrong side. The boat pictured here was the first one from Vosper equipped with three 1200-hp Packard-Merlin engines, a set that became the standard power package. It was also an early user of the light-weight search radar. Records show that the boat that bore pennant number 73 was delivered to the Royal Navy in early October 1941. She was sunk by German aircraft in November 1943 off Sardinia, an island that had been "captured" earlier by two Fairmile MGBs.

■

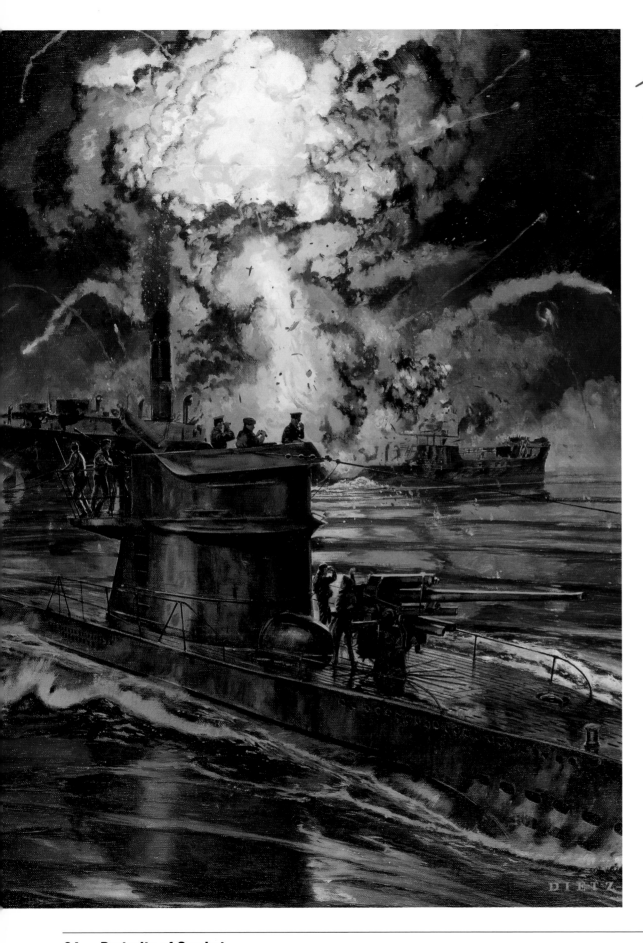

U-BOAT LEOPARD

ALL OF THE GERMAN MILITARY BRANCHES WERE surprised when Hitler chose to attack Poland in 1939, but none was as ill-equipped for war as the Kriegsmarine. The German Navy had devoted the preceding years to the capital-ship program, which involved the creation of a balanced fleet of surface and submarine vessels. Admiral Erich Raeder and his U-boat chief, Karl Dönitz, had been promised four more years to prepare for conflict. In September 1939, they had fewer than two dozen deep-sea submarines available for duty and an equal number of "Baltic" boats. They managed to sink more than one hundred Allied merchant ships before the year was out, with a loss of only nine submarines, but Great Britain alone had about three thousand merchant ships in commission at that time.

The "terms of trade" in the submarine campaign favored the Germans until mid-1941. Dönitz lost twenty-three boats in 1940 in exchange for more than 754 ships, but in 1941, thirty-five lost U-boats only bought 633 sinkings. America's entry into the war provided hundreds of new targets for the U-boats, and they made the most of them in 1942, sinking more than 1,100 ships against eighty-six submarines lost. Hellish weather in the Atlantic greeted the dawn of 1943, but the spring looked good for the Kriegsmarine, which sank more than 200 ships by the end of March. Then the hull collapsed, so to speak, on the U-boat sailors. Fifteen U-boats were lost in April, and forty-one in June. The year's toll of U-boats was an incredible 236. In any strategic sense, the U-boat war was won and lost in the summer of 1943.

The workhorse U-boats, Type VIIs and Type IXs, were awkward weapon systems at best. They were deadly against lone merchant ships, and wolf packs attacking convoys could be fearsome, but they were slower than their foes, had a short lethal range, and required a highly trained

crew. Their essential strength was stealth, but once detected, the U-boat had one objective, and that was escape. By early 1943, they were being detected by any number of means. Ship and airborne radar, radio-direction finding, code-breaking, and aircraft patrols combined to make the U-boats the prey rather then the predators. If they managed to engage a convoy, they met more escorts with better weapons.

Historians and participants have spent more than sixty years analyzing the U-boat campaign, and they still agree on little beyond raw data of tonnage sank and tonnage built. It is currently fashionable to presume that the U-boats never had a chance of strangling the British military effort and were at best an expensive sideshow. U-boat advocates have always held that the steel and machinery expended on *Bismarck*, *Scharnhorst*, and all the other capital ships, would have been better used for submarines. Similar arguments can be made for converting the U-boat resources into Panzer divisions for the Eastern Front. A telling statistic of the U-boat war is that not one of the major European amphibious operations was materially hindered by German submarines, including the 1942 invasion of North Africa. Britain not only stayed thoroughly in the war, but was aided considerably by Canadian and American men and equipment, all brought by ship.

◾

U-BOAT OFFSHORE

There is a mystique about the *Unterseeboot*, or U-boat, of World War II that does not apply to other submarines or other times. The U-boat was not the most efficient or most strategically effective submersible of the war, but its legacy has a special aura to it.

Dietz estimates that he has done twenty submarine studies during his career. They range from World War I "pig boats" to futuristic science fiction craft, but none works as well artistically as the basic U-boat. The fact that U-boats early in the war approached their targets on the surface is a boon to artists. A sub on the surface reflects the colors of the atmosphere, shore lights, sunset, flame, or moonlight. And the conning tower rising above the sea looks more than a little bit like the fin of a shark carving towards a swimmer.

To Dietz's eye, the design of the classic U-boat is predatory. By comparison, the big U.S. fleet submarines look industrial and benign. The archetypal image of the American submarine is populated by khaki-clad officers and sailors with rolled-up sleeves, scanning sunlit Pacific horizons. By comparison, depictions of U-boats are crewed by bearded men in leather jackets who attack by night. American submarines "cruised" from Honolulu, while U-boats roamed the Atlantic in "wolf packs." The allure of the lost cause clings to the U-boat as well. The German submarine service was nearly exterminated, and every image of it is ultimately a reminder of Allied victory.

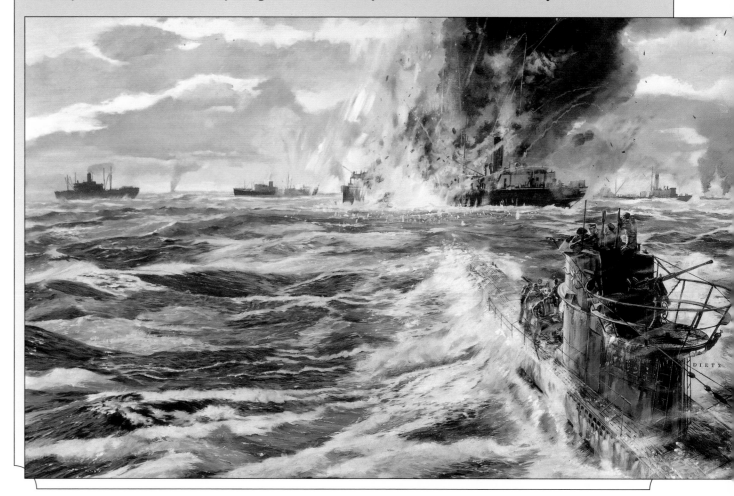

PEARL HARBOR

NO ONE WAS PLANNING TO CHRONICLE A MAJOR historical event on December 7, 1941. There are relatively few records of the attack, and few of the eyewitness accounts portray it as an artist can, making Pearl Harbor a popular subject for painters.

For this book cover illustration, Dietz relied on survivor recollections, aftermath photographs, and the ubiquitous towering columns of petrochemical smoke. In particular, he has captured the visual impact of the shattered ships on battleship row. A view of small ship crews fighting back from the fringes of the harbor may have been more Dietz's style, but it would have failed to convey the fury of the raid. Men ducking away from strafing fighter planes ignored the huge material damage inflicted on the fleet. Aerial points of view featured individual attackers, but failed to encompass the scope of the surprise attack. A following view of a Kate torpedo bomber pulling over the stricken *Oklahoma* or *Nevada* was powerful, but the Val dive-bomber was a more memorable symbol of Japanese carrier aviation. The Kate was more destructive but less evocative of the event.

Soldiers and sailors commented on how big the red Japanese insignia looked on the attacking planes. The painting pulls the planes down low and places the "meatball" against the oily smoke for both size and contrast. The view down the row of burning battleships conveys the magnitude of the disaster. The big stationary gun turrets and the old-fashioned fighting top on the *Arizona* look like monuments to an outdated technology. Down at the bottom, standing out against the darkness, the tattered Stars and Stripes reminds anyone who might have forgotten that this was not the end, but the beginning, of America's involvement in the war.

■

THREE BELLES

As a painter, Dietz has a natural affinity for the scenes surrounding cataclysmic events. The tension of the moment just before an explosion is a more interesting thing to capture than the blast itself. *Three Belles* is an attempt to recapture an American scene in the short moment between the Depression and World War II. Dietz is an unabashed movie fan, and this little study gives an unabashed nod to the Hollywood image of pre-war Hawaii.

The Hawaiian Islands were still an exotic destination in the 1930s, a land unrelated to the closed factories and relief lines of Depression-era America. Most travelers reached Honolulu aboard a Matson liner, but the very adventurous could fly on Pan Am's China Clipper. Flower-draped *wahinis* taught the hula on Waikiki. Harry Owens and the Royal Hawaiians were the house band at the big pink hotel. Pearl Harbor was a sought-after duty station, and tourists in Honolulu could gawk at the Far Eastern culture in evidence on the island.

Only a Hollywood art director (or a painter) would replant those palm trees alongside the ship channel at Pearl Harbor. For Hollywood, the *Arizona*'s officers would have to be in their summer-duty whites and the aircraft on the turret would be a Vought biplane in the lively peacetime colors. The streamlined Continental V-12 convertible evokes a nation trying to turn its back on lean times, and whether the young woman in the car is waving hello or good-bye, it is still *aloha*.

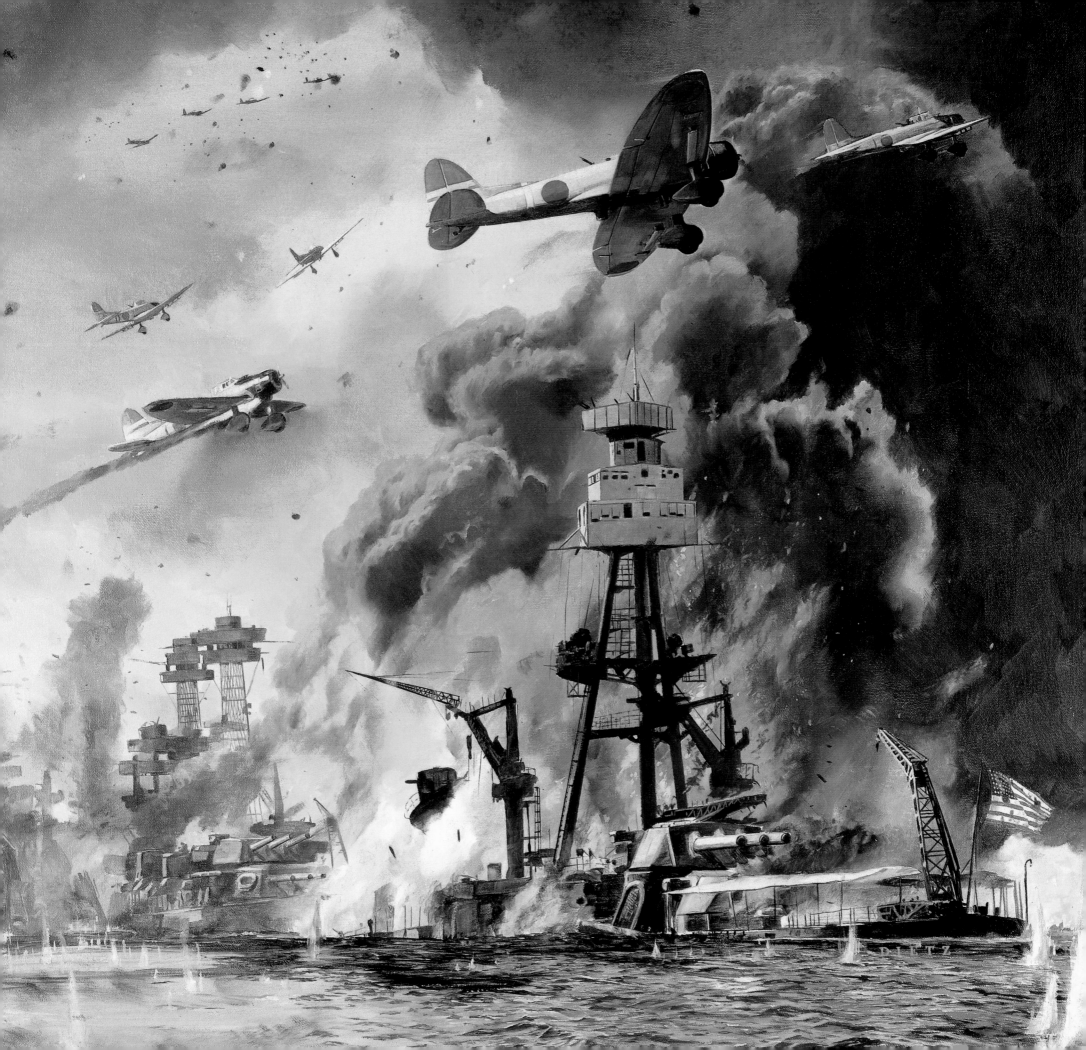

1941

PHILIPPINES PT

THERE WERE TWENTY-NINE PT BOATS ON THE U.S.
Navy roster at the time of the Pearl Harbor
attack. Motor Torpedo Boat Squadron Three,
under the command of John Bulkeley, was oper-
ating six of them in the Philippine Islands. His
little force was slowly whittled down to zero by
accidents, enemy action, and lack of spare parts,
but their activities in the losing cause convinced
the Navy that this type of small surface vessel
would be vital for the rest of the war.

The U.S. Navy, like its British counterpart,
envisioned the new PT boats as a fast attack
craft, capable of ambushing and sinking much
larger opponents with their torpedo main arma-
ment. This was theoretically possible, if the larger
opponent was surprised and if the torpedoes
functioned properly. Early operations in the
Philippines revealed that there were great gaps
between theory and practice. An idling PT boat
could patrol very stealthily at night, but extreme
stealth was achieved at the price of patrol range.
The ambushing PTs had to know when and
where the enemy might appear. At high speed, a
PT boat was a difficult gunnery target, but it left
a huge—and often phosphorescent—wake that
could be seen for miles. In later campaigns, this
made PT boats easy prey for slow float planes
patrolling at night.

Squadron Three is famous for spiriting
General Douglas MacArthur and Filipino
President Manuel Quezon away from the
advancing Japanese, but they also fought long-
odds engagements against Japanese destroyers
in the central and southern Philippines. In the
incident pictured here, two PTs took on a
Japanese destroyer group and its light cruiser
flotilla leader off the coast of Cebu, on the night
of April 8–9, 1942. In a confused running action,
lit by searchlights, gunfire, and explosions, both
Commander Bulkeley on PT 41 and Lieutenant
Robert Kelly on PT 34 were confident that the
enemy cruiser had been sunk, although they

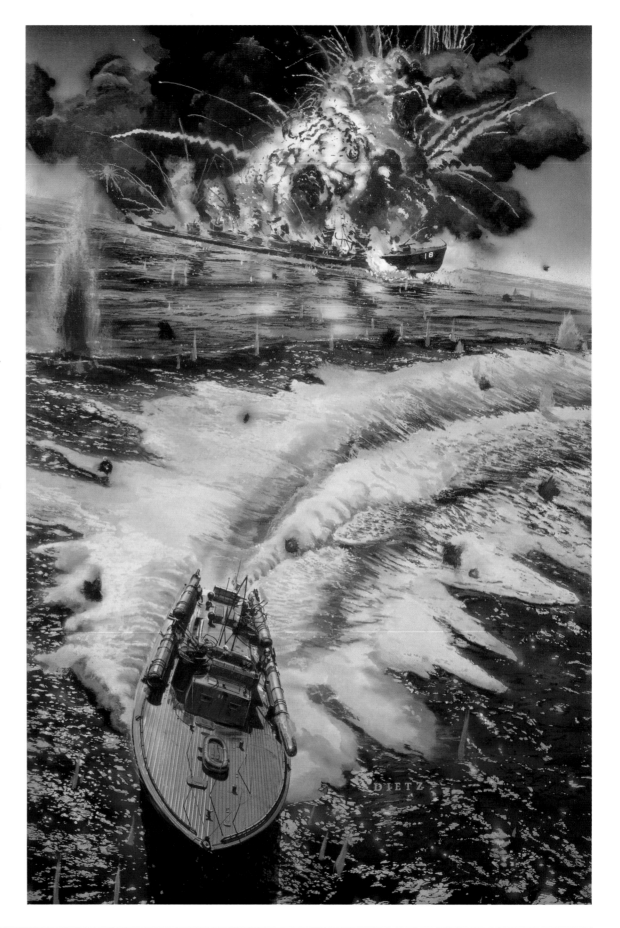

disagreed on exactly which class of ship it was. Postwar investigations showed that the Imperial Japanese Navy Ship *Kama* was hit by a dud torpedo on that night and set afire by gunfire, but she survived to fight for two more years. In any case, the Japanese knew that there was still a U.S. Navy, albeit it a tiny one, in the Philippines.

Within six months of Bulkeley's last fight with Squadron Three in the Philippines, PT boats were operating in support of the Guadalcanal invasion. It was during this Solomon Islands campaign that they evolved from torpedo carriers to heavily gunned hunters of enemy supply ships, barges, lighters, and landing craft. The initial armament of twin .50-caliber machine gun mounts grew with the addition of 20mm Oerlikon automatic cannons, then a 40mm Bofors gun, and even multiple rocket launchers. At the same time, the torpedo launching systems were completely reengineered and the dismal early torpedoes were replaced by new, harder-hitting models initially designed for aircraft use.

PT boats saw combat in Alaska, the South Pacific, the Mediterranean, and the English Channel. In a numerical quirk, the U.S. Navy's official record of PT boat operations reports that the were twenty-nine PT squadrons in commission at the height of World War II, one squadron for each boat at the beginning of the war.

■

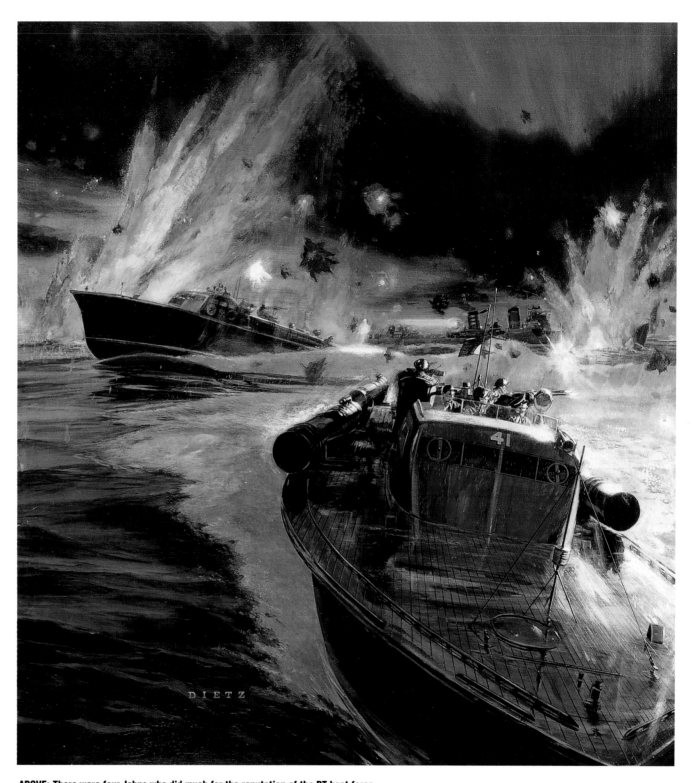

ABOVE: There were four Johns who did much for the reputation of the PT boat force. Very briefly, John Ford met John Bulkeley on a flight back from the Mediterranean and was immediately taken with the idea of making the film *They Were Expendable.* The film turned out to be one of Ford's best, with John Wayne playing the lead. Finally, there was John Kennedy, the young lieutenant (junior grade) who was one of the first skippers to mount a "big gun" on his boat. He lost the ship, but saved most of the crew and went on to be the second World War II veteran to be elected president of the United States.

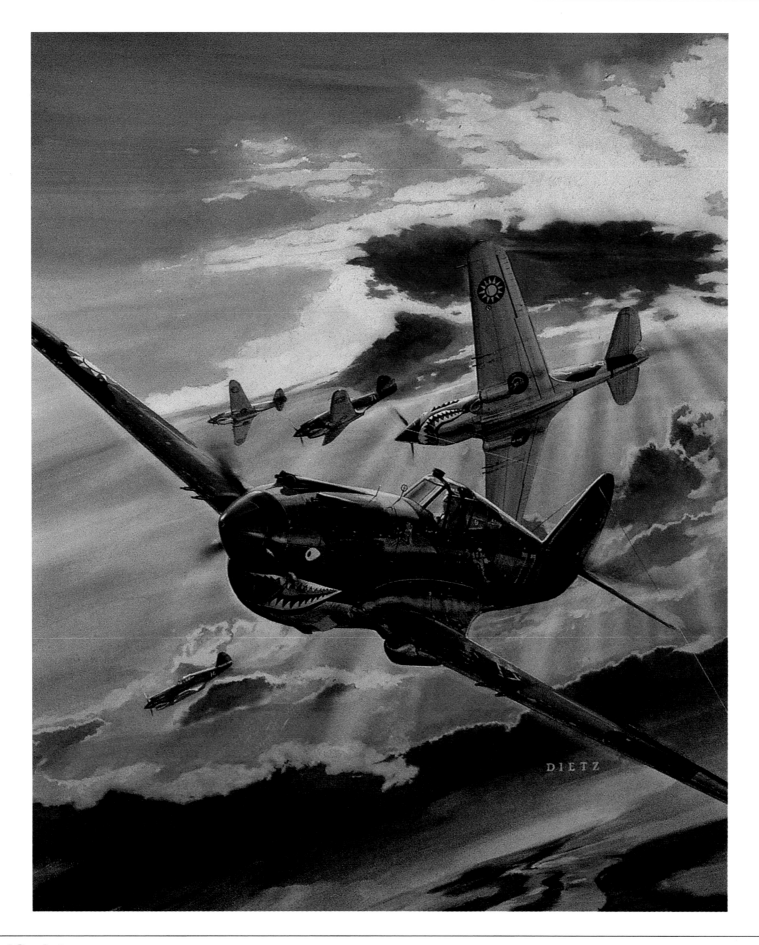

FLYING TIGERS

THE AMERICAN VOLUNTEER GROUP WAS A PULP novelist's dream. Their tale included devil-may-care mercenary pilots, sympathetic officials, a controversial commander, squadrons of shark-toothed aircraft, and plucky underpaid comrades. Set against a background of Oriental intrigue, and timed to be the only good news in three months of disaster, it is no surprise that the AVG found a place in American legend.

The group grew out of Claire Lee Chennault's civilian contract to inspect and advise the Chinese Nationalist air force. He quickly decided that the fastest way to make that force effective was to hire it en masse from abroad, a notion that meshed nicely with Franklin Roosevelt's growing concern for China's survival. Chennault was allowed to recruit from

the ranks of active-duty military personnel, and the Chinese were promised three squadrons of Curtiss P-40 fighters

The Japanese began their December offensive just as the AVG in Burma was nearing combat readiness. The group shuttled squadrons from Rangoon at the south end of China's supply line to Kunming at the north. Legend holds that their success at Kunming inspired the Chinese to dub the planes *Fei Hou*, "flying tigers."

Over Rangoon things were less one-sided, as the RAF and AVG battled the Japanese Army for control of the skies over the vital port. Advancing Japanese ground forces ended air operations in Rangoon in late February, and the AVG moved north. By April the Flying Tigers were war-weary, short of supplies, and increasingly wary of

encroaching USAAF command staffs. Chennault was reinstated as a Brigadier General, and the handwriting was on the wall for all the bounty-hunting freelance flyers to see. Soon, most of the AVG pilots decided to let their Chinese contracts lapse and returned to the States to fight the war in their original uniforms. On July 4, 1942, the remaining AVG equipment and personnel were folded into the 14th Air Force.

■

BELOW: This sketch of USAAF mechanics servicing P-40s beneath equatorial palm trees was an early study for a Henderson Field painting. The shark mouth motif appeared on RAF P-40s in North Africa, was made famous in China, and by 1943 could be found in most theaters of operations.

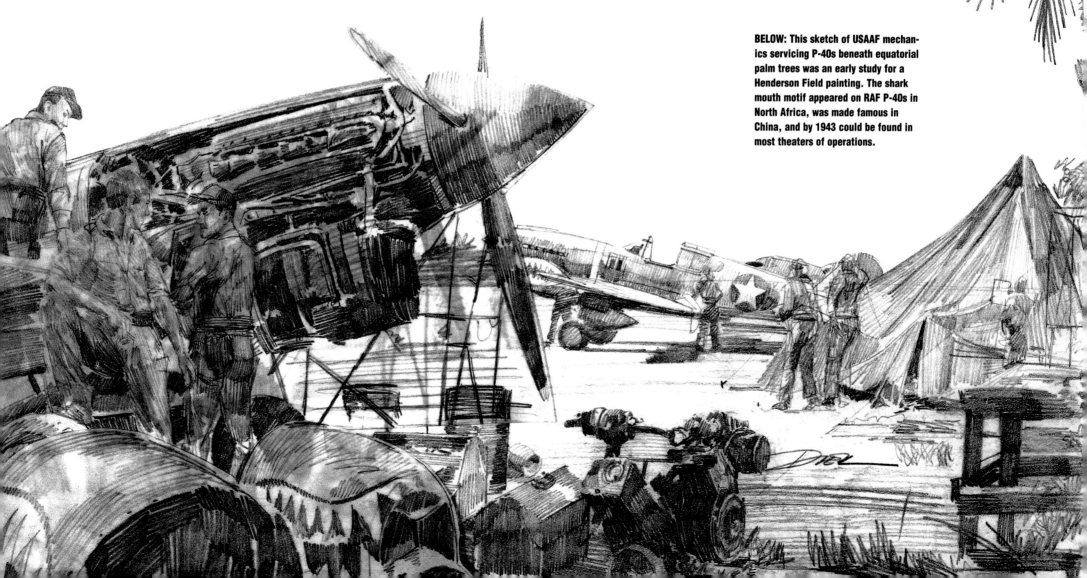

LETTER FROM CHINA

BEING PART OF "THE FORGOTTEN WAR" WAS A PER
verse point of pride for many soldiers and
sailors of World War II. Few had as strong a claim
on the title as the men and women in the China-
Burma-India theater of operations. The 14th Air
Force in China was at the bottom of the logisti-
cal pecking order, rife with inter-Allied and intra-
service politics, and devoid of land communica-
tion with friendly forces. It encompassed joint
Chinese-American units and odd fighter-liaison
squadrons. The 14th even hosted B-29s for an
early series of raids on Japan. At the far end of
the earth, the flyers in China were apt inspiration
for the *Terry and the Pirates* comic strip.

The 14th Air Force was created on July 4,
1942, starting with one bomb squadron and the
remains of the AVG. Claire Chennault was its
commander. His fighter group was led by one of
the few Flying Tigers who stayed on; a Doolittle
raider commanded the bomb squadron. The
14th was entirely dependent on fuel, munitions,
and spare parts flown over the Himalayas by the
Air Transport Command. The cost of "keeping
China in the war" was paid in the currency of
dead aircrews and wrecked transports scattered
all the way from the steamy plains of Assam to
the runways at Kunming.

As the 14th grew, flyers in China flew combat
missions whenever they had sufficient bombs
and fuel on hand. When the supply situation was
critical, their bombers flew to India on supply
runs. Veterans debate which missions were more
dangerous. Their combat tasks ranged from close
air support and interception to the bombing and
mining of ports and waterways from Haiphong
to north China, but their real victory was in
proving that America had the material and
human resources to operate an Air Force any-
where under any conditions. It was an honor
that was dearly won.

■

THUMBS UP

The client for this painting wanted the piece to replicate the look of a World War II
recruiting poster. That meant it needed to be colorful and easy to understand. The
Americans depicted had to look either very healthy or very determined, or both.
There had to be room for a slogan, and the design had to lift the eyes, head, and
spirit. A bold "You Buy 'Em, We'll Fly 'Em" could easily be blazoned across the top
of this image, with a U.S. Army Air Forces tag along the bottom.

Propaganda art was important to all sides in the war, and was remarkably simi-
lar around the world. The "good guys" had to look like noble winners. Pilots in
Britain, America, Russia, and Germany lifted chiseled chins to the sky. The enemy
was lucky to be humanoid. Rats, monkeys, insects, and snakes were popular repre-
sentations of the foe. Caricatures that turned the enemy into animated war
machines relieved the viewer of any sense of common humanity.

The cautionary poster was another worldwide standard. "Loose Lips Sink
Ships," "Somebody Talked," "A Few Careless Words," and "Be Like Dad, Keep
Mum" all warned of the dangers of spies among us. The seductive blonde surround-
ed by middle-aged staff officers on "Keep Mum, She's not so Dumb" did the same
with an *Esquire* touch.

The combat artists who followed the course of the war produced works that are
still powerful decades later, but the best-known painted images of World War II are
the ones produced by advertising agencies with slogans like "Keep 'Em Flying."

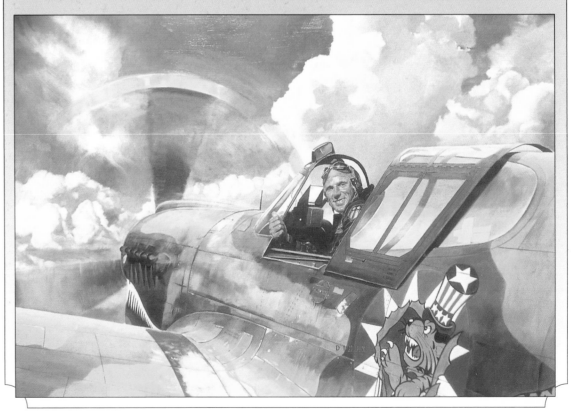

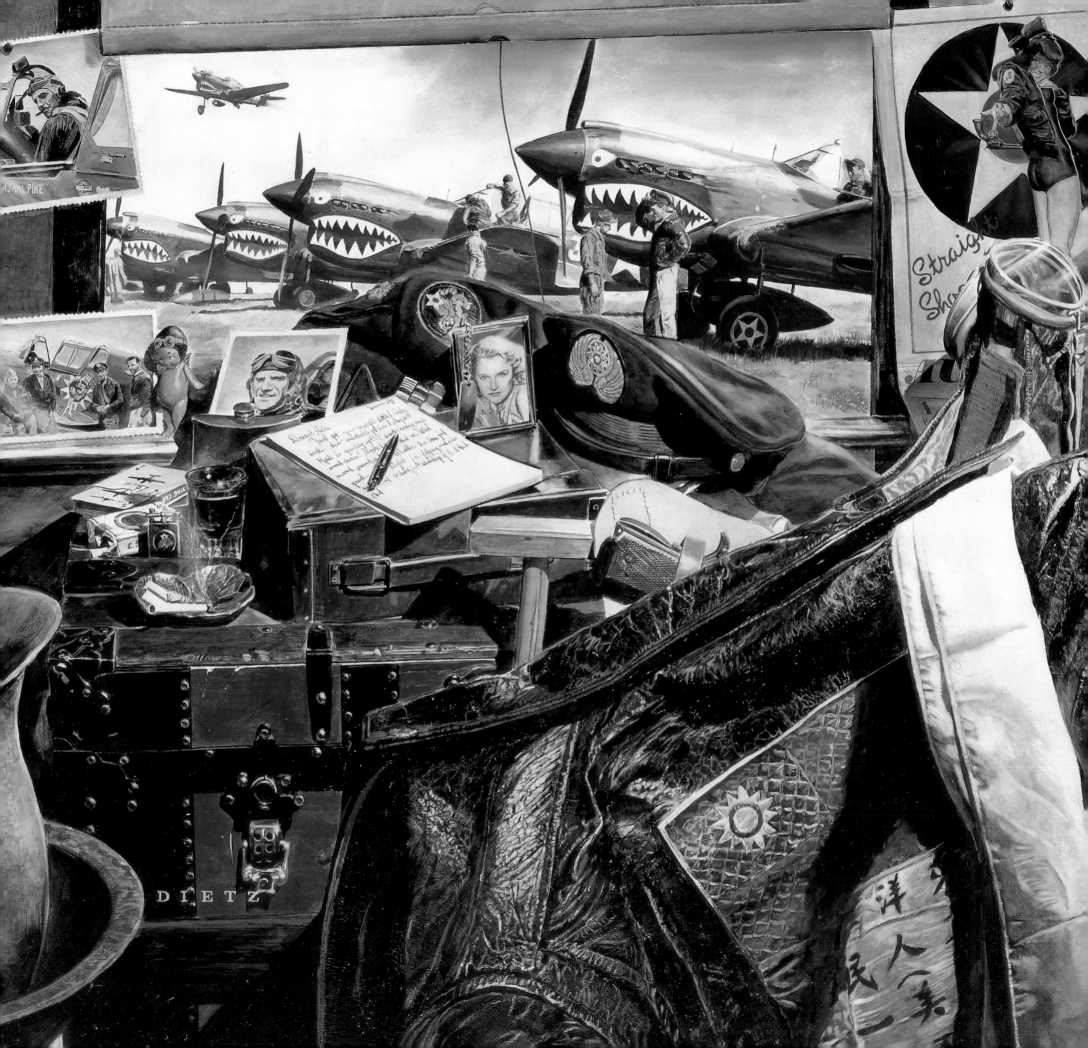

BOTTOM OF THE FIRST

JIM DIETZ CHOSE TO TURN THE STANDARD B-17 stories inside out as he sketched this commissioned work for a northwestern art collector. The Flying Fortress is one of the most frequently portrayed American aircraft, and fine paintings have been done of battered B-17s returning to England, stately B-17s against towering clouds, embattled B-17s beset by fighters, and massed B-17s dragging contrails across Germany. Such paintings celebrate the fact that if any plane could bring its crew back to base, it was the Flying Fortress.

The B-17s in the Philippines were in a different situation. They were leaving and they weren't coming back. The planes that survived the first Japanese air attacks made futile attempts to strike at the invasion fleets, but were quickly assigned to long-range patrol and emergency transportation duties.

A week after the Pearl Harbor attack, the Japanese Army began operating fighter planes from Luzon airfields. The war was already in full swing farther south, and Flying Fortresses were being used to evacuate "essential" personnel to Australia. Soon, the B-17s would be gone from Mindanao for good and many of the ground echelon and support personnel would be left to an uncertain future.

Bottom of the First attempts to capture the backs-against-the wall feeling on Mindanao as two weathered B-17Cs prepare to sortie. Every flight out of Del Monte entailed terrible choices between those who would escape and those who would stay behind. The American soldiers and mechanics, thousands of miles from home and cut off from friendly forces, had few options. The two armed men seen walking away from the B-17 appear to have chosen something other than surrender.

■

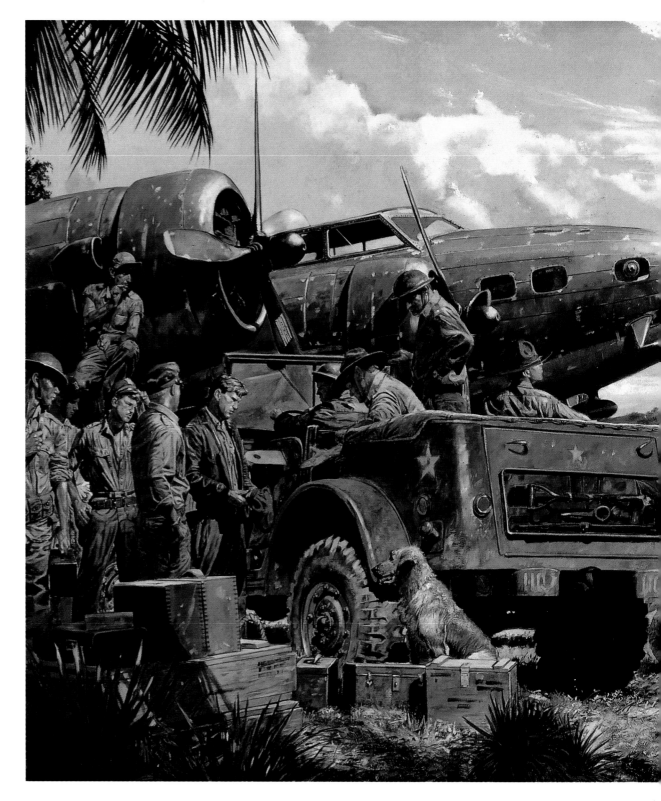

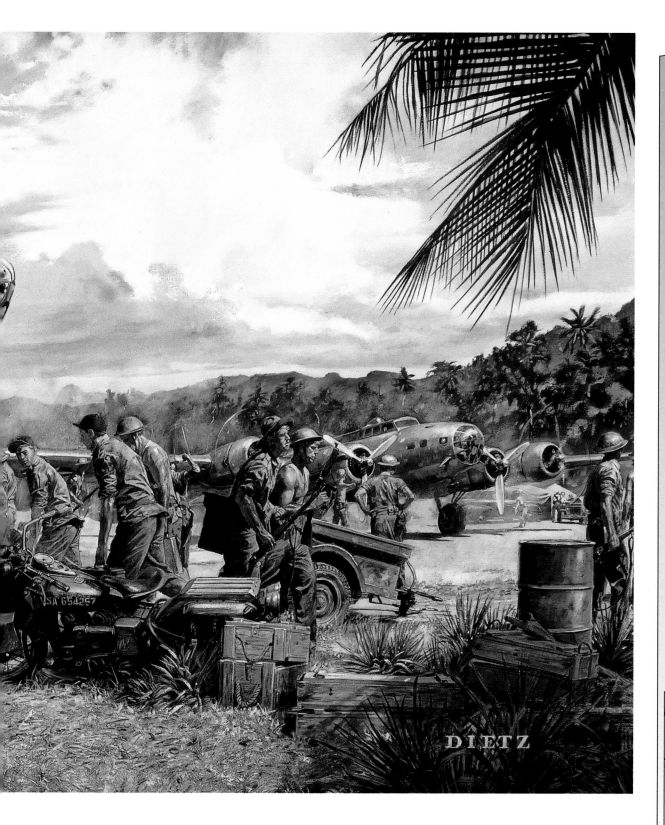

COLIN KELLY

Captain Colin Kelly was a B-17 pilot with the 14th Bomb Squadron. On December 8, his unit was at Del Monte on Mindanao when the Japanese smashed the bulk of the 19th Bomb Group at Clark Field. The remaining planes and pilots of the 19th attempted to continue with the Air Corps war plan, but the odds were against a handful of B-17s materially affecting the outcome of the campaign.

On December 10, 1942, Kelly's was one of three B-17s sent to bomb the invasion fleet at the northern tip of Luzon. He managed to find a Japanese minesweeper off Aparri, and left it sinking. On the way home, his plane was attacked by Zeros patrolling above the newly captured airstrip at Vigan. The Japanese swarmed over the Boeing and followed it south, attacking in turns. The heavily damaged B-17 flew on. The plane finally began to burn as it approached Clark Field, and Kelly ordered his crew to bail out. He kept his B-17 under control while five men jumped, but the plane exploded before Kelly could exit. The Army awarded him a posthumous DSC for his actions. The Air Corps and the American press quickly turned Kelly into their first hero of the war; his brave self-sacrifice became the inspiration for a wave of propaganda reporting.

Years after this painting was completed, Dietz found a reference indicating that Kelly's plane was shot down before it received its olive drab paint.

BATAAN DEATH MARCH

THE COMMAND STAFFS OF THE U.S. ARMY AND Navy developed master plans for a Pacific war throughout the 1920s and 1930s. No matter the version or code name, the plan usually returned to a focus on a holding action in the Philippine Islands and a fleet expedition to relieve the defenders and destroy the Japanese Navy. Unfortunately for the Army planners, the fighting force in the Philippines was never properly developed. As for the Navy, the devastating attack on Pearl Harbor rendered decades of staff conferences moot almost overnight.

Luzon's defenders were pushed back to the gates of Manila in less than three weeks, and the dawn of 1942 saw them withdrawing to defen-sive lines on the Bataan Peninsula in the face of the Japanese advance. There were more than 75,000 Philippine and American troops and thousands of civilians on Bataan, but only a meager store of food, medicine, and ammuni-tion. The garrison defeated the initial Japanese attempts to force their defenses, but couldn't solve their supply problems. Malnutrition and malaria soon became the real enemy. The Japanese Army renewed the offensive in March, and by early April the defenders and their sup-plies were finished. Faced with certain defeat, the commander of the Bataan forces, General Edward P. King, ordered his troops to surrender on April 9, 1942.

The victorious Japanese were mentally and materially ill-equipped to deal with tens of thou-sands of prisoners of war. The idea of surrender was anathema in their military code, even when surrendering troops were following direct orders of their superiors. There were no plans in place for feeding, transporting, or housing the captives of Bataan. The simple expedient was to herd the POWs together at the town of Mariveles and then march them north to the nearest railroad, almost sixty-three miles (100km) away. The con-centration of the defeated troops was hurriedly done, and the first groups were started north on April 12. The prisoners lost unit cohesion in the chaos of the mustering process, and there was

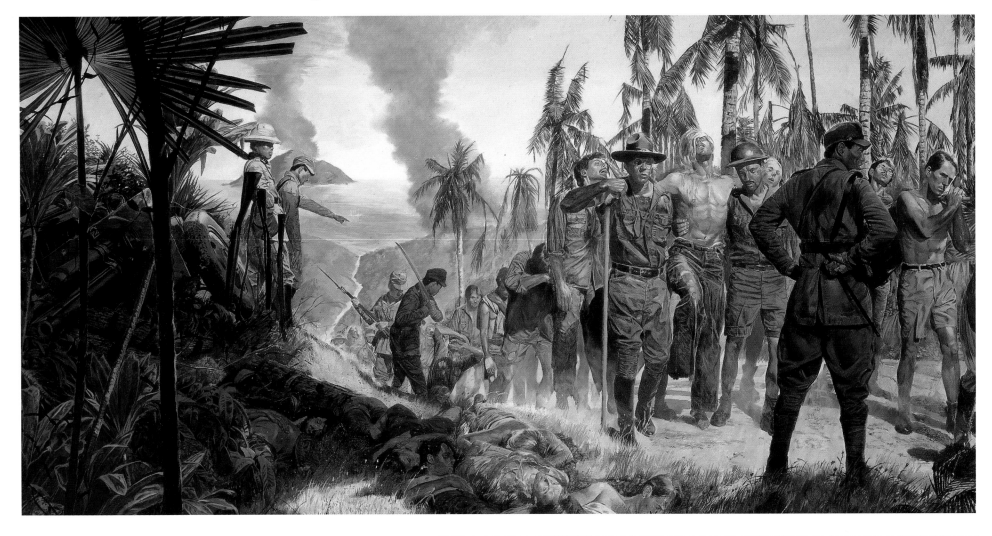

little mutual support among the marchers. The men in the groups slogging north were largely strangers to one another, and those who faltered had few buddies to urge them on. The Japanese enforced a brutal march discipline using rifle butts, bayonets, and swords.

There were no arrangements for food and water along the route, and the malnourished, disease-racked defenders began falling out of the column within a few miles. Approximately 650 of 10,000 Americans died on the way. There were more than 65,000 Filipino soldiers in the round-up on Bataan, and almost a fourth of them were lost en route to the prison camp. A few thousand of those are thought to have escaped into the surrounding population, but most died along the way.

The route to the jammed boxcars at San Fernando station was replete with horrors. Summary execution was common. Some prisoners were even used as human shields to protect the Japanese artillery pieces shelling the island of Corregidor. For all the prisoners, the trek meant over a week without food, little shelter, and only the water they could find along the road.

The condition of the Bataan prisoners was reflected in the survival rates in Japanese prison camps. Prisoners from Corregidor, which surrendered after the last of the Bataan victims had reached the camps, were spared the widespread disease and the starvation that the Bataan defenders suffered. A Corregidor veteran was statistically twice as likely to be alive at Liberation than one from Bataan. Reports of the march on Luzon and the prison camp conditions filtered throughout the rest of the archipelago, convincing Filipino and American guerillas that surrender would not be an option for them.

∎

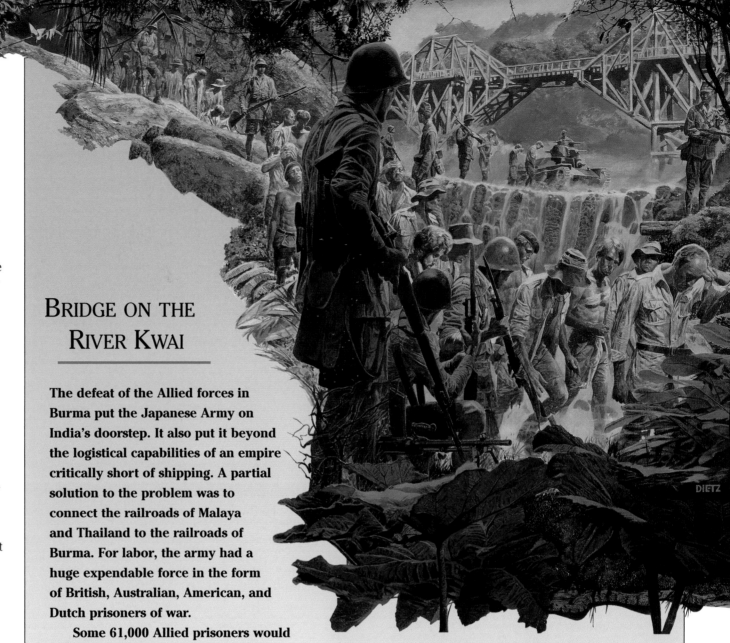

BRIDGE ON THE RIVER KWAI

The defeat of the Allied forces in Burma put the Japanese Army on India's doorstep. It also put it beyond the logistical capabilities of an empire critically short of shipping. A partial solution to the problem was to connect the railroads of Malaya and Thailand to the railroads of Burma. For labor, the army had a huge expendable force in the form of British, Australian, American, and Dutch prisoners of war.

Some 61,000 Allied prisoners would be transported to the Thailand–Burma Railway (TBR). They worked as slave labor on the Kwai Noe Valley route that had been surveyed by the British long before the war. The peacetime schedule for construction of the line was five years, but the Japanese Imperial staff wanted it done in a third of that time. When 1943 opened with sequential Japanese setbacks in other theaters, the pace was quickened even more.

The Japanese showed little regard for the nourishment or medical care of their prison laborers. As work gangs wore down, new groups were brought up the tracks to face malnutrition, cholera, malaria, and deep infectious tropical skin ulcers. Treatment was brutal, but there was almost no danger of escape from the TBR camps. The jungle made a more effective barrier than rows of barbed wire, and prisoners quickly lost the strength to escape. They just endured, trying to stay alive, and building as bad a railway as they could manage. The line was officially opened on October 17, 1943, at a cost of 16,000 lives.

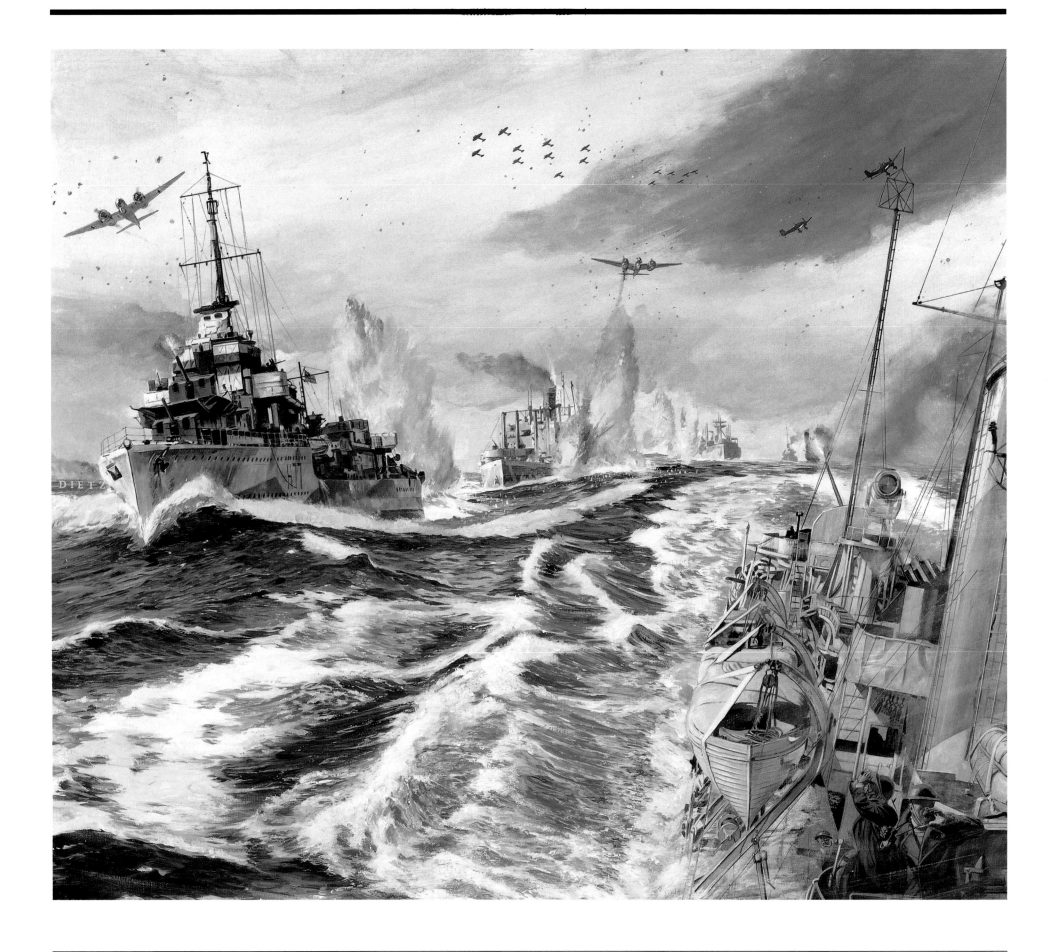

ARCTIC CONVOY

AN IMPRESSIVE LITANY OF HAZARDS FACED THE convoys delivering supplies to Murmansk in 1942. The Luftwaffe had total control of the northern coast of Norway, and the German pilots enjoyed constant daylight from May to August. U-boat wolf packs had ample time to intercept slow-moving convoys, and the Norwegian fjords were home to powerful German surface units. In addition to these perils, Allied ships had to contend with the usual dangers of operating in arctic waters. The fact that the Atlantic partners

BELOW: An homage to Nicholas Monserrat's great books about Royal Navy escorts, this Flower Class corvette was part of an alternative design of *Arctic Convoy*.

sent a wartime total of seventy-seven convoys around North Cape to Murmansk illustrates how vital they felt it was to assist Russia.

The most famous—and least representative—of the arctic convoys was PQ-17. In July 1942, it was the victim of a concerted aerial and submarine attack, compounded by a ghastly command failure at the top levels of the Royal Navy.

Early convoys had slipped into Murmansk unscathed, but the two immediately preceding the thirty-five merchantmen of PQ-17 had lost a total of a dozen ships, mostly to aircraft attack. Number seventeen would be inviting trouble from the Luftwaffe at the most dangerous time of year. Also, *Tirpitz*, the sister battleship to *Bismarck*, was reportedly operational, and at least one heavy cruiser and Germany's surviving destroyers were known to be stationed in Norway.

The Allied navies piled on the escorts for PQ-17. In addition to the convoy anti-submarine screen, there were four cruisers and their destroyers in close company. The new battleships *Washington* and *Duke of York* and the carrier HMS *Victorious* were part of a covering force, ten hours steaming time astern of the convoy. The convoy sailed from Iceland on June 27, 1942, and although it was quickly spotted by the Germans, there were no attacks until torpedo bombers appeared late on July 2. They were driven away by the convoy's concentrated anti-aircraft fire, as would be most of the Luftwaffe sorties the next day.

The real trouble was brewing in London, where the Admiralty had lost track of the *Tirpitz*. The senior command envisioned a worst-case scenario of sunken cruisers and a destroyed convoy, with the Germans escaping before the Allied battleships could intervene. Against the advice of his senior staff, the First Sea Lord ordered the covering force to withdraw to safety. The convoy,

which was comprised mainly of American flag freighters, was ordered to disperse. The *Tirpitz* never did put to sea, but the bombers and submarines feasted on the scattered merchantmen. Only a third of the ships reached Russia, some by sneaking along the edge of the arctic ice pack.

The mishandling of PQ-17 cast a grim chill over relations between the American and British naval staffs. American officers could not understand why their allies had avoided the chance to bring *Tirpitz* to combat. The Chief of Naval Operations, Admiral Ernest King, a man of fierce opinions, was furious at his British counterpart for ordering the U.S. Navy escorts away from American flag ships as they stood into danger. The abandonment of the convoy colored the way King would approach joint operations in the Atlantic for months to come.

The next convoy, PQ-18, was heavily escorted and fought its way through the air and undersea barrage in September. A third of its merchantmen were sunk. These were unacceptable losses, but the Germans paid a price as well, losing three U-boats and many of their best Norway-based bombers. The next convoy sailing would be postponed until winter sent the Luftwaffe south and brought darkness to cloak the ships. Soon, the arctic convoys were regularly screened by escort carriers, and ever stronger surface forces hunted the German surface ships. More than fifteen hundred merchant voyages were made to northern Russia by the end of the war. Fewer than a hundred of those ships on the Murmansk run were lost, and a fourth of that total had sailed from Iceland with PQ-17.

■

SEA WOLVES

America's entry into the war as a combatant, rather than a heavily armed neutral, gave the Kriegsmarine U-boat force an unexpected opportunity to return to full offensive action. With the United States as a belligerent power, the Germans were free to strike when and where they could. The first blow was code-named Operation Drumbeat, and was limited only by ship availability and long transit times.

The first of five long-range Type IX U-boats arrived in U.S. waters in the second week of January 1942. The handful of submarines sank their first ship on January 11 and continued to sink at least one a day until they ran out of torpedoes. It was a second "happy time" for German submariners, who faced a foe that had no convoy system, grossly insufficient anti-submarine forces, a peacetime mentality regarding blackouts, and a huge volume of coastal trade. U-boats would spend the daylight hours submerged, or even resting on the bottom, then surface and prowl the shoreline under cover of darkness. The British offered their hard-earned advice, but the U-boat war on the nation's doorstep was never America's top priority.

The carnage of Drumbeat continued through the early spring as subsequent waves of U-boats began to range farther down the eastern seaboard and into the Caribbean. The Germans began refueling operations in the mid-Atlantic, which increased the patrol time off the U.S. coast by weeks. Gulf Coast shipping and the oil tanker traffic from Venezuela were now in range of the workhorse Type VII boats, pictured in this book cover painting.

America had established a workable coastal convoy system by mid-May 1942, along with more and better shore-based patrol aircraft. The U-boat's one-a-month loss rate of April and May doubled in June, and the last boats were withdrawn after three were sunk in early July. Happy times were over.

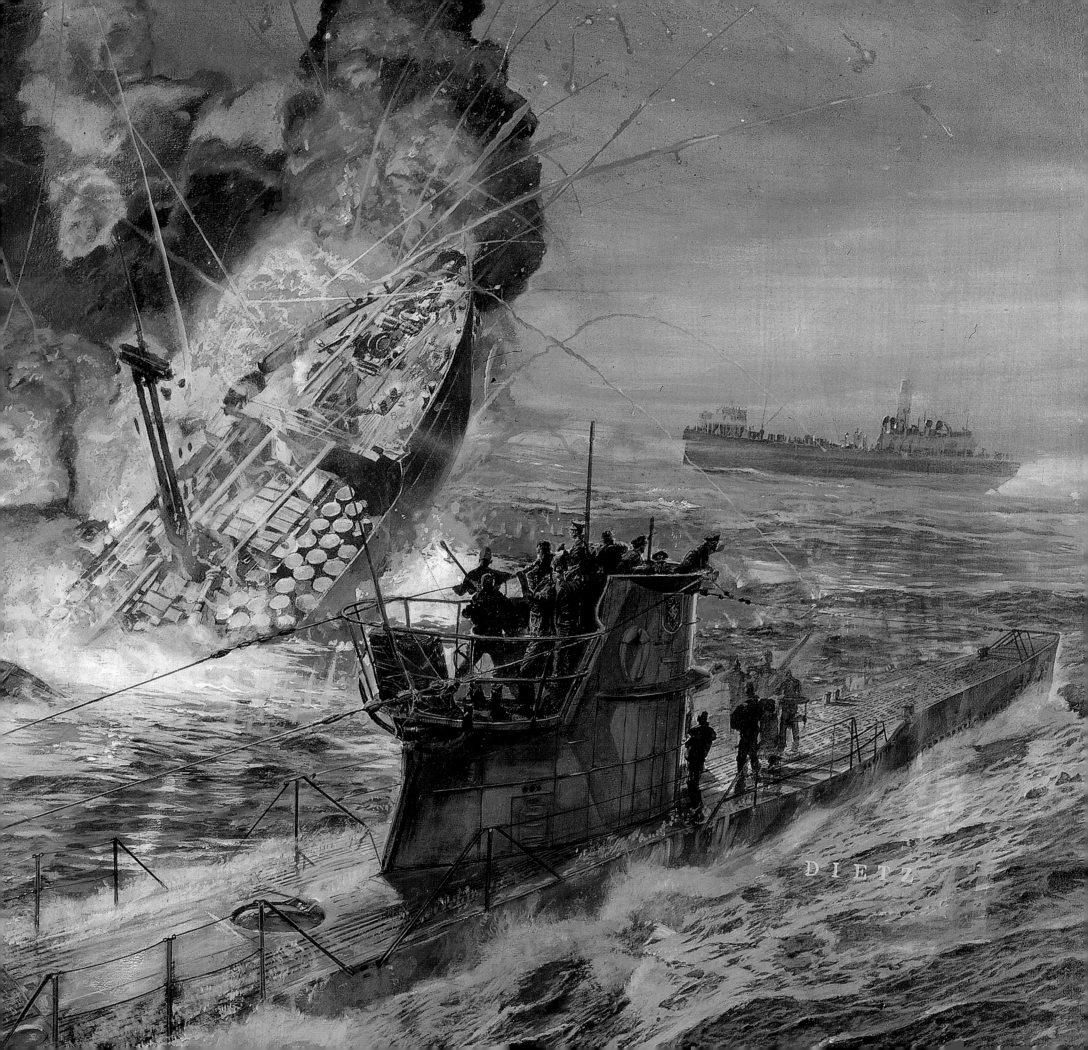

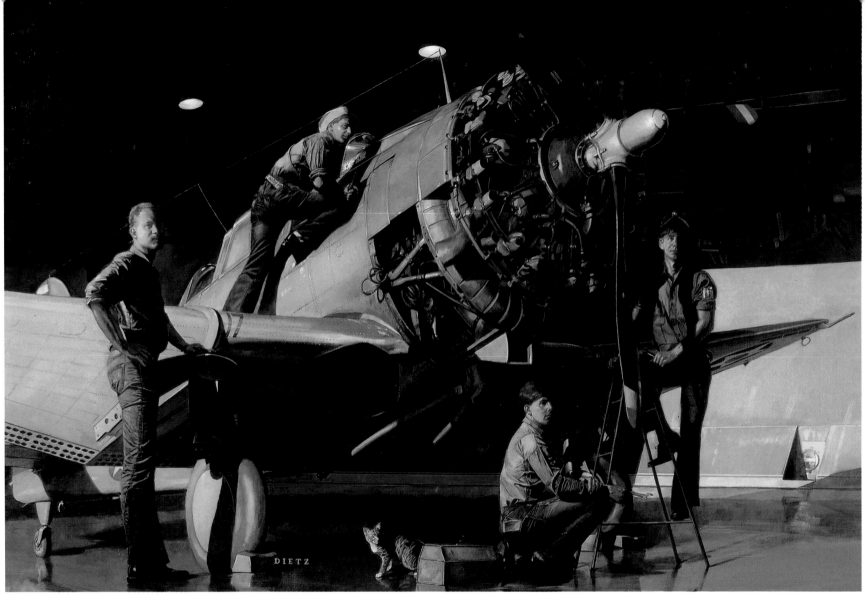

UNSUNG HEROES

IN A SENSE, WORLD WAR II IS DIFFICULT TO PAINT. IT was a massive industrial undertaking that dwarfed individual actions. The dull statistics of aluminum output and vacuum-tube production could be as crucial as the brave deeds performed by brave people. The chain of effort needed to keep each infantry squad or fighter plane in combat could involve hundreds of people and stretch around the world, from the factories to the battlefield.

Unsung Heroes was painted for the 75th Anniversary of United States Naval Aviation, and it celebrates the men who kept the planes flying when planes were the only effective offensive weapon the Navy had. American aircraft carriers

were in constant action and constant peril in the year after Pearl Harbor, from island raids to the Doolittle mission, from the Coral Sea and Midway to Guadalcanal, and in the battles of the Eastern Solomons and Santa Cruz Islands. Four American fleet carriers were sunk before the end of 1942 and two others were laid up for repair of bomb and torpedo damage.

In the brutal equation of carrier battles, more sailors could be canceled out in the instant of a bomb's blast than air crew lost in a long day of flying and fighting. When the long day ended, the aviation ratings who had been standing duty in damage-control parties or as stretcher bearers would go back to work on the

returning aircraft. Every day and every night the men working on SBDs like the one pictured here were the last link in the chain of spark plugs, gaskets, insulated wire, and carburetor parts that went all the way back to Long Beach, Akron, Detroit, and Cleveland.

∎

DESERT FOX

FIELD MARSHAL ERWIN ROMMEL'S REPUTATION AS A commander and patriot soared in the postwar years. He was the subject of well-written biographies as well as a popular movie and was treated with much professional respect in the memoirs of his victorious Allied opponents. His field commands were not linked in public memory with the horrors of the death camps or the Gestapo regime, and the fact that he died in the wake of the failed attempt to assassinate Hitler removed him from the category of "Nazi enemy." All of these facets made him such a popular subject for a whole generation of American illustrators that new Rommel pieces demand both artistic weight and passable historical accuracy.

Desert Fox was commissioned as a wraparound illustration for a book cover, but the artist was able to craft it into a classic military ensemble more in the style of nineteenth-century academy painting than twentieth-century advertising. The sunburned soldiers on the motorcycle seem to be studiously staying out of the way while drawing the viewer's eye up to the figure standing in the big command car. The troopers perched on the tank to the right add to the focus on the commander. The baked desert, angular armored vehicles, and the bright red pennant on the fender leave no doubt that this is Rommel and the Afrika Korps. The few tanks fading in the distant background give

the sense of massed strength—an advancing force rather than a retreating one. The serious student of the North African campaign might examine the insignia and the production versions of the vehicles to see if the painting depicts a specific time and place, but most viewers will wonder what it could be that all those men are studying beyond the edge of the canvas.

■

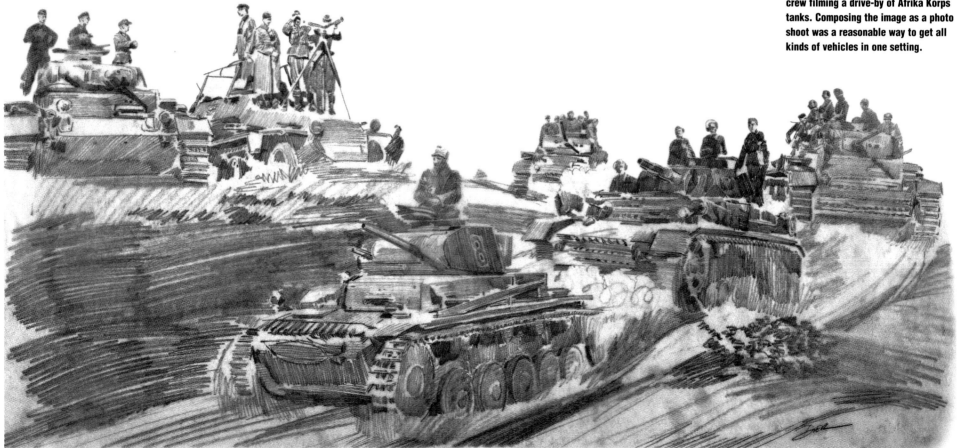

BELOW: This alternative composition sketch has a Propaganda Kompanie crew filming a drive-by of Afrika Korps tanks. Composing the image as a photo shoot was a reasonable way to get all kinds of vehicles in one setting.

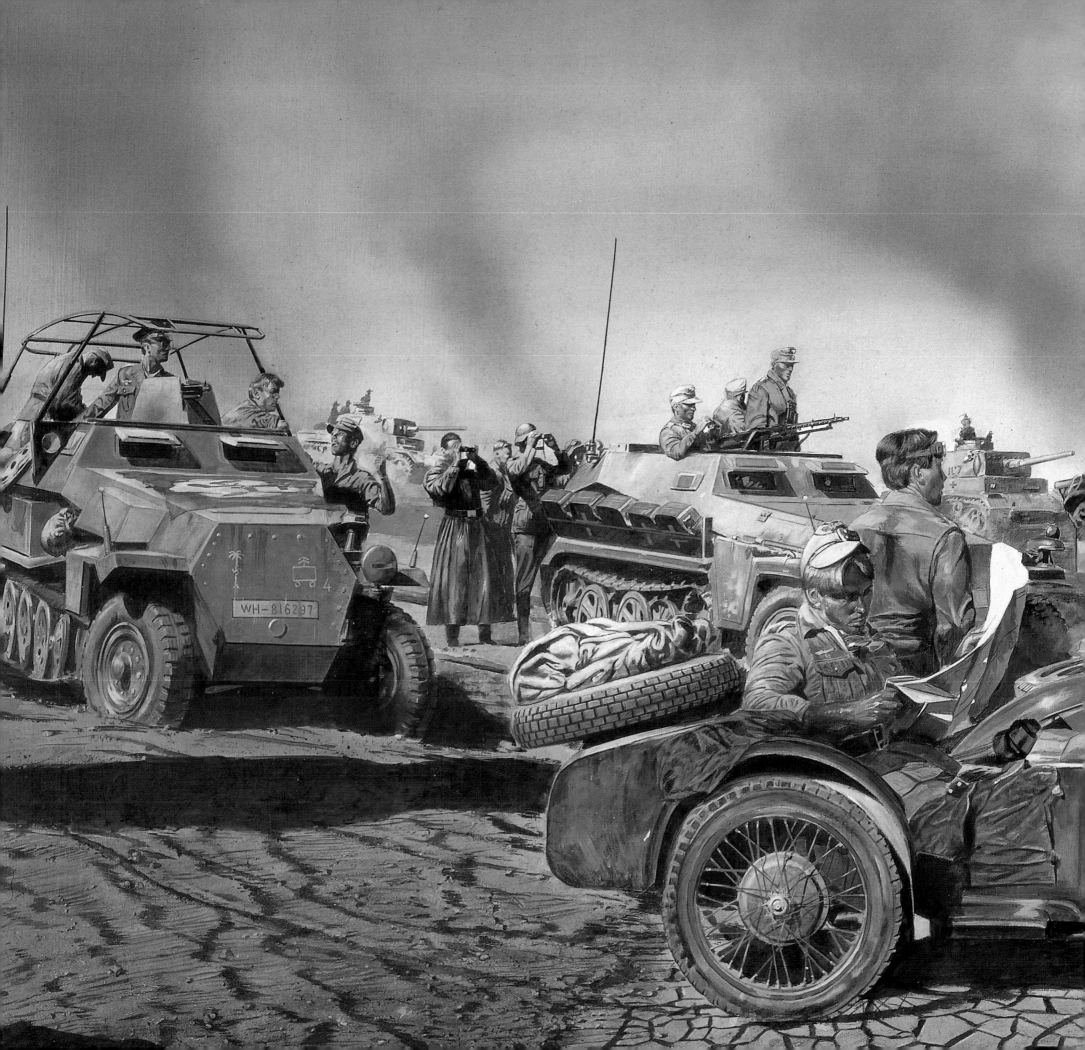

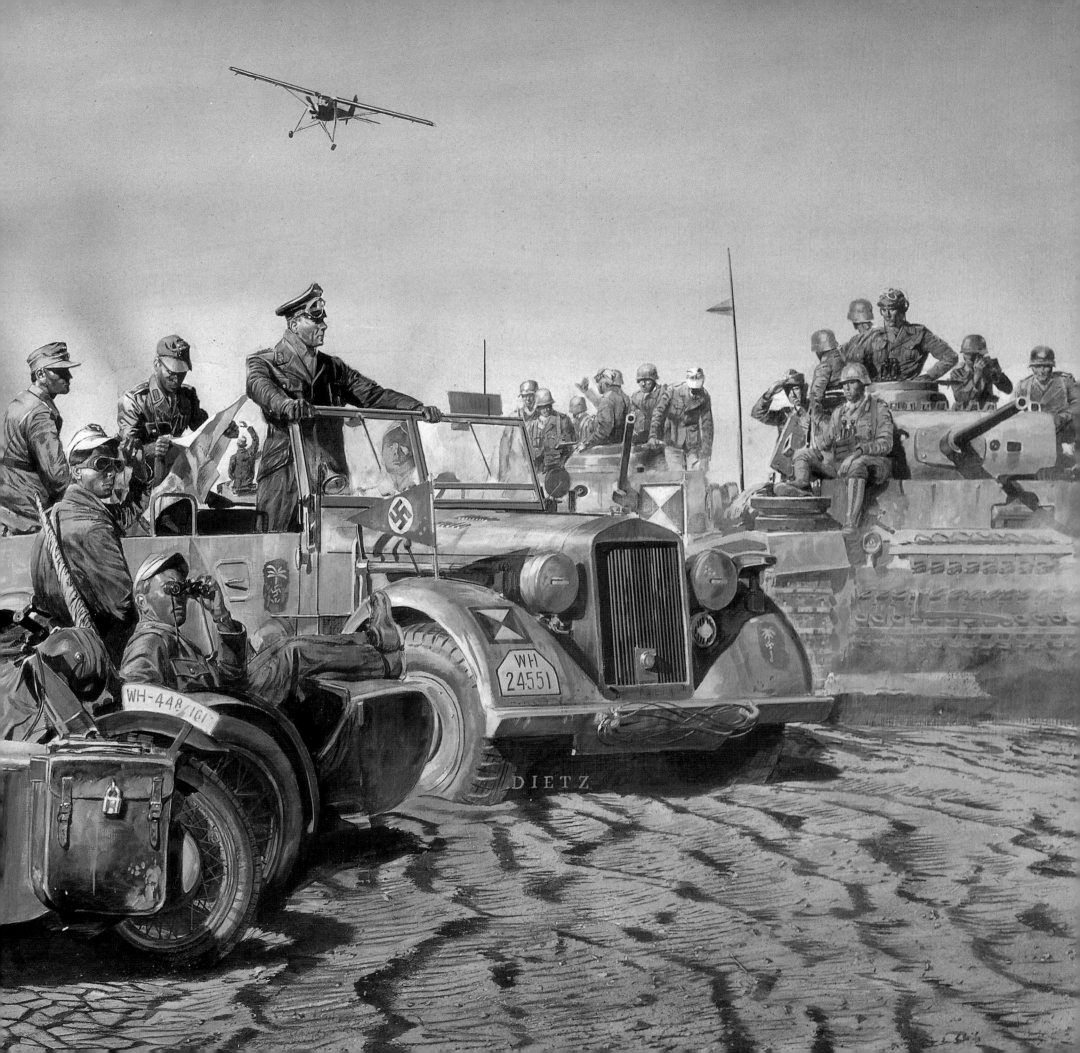

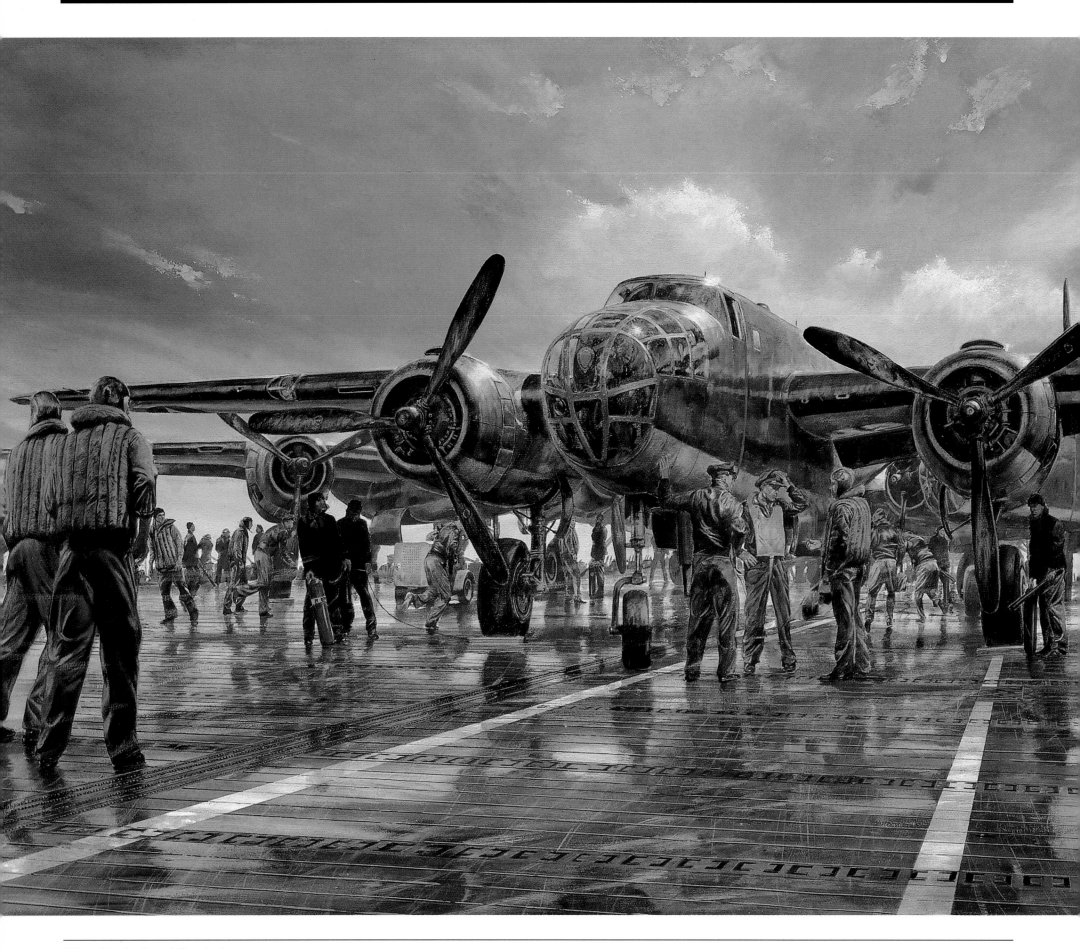

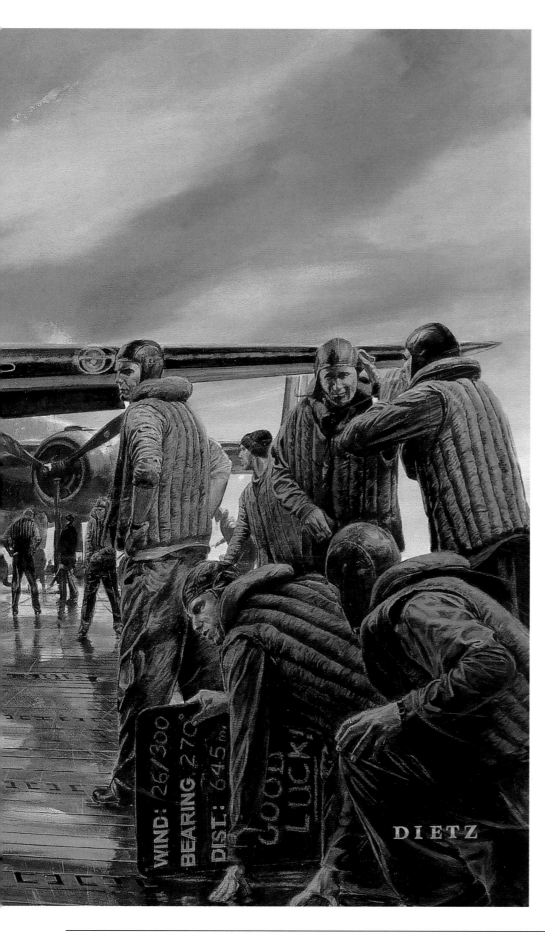

EARLY LAUNCH

THE GIANT NEWSPAPER HEADLINE "DOOLITTLE BOMBS Tokyo" was the first absolutely good news that the American public had in World War II. After five months of gloom following Pearl Harbor, the word that the United States had finally struck back was electrifying.

Pearl Harbor was traumatizing, and then Guam and Wake Island fell. Hong Kong was gone before December ended, and the Japanese were rapidly marching through the Philippines. By Christmas Day, 1941, the bulk of the islands' defenders were besieged on the Bataan Peninsula. January 1942 saw the first U-boat assault on the East Coast, further Japanese advances throughout Indonesia, and the loss of all of Malaya. February was worse. The invincible British bastion at Singapore surrendered, the last important Allied naval forces in the Western Pacific were destroyed off Java, and the Japanese were firmly in place throughout Southeast Asia. March marked the end of resistance in Dutch Indonesia and most of Burma. In early April, Japanese carriers were sinking British warships off the coast of Ceylon. On April 9, the starving defenders of Bataan surrendered.

Taking off on a stormy April 18, Doolittle's sixteen B-25 medium bombers were never going to do much damage to an industrialized war machine, but their effect on Allied morale and Japanese planning was immense. They compelled the Japanese Army to consider further air defenses for the home islands. They helped convince Imperial Navy planners that their defense cordon should include Midway Island. That was sure to either keep the elusive American carriers out of range or, better yet, bring them to battle.

Early Launch is a fitting title for Dietz's deck scene on the *Hornet*. The bombers were launched a full day ahead of schedule, as the carriers had run across a Japanese picket boat.

■

VB-6

BEST ON DECK

THE BATTLE OF MIDWAY MARKED THE END OF THE beginning of the war in the Pacific. On the evening of June 4, 1942, the huge task forces of the Imperial Japanese Navy, devastated by the loss of four fleet carriers, began steaming back to their anchorages. Though there would be many desperate days to come for the outnumbered, outgunned U.S. forces, the American admirals knew they were not going to lose the war. The big carrier battle north of Midway had been Japan's last chance to take control of the entire ocean with one stroke.

Best on Deck depicts the flight-deck action on board the USS *Enterprise* as Lieutenant Commander Dick Best, commander of Bombing Six, prepares to lead a mixed strike group of Douglas Dauntlesses to hunt down the *Hiryu*, the only Japanese carrier still afloat. This was the second strike mission of the day for the SBDs of *Enterprise*'s bombing and scouting squadrons. They had plunged down against the *Akagi* and *Kaga* at the peak of the battle, and now the few planes that could be made ready were taking off for the last round. Above the action, the *Enterprise* pilots watched the *Hiryu* wriggle out from under the attacks of the leading flights, until theirs were the last planes of the strike with a chance to score. Their dives ended with direct hits; when a follow-up strike of *Hornet* dive-bombers arrived, they found the *Hiryu* enveloped in flames from bow to stern.

Lieutenant Commander Best ended the day exhausted and was soon coughing up blood. Navy flight surgeons discovered that he suffered from active tuberculosis, which he had either contracted during the grueling campaign of 1942 or via contaminated oxygen bottles. He was whisked off the ship to convalescent duty and, despite numerous appeals, never flew another mission. His last carrier takeoff was the one that put the finishing touch on the most important victory in the history of U.S. naval aviation.

∎

BELOW: This preliminary sketch for *Best on Deck* was a good airplane study. Unfortunately, Lieutenant Best virtually disappeared, while the foreground figures added little to the sense that the scene is an aircraft carrier flight deck.

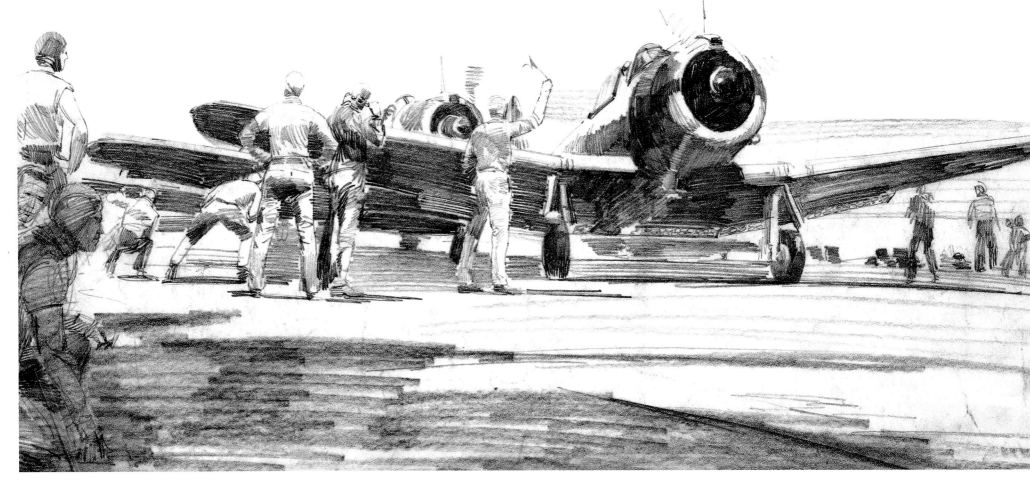

TBDs at Midway

In *Best on Deck*, a painting of the men who fought the Battle of Midway (rather than of the battle itself), the characters arrayed around the central Douglas Dauntless create the tension of the scene. By contrast, the gaudy book cover art below shows just how far off the historical record an artist can be pushed by the requirements of a commercial job.

A book cover needs to attract attention, and when this cover was commissioned, that meant action and color. Red is the attention-getting color, so red dominates: red explosions, red reflected on the sea, red stripes on the tails of the planes. Action was required of the composition and it had to include as many story elements as possible. Within these parameters,

foreshortening the scene, compressing time, and bending technical and tactical realities were all acceptable tricks of the trade.

The catalog of resulting factual sins, however, is robust: the planes have the wrong national insignia; they have achieved a torpedo hit that never happened; and they are too high for a torpedo run, too close to each other by hundreds of yards, and far too numerous. Sadly, the American torpedo bombers were all sinking or driven away before the first explosions occurred on a Japanese carrier, and no squadron had so many planes still flying so close to the enemy. As Jim says, "R.G. Smith had nothing to fear from this illustration."

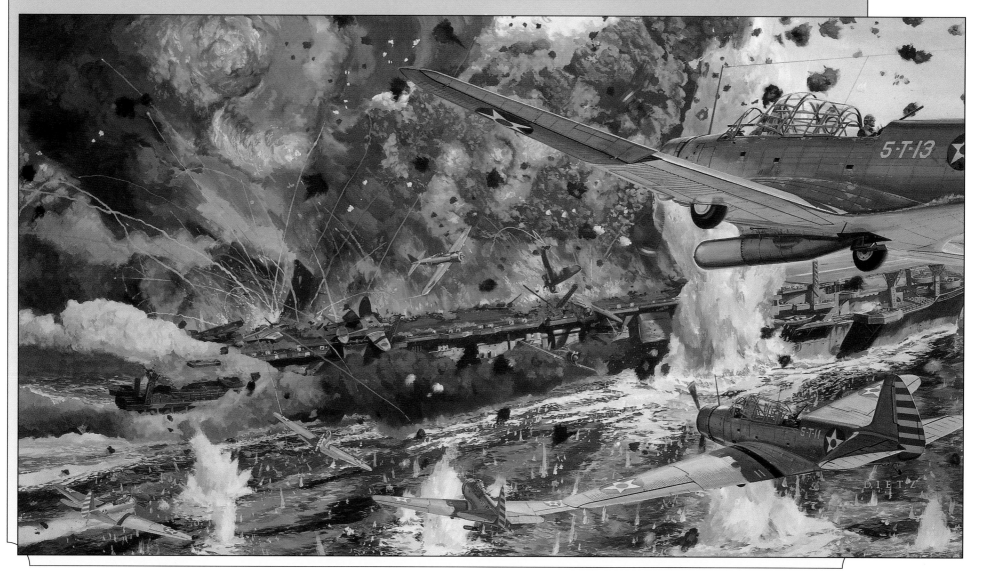

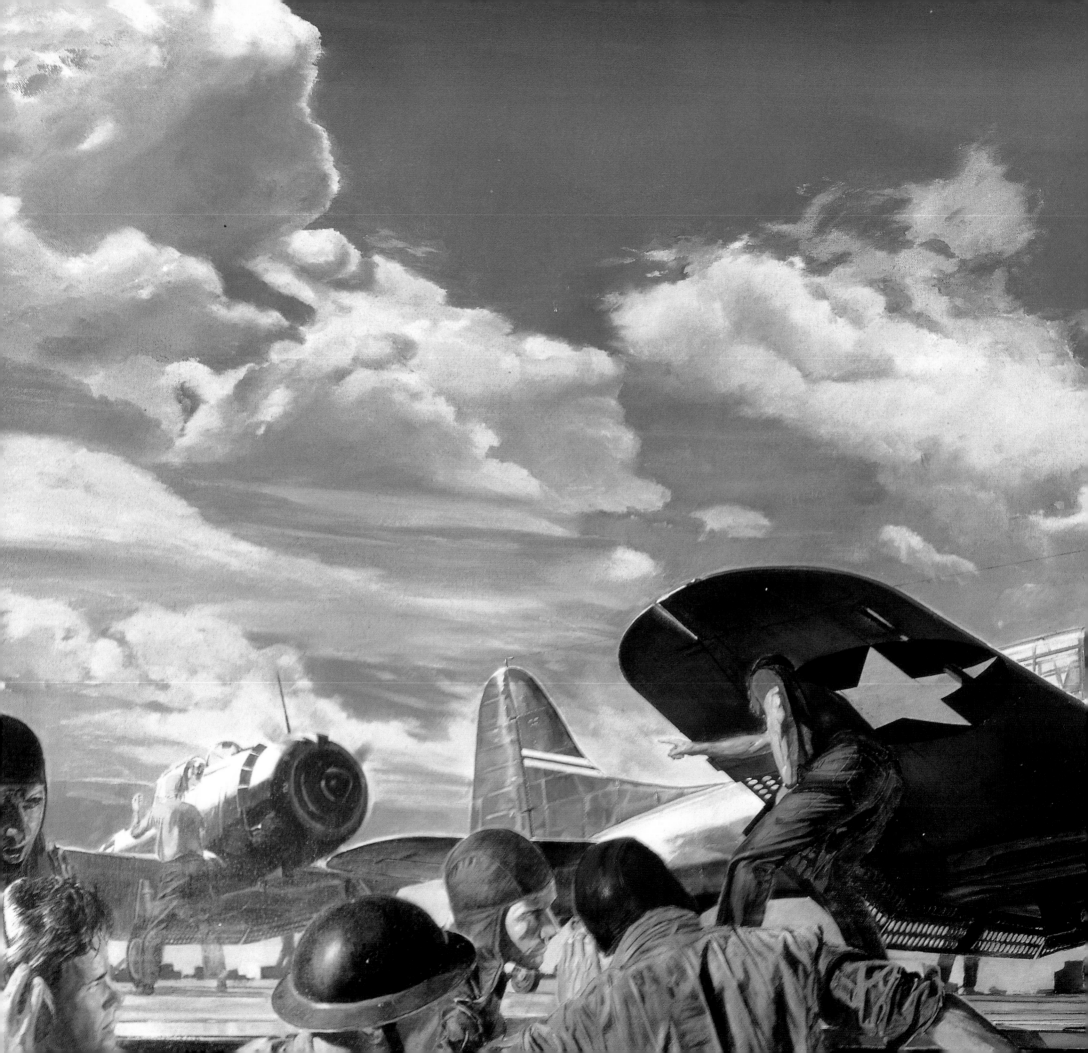

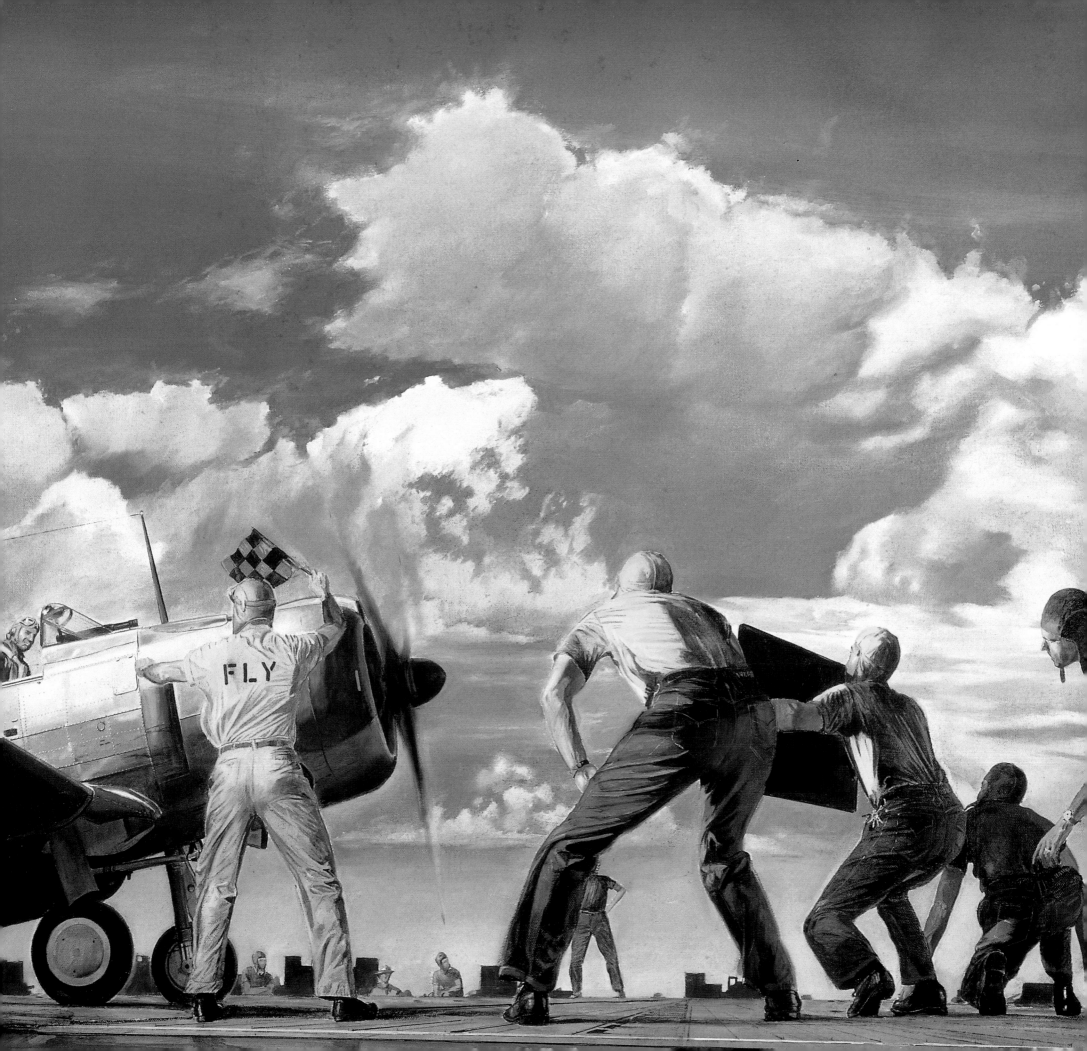

GUADALCANAL AMBUSH

NO JAPANESE OR AMERICAN STRATEGIST EVER predicted that the Solomon Islands would be a pivotal point in a war between their two countries. Guadalcanal, on the south end of the island chain, was at the remote tip of the most tenuous logistics train in the Pacific theater. For the prize of its one flat bit of jungle-rimmed tropical savannah, the two foes fought half a dozen major naval engagements, ten pitched land battles, and innumerable skirmishes on land, at sea, and in the air. Historian Samuel Elliot Morrison called the battle to hold Guadalcanal "the most bitterly contested in American history since the campaign for Northern Virginia in the Civil War." It defined the kind of war the United States Navy and Marines would fight for the next three years.

The Marines, who landed eight months to the day after the attack on Pearl Harbor, quickly understood that they were on the island to stay. On the second night of the campaign, the Japanese Navy shattered the Allied task force protecting the landings. There could be no Dunkirk-style evacuation if things went wrong. The Marines had to hold their positions around the airstrip, which they had named Henderson Field.

The Japanese amphibious forces were confident; they had never lost a battle. They did not realize how many Marines had come ashore, and how much courage, tactical skill, and fire-power the defenders could deploy. The Japanese Navy owned the night, but American ships and aircraft ruled the day. Both sides fought in and with the island's jungle. The grim campaign ended with a brilliant Japanese evacuation six months after the landings; when it was over, there was no question which side was on the offensive in the Pacific.

■

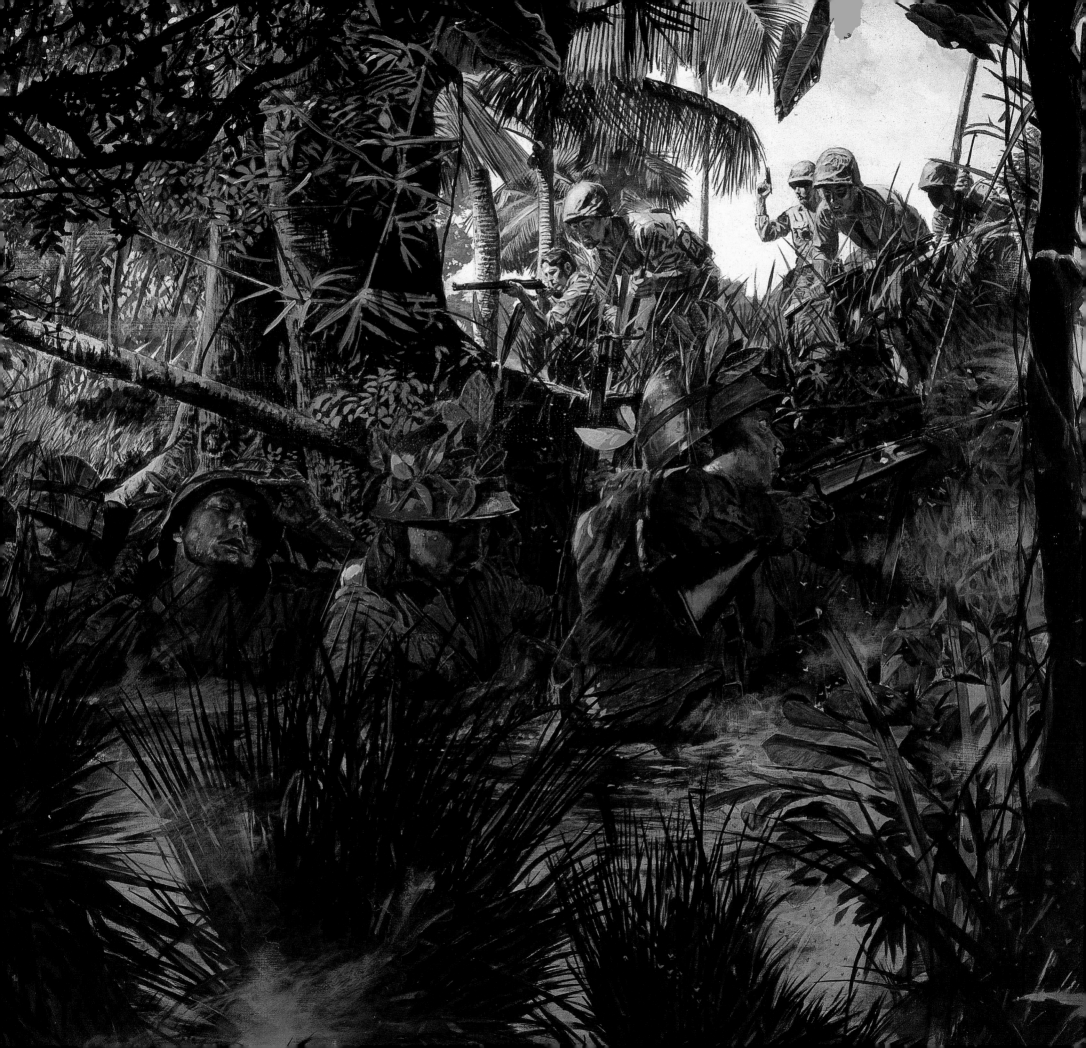

RIVER CROSSING

VETERANS OF THE OPERATIONS IN THE SOUTHWEST Pacific have congratulated Dietz for capturing the feel of their campaigns, the sense of being surrounded by jungle. Then they add something like, "Of course, you could never see all that at once. You had to run right into something to find it."

An artist needs light to display his subjects, and even the deep green tone that Dietz used in the Guadalcanal painting is several shades lighter than what is found at the bottom of multiple-canopy rain forests. Depth of field is the artist's other problem in a thick jungle, since there are few open lines of sight to help establish perspective. One of the few places under the jungle canopy that provides a plausible combination of light and depth is a river or stream bank. Dietz used that setting to depict a troop of Australian Army light tanks passing through a line of American GIs.

The little Stuart tank was a useful weapon in the Solomons and in the early New Guinea campaign. It was light enough to be somewhat mobile, and protected enough to act as a moving pillbox that could flush the enemy out of jungle positions. In this exhausting tropical environment, it was much easier to drive a tank to a muddy jungle skirmish than to manhandle an antitank gun to the same place.

This painting was not meant to portray a particular river on a particular day, just another stream on the way to Buna. It was done as a book cover for an account of the early New Guinea campaign, and putting the tanks in Australian codes honored the major role the Aussies played there. Nonetheless, the scene evokes almost every island action from Guadalcanal to the Philippines.

■

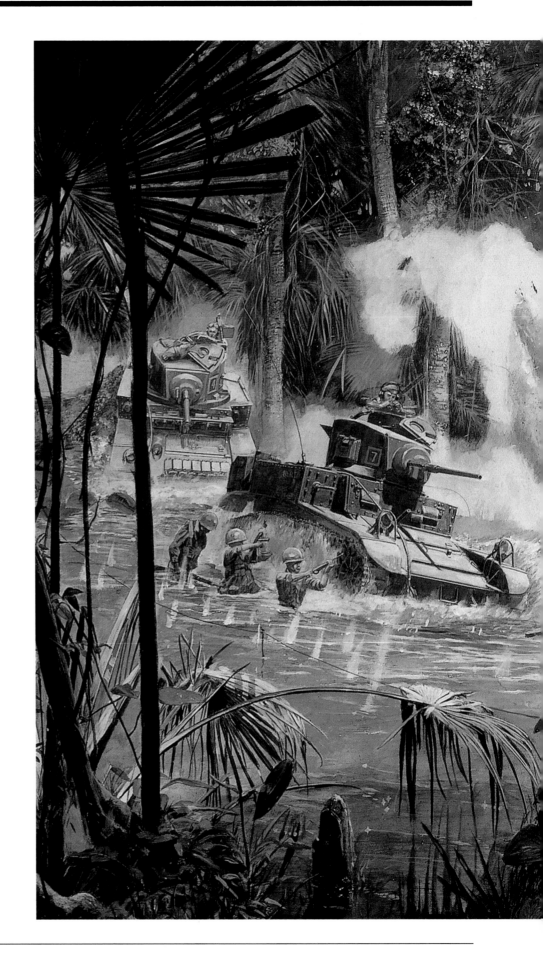

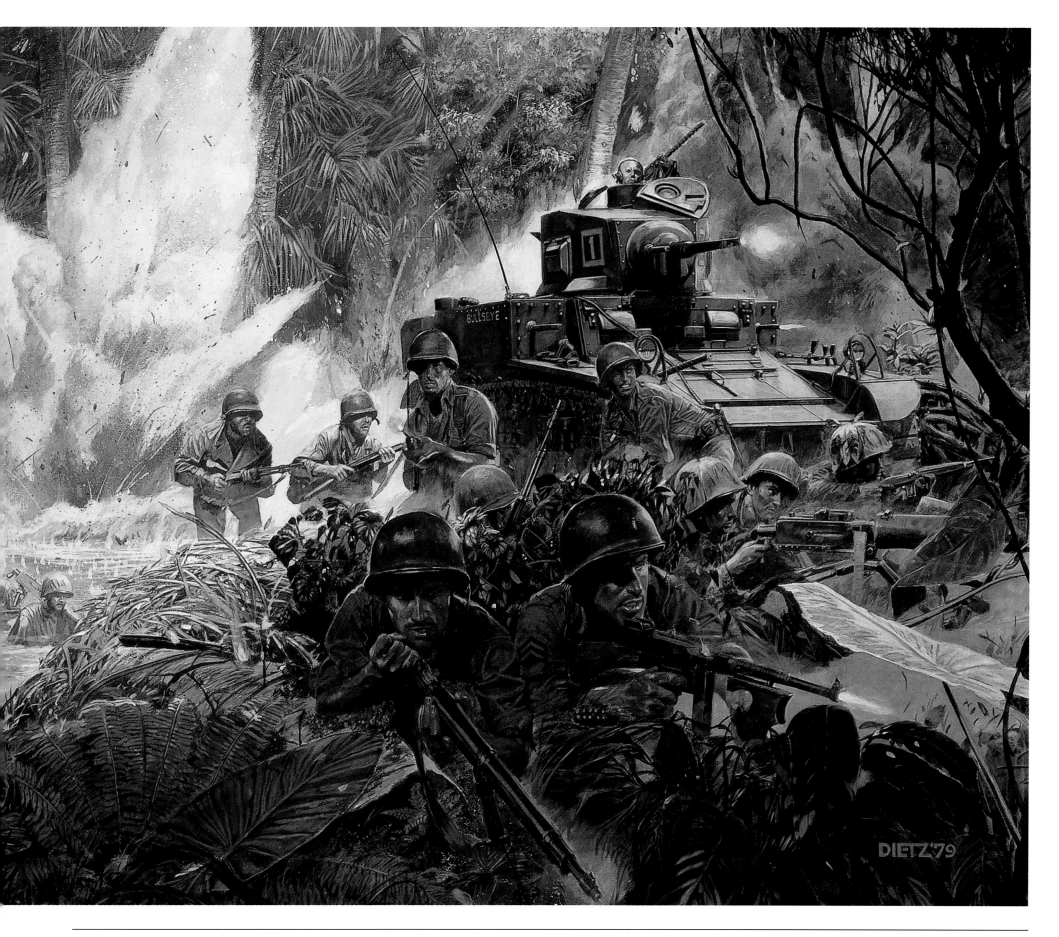

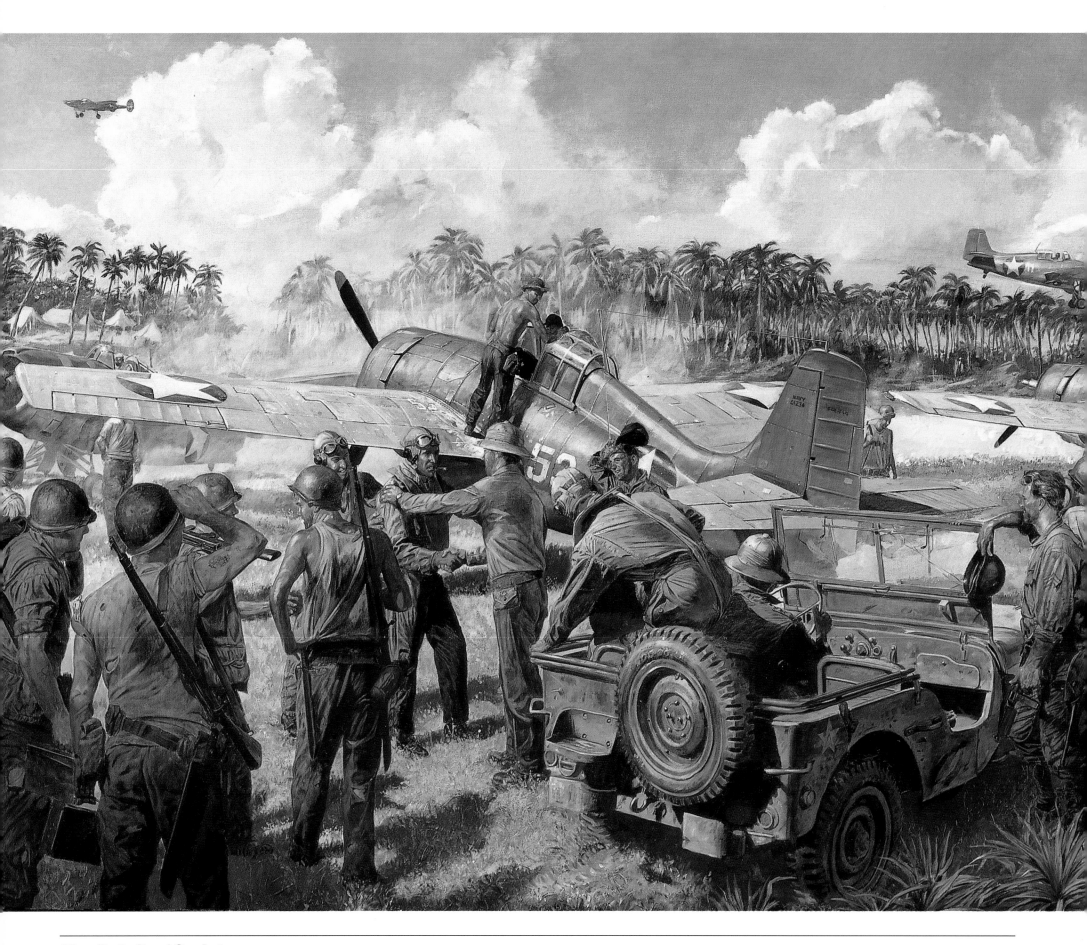

Warm Reception

IN 1942, REAR ADMIRAL JOHN MCCAIN PREDICTED that Guadalcanal would become a "sinkhole of Japanese aviation." The phrasing was inelegant, but the prediction was accurate. The loss of a remote unfinished airstrip on Guadalcanal to U.S. forces was to prove the undoing of the Japanese South Seas strategy. The Marine, Navy, and Army Air Force pilots who began operating off Henderson Field on August 20, 1942, quickly served notice to Japanese fliers that times were changing. The Japanese naval air groups in the South Pacific had never faced such opponents. The waters between Guadalcanal and their bases in the northwest Solomon Islands became the graveyard of Japan's best pilots and planes, not to mention the emperor's beloved ships and soldiers.

The squadrons on Guadalcanal, the island code-named Cactus, faced air raids by day, shelling by night, and miserable conditions in between. Usually outnumbered, but nearly always forewarned, the Marine and Navy F4Fs ripped into the enemy bombers and escorts. The Cactus air force taught all American pilots in the Pacific that the qualities of the Zero had been definitely overstated, though a high tuition was paid in men and equipment. Marine lore claims that only one man from VMSB 232, the first dive-bomber unit on Cactus, was able to walk to his evacuation flight when the unit was relieved. Squadrons were ground down at an alarming rate, but there were always more in the pipeline. It was poetic justice that the Army Air Force P-38 mission that intercepted and killed Admiral Yamamoto on April 18, 1943, took off from Guadalcanal—that remote unfinished airstrip.

Joe Foss, of VMF-221, is the pilot represented in this painting. Joe was the best known of the Marine aces and Medal of Honor winners from the Cactus air force, and the highest-scoring Marine ace of World War II.

■

BELOW: Before the men who flew the intercept mission against Admiral Yamamoto received their P-38s, they flew Bell P-400s and P-39s. The planes were suitable for barge-busting and little else, so the U.S. Army flyers had to leave air defense to the Marines and Navy. This is another Henderson Field maintenance sketch.

THE ROAD FROM STALINGRAD

AMERICAN ILLUSTRATORS RECEIVED FEW COMMISsions for Russian Front subjects during the Cold War era, and when they did, the emphasis was on the invaders rather than the defenders. Jim's book cover for an account of the Stalingrad siege was one of the few Eastern Front illustrations he did in those years.

When this job was commissioned, the figure of the gaunt, hollow-eyed German survivor staring into the far distance was already a familiar icon of the Russian Front, as were the images of soldiers with their feet wrapped in torn blankets. Jim chose to do a painting with no human figures at all. Only the helmet on a Mauser speaks to the men who belonged to all the equipment. Instead, he combined readily recognizable images of German convoys with the classic studies of the Grande Armee's retreat from Moscow. The vehicles are not particularly battered, but the open hatches and randomly aimed guns on the Mk IV Panzers suggest hasty departure. The convoy seems to go in three different directions, which recalls the plight of Hoth's 4th Panzer Army, first fighting south along the Volga, then redirected to break through to surrounded Stalingrad, and finally repulsed and retreating westward. The tall perforated wheels of the 8.8cm gun carriage looming above a frozen horse and cart in

the middle of the painting make a visual connection between this monstrous mechanical army and the army Napoleon left on the steppe 130 years earlier.

The only physical movement in the scene comes from the two Sturmoviks low in the sky. They are not quite buzzards, not quite hawks. The viewer is certain of one thing: the glow visible on the horizon is not Moscow burning.

■

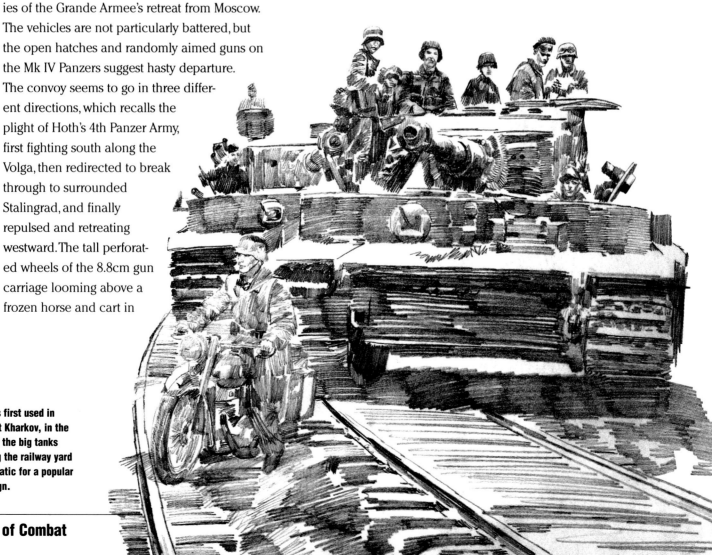

RIGHT: The Tiger I was first used in significant numbers at Kharkov, in the Ukraine. This study of the big tanks detraining and leaving the railway yard was considered too static for a popular history of the campaign.

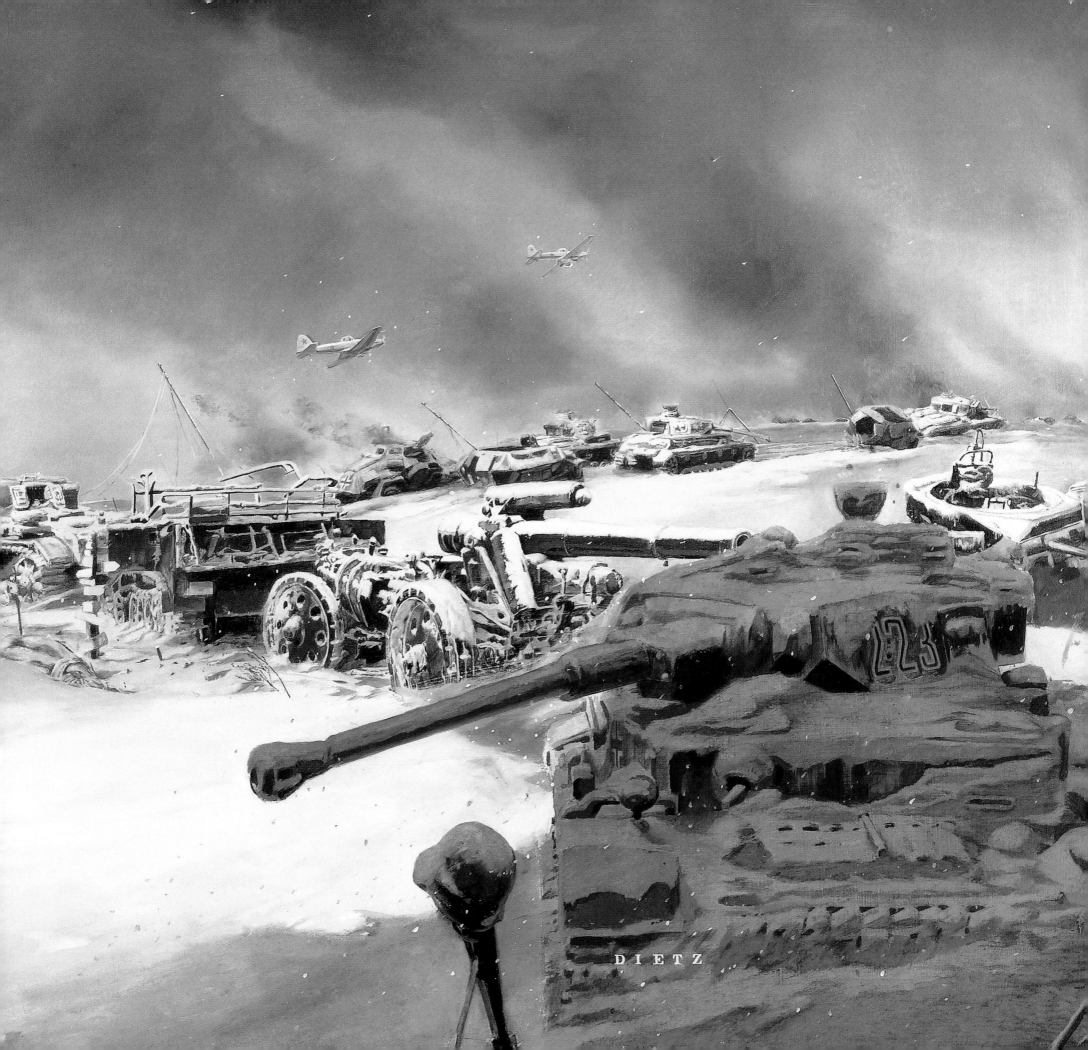

Last Hurrah

Field Marshal Erich von Manstein was a real- ist. He knew there was little resilience left in the shocked Wehrmacht following the encirclement of the German 6th Army at Stalingrad. Instead of digging in, he saw to the extraction of German forces from the Caucuses, the reorganization of shattered units, and the rebuilding of a mobile reserve. He managed this in the face of relentless Soviet attacks, and at the cost of thousands of square miles of captured Russian territory. Some Russian tank formations were 400 miles (640km) west of Stalingrad before the job was done.

In mid-February 1943, von Manstein ordered Hermann Hoth's 4th Panzer Army to advance against the exhausted Russian armored forces that had pushed into the Ukraine. Spearheaded by the 2nd SS Panzer Division, the Germans drove the Russians back almost one hundred miles (160km) from the Dneiper River to the Donets, then wheeled north toward the historic city of Kharkov. The Germans fielded their huge new Tiger tanks in this offensive, and they were nearly unstoppable. An early thaw in the first days of March brought the Panzers to a halt, but when the ground refroze with the return of cold weather, the attackers set off again. They swept past Kharkov, then made a wide arc east to cut off the defenders. They recaptured the city on March 15, and three days later took Belgorod before the real thaw stopped all movement in the East.

The Kharkov attack was the last hurrah for the Panzer armies on the Eastern Front, and it set the stage for the destruction of Germany's offen- sive power. At the end of the battle, the Russians had been pushed into a huge bulge around the city of Kursk, where they were digging in and resupplying. When the massive summer tank battles around Kursk ended, it would be the Wehrmacht staggering away from the fight.

∎

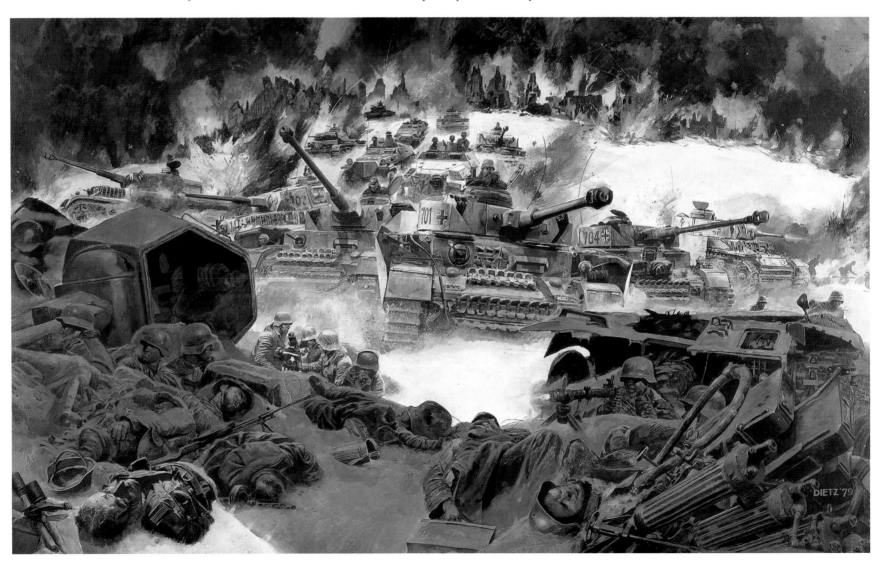

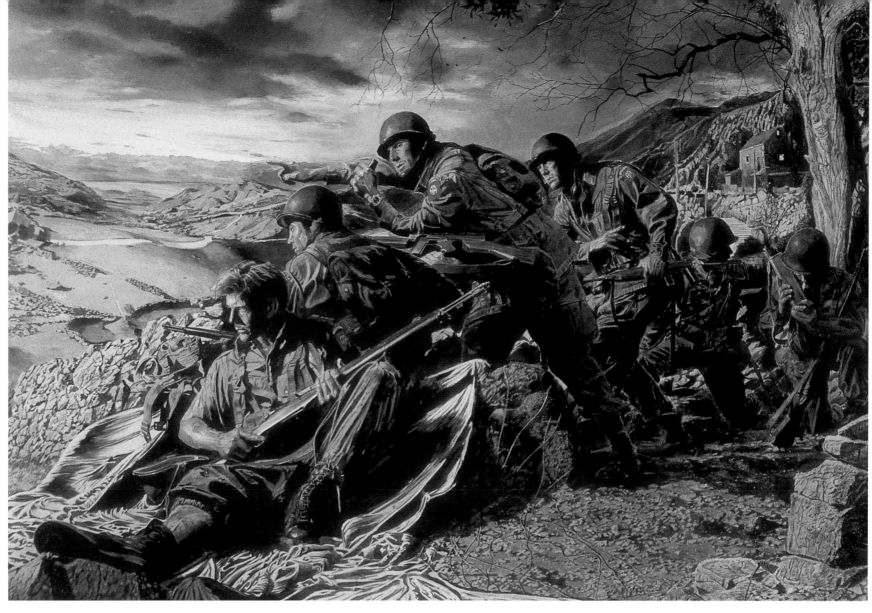

IN THE BEGINNING

AN OLD APHORISM HOLDS THAT GENERALS ARE always preparing to fight the previous war, but no one could accuse U.S. Army leaders of this at the dawn of World War II. As they watched the brutal efficiency with which mechanized conflict spread over Europe in 1940, American planners were inventing an armed force unlike any the country had ever seen. They formed the Parachute Test Platoon in late June 1940, and a year and a half later were ready to assemble airborne divisions. The 82nd Infantry Division— whose double-A insignia recalled its World War I title of "All-American"—was the first.

The first big test for the new 82nd Airborne came during the invasion of Sicily on July 10,

1943. The night jump was a triumph over Murphy's Law. High winds and anti-aircraft fire scattered the transports; the division's 505th Parachute Infantry Regiment spread across sixty miles (96.5km) of the south Sicilian coast. Some airplanes never found the island at all. Even worse, two days after the assault, hundreds of paratroopers and air crew taking part in a regimental reinforcement drop were killed in a storm of "friendly" anti-aircraft fire.

On top of everything else, many of the scattered paratroop units dropped right into the path of the Hermann Goering Division's heavy armor. This juxtaposition of heavily armed German forces and American paratroopers may

have saved the concept of airborne assault. For two days the parachutists fought the Panzers at Biazza Ridge and Piano Lupo. Three days after the landings, the Germans realized they could not smash through to reach the forces forming in the beachhead, and they began to plan their evacuation of Sicily.

General Eisenhower was appalled by the outcome of the airborne assaults and considered dissolving the airborne units. Upon reflection, however, he took much of the blame on his own shoulders and refused to disband a formation that had fought so gallantly against such long odds.

■

JUNGLEERS

VETERANS OF THE DESERT WAR HAVE OFTEN STATED that it was the perfect place to fight. There was virtually nothing of value nearby to be accidentally damaged while the opposing armies attempted to destroy one another. The jungles of New Guinea were similarly devoid of architectural wonders and large civilian populations—but no one has ever said that they were perfect for anything. For the National Guardsmen of the 41st Infantry Division, the equatorial jungles of New Guinea were as awful as anything they could imagine.

The 41st was formed of National Guard detachments from the cool valleys and dry plains of Idaho, Oregon, and Washington. The first regiment of the division, the 163rd, arrived in New Guinea the day after Christmas and was put into the line with the battered, but unbroken, 7th Australian Division. From day one, the 41st was engaged in two simultaneous to-the-death struggles: one with the Japanese, the other with the jungle.

They faced unknown varieties of tropical fever plus the ever-present malaria; and the poisonous insects, reptiles, and plants were the bane of Allies and Japanese alike. Leather turned green, boots rotted off, metal rusted, web gear went soft, and uniforms disintegrated. Torrential rains turned trails into rivers and roads into swamps. Vehicles were known to simply sink out of sight. All the while, they faced an implacable human enemy.

The 41st wrote much of the manual on jungle warfare during a year and half of campaigning in New Guinea. Appalled at the cost of head-to-head warfare against the Japanese in the jungle, MacArthur organized his naval forces for sequential amphibious invasions at key points along the wild coast of the island, leaving the bulk of the Japanese Army on New Guinea to decompose in their jungle strongholds. The names—Salamaua, Hollandia, Nassau Bay, Wadke, Arare, and Biak—are almost forgotten now, but they were all part of a long, grueling, and ultimately victorious campaign.

The 41st fought in the Philippines and ended their federal duty as occupation troops in the home islands of Japan. The survivors returned home proud to be known as "jungleers," hoping never to see a jungle again.

∎

LEFT: This GI in 1943 European combat gear is putting his thumb in harm's way as he loads his M-1. The sketch was done as part of a Springfield Armory commission.

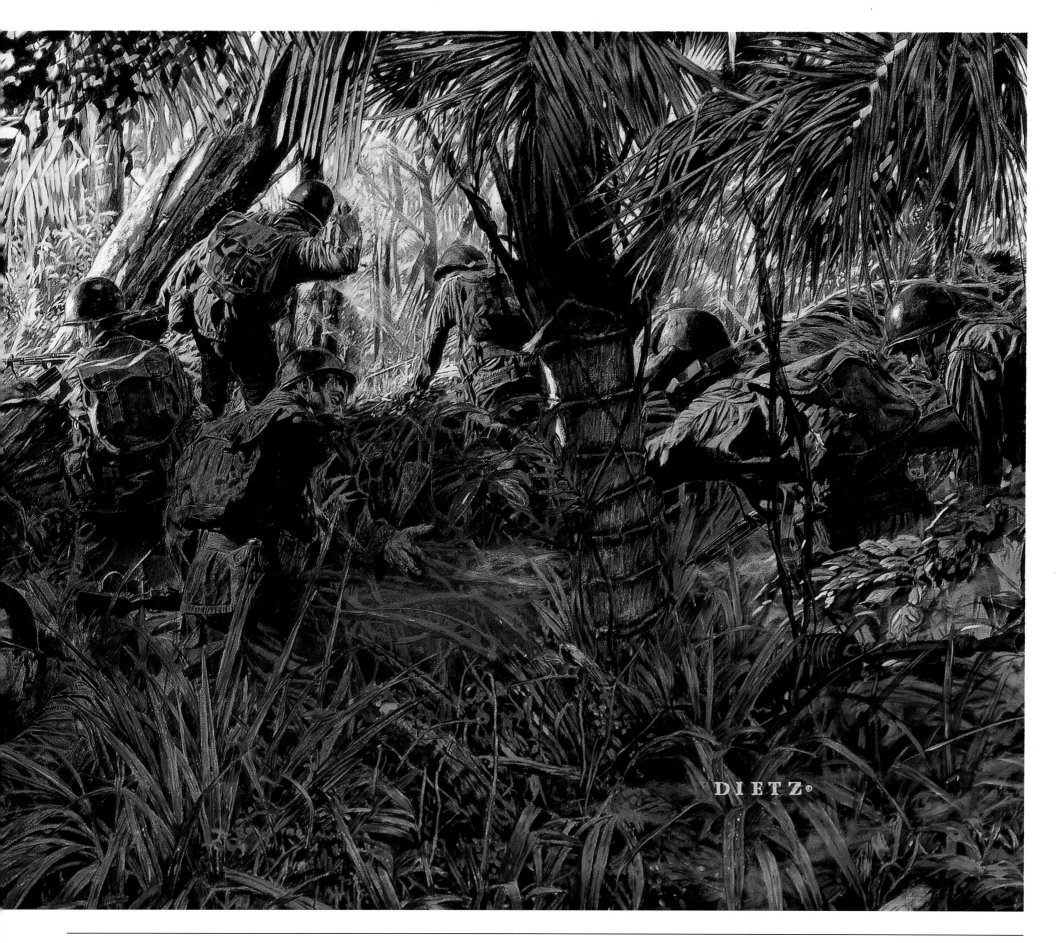

TOUGH DAY

THE GROUPING OF PLANES, PEOPLE, AND VEHICLES IN *Tough Day* shows a bleak gathering of the most colorful Fw 190As in Jagdgeschwader 2 in the autumn of 1943. JG 2 "Richthofen" was one of the rare Luftwaffe units that campaigned in France from the first day of the 1940 blitzkrieg to the end of the German occupation. The stalwart JG 2 witnessed the entire fall and rise of Allied air power.

The Richthofen pilots fought off the first RAF forays over France in 1941. In the spring of 1942, a switch to the new Focke Wulf provided a brief period of superiority in equipment. JG 2 downed numerous British aircraft during the Dieppe raid, but the RAF kept its fighter sweeps coming with more planes and new tactics. A sign of things to come, the first missions of the American 8th Air Force were flown against JG 2 opposition in 1942.

New and better RAF fighters appeared in 1943, and the 8th Air Force's heavily armed P-47s and P-38s began ranging all over northern France. JG 2 faced the American heavy bombers that were targeting German air bases in western Europe, as well as U.S. missions against targets in Germany itself. Across the English Channel, another entire Allied air force, the 9th, was being formed to fight over France. In 1943, JG 2 reported almost 200 pilots dead or missing, with a similar number wounded. Three years earlier, the conquest of France and the entire Battle of Britain had cost the unit thirty-six flyers.

The automobile in *Tough Day*, a BMW 328, recalls happier times. It was taken out of production early in the war as BMW geared up for the manufacture of 801 radial engines for the Fw 190.

■

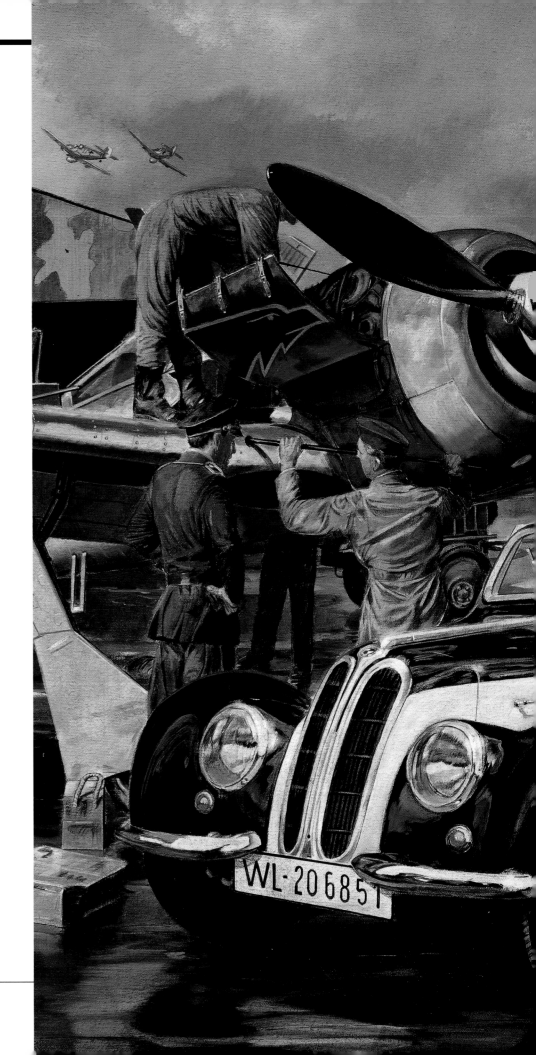

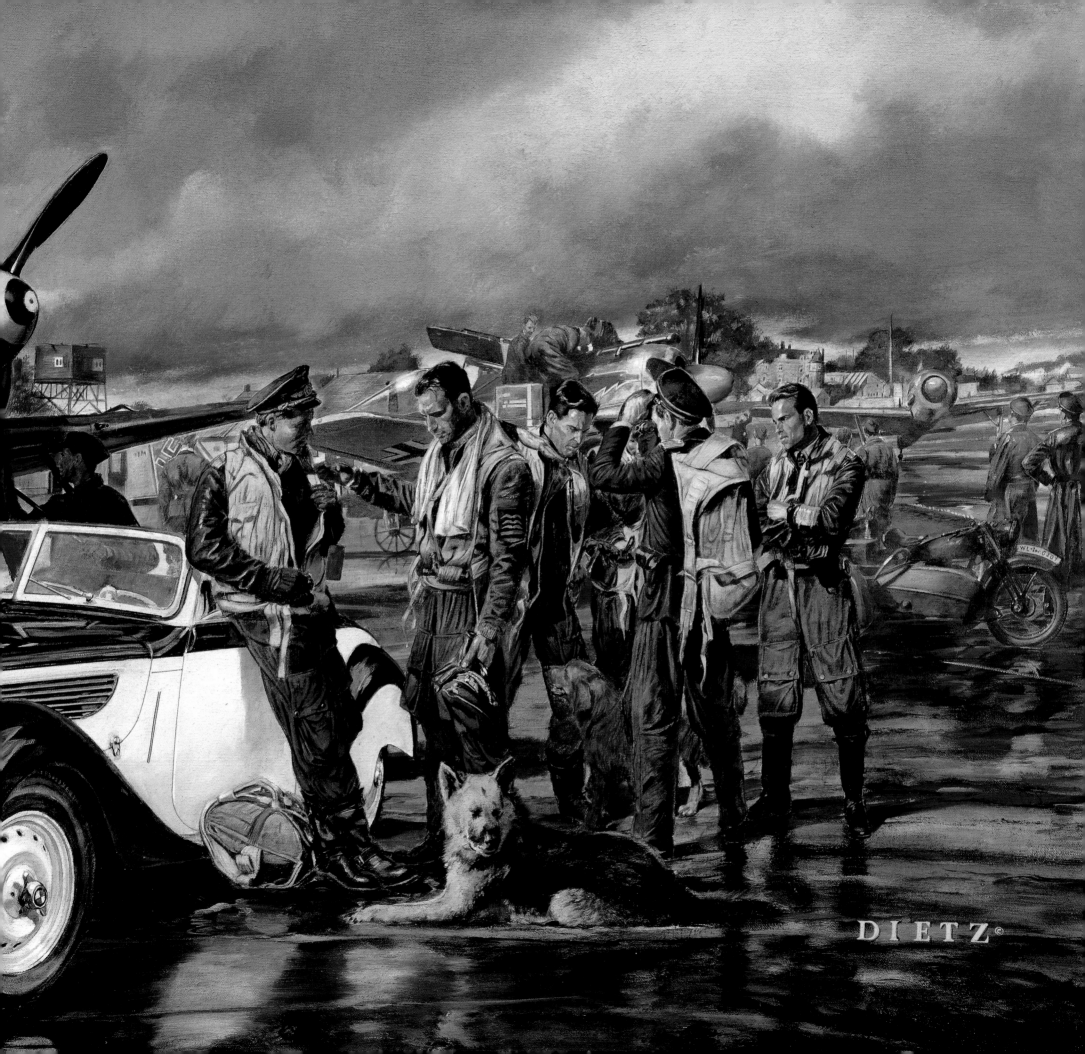

HOWITZER

THE ALLIED ARMIES IN WORLD WAR II WERE UNRIvaled in field artillery. They enjoyed a combination of immense industrial output, practical scientific advances, and improved communications that made itself felt in almost every theater of the war. Each American combat regiment included field artillery companies. Each division had its own artillery battalions, while corps and Army headquarters controlled even more. The size of the field pieces generally increased with the size of the organization to which they were attached, culminating in massive 8-inch (20.3cm) and 240mm howitzers. Armored units were equipped with self-propelled guns, while airborne units had lightweight pieces that could be landed by glider. Artillery assaults could be predetermined "time on target" shoots, or frontline observers and commanders could use radio or field telephones to call down fire. Army Air Force observation squadrons assigned spotter planes to individual artillery battalions; to German tank commanders, the sight of a little brown Piper Cub in the air could be as distressing as a flight of shiny aluminum fighter-bombers.

No matter which organization owned the artillery, it could be brought to bear on the most specific of targets. In the Hürtgen Forest battles, the U.S. Army used self-propelled 155mm guns as squad-level assault weapons against concrete fortifications. These long-barreled pieces had a maximum range of 20,000 yards (18.2km), and were devastatingly effective at small-arms range. The big 95-pound (43kg) shells from distant 155mm howitzer batteries enabled the 82nd Airborne Division's troopers to withstand massed tank and infantry attacks above the invasion beaches on Sicily. The insertion of standard and airborne artillery batteries at Bastogne was crucial to the defense of the town.

Artillery was often employed at rates far above its design specifications. German officers in Italy supposed that the New Zealand Division had automatic artillery pieces. This was the logical explanation for the rate at which the shells from the Kiwi 25-pounders were falling. At the Bulge, the 3rd Armored Division's 105mm howitzers were cycling more than ten rounds a minute during crucial fire missions, rather than the training rate of four. Such abuse meant that the "tubes" wore out much faster and were less accurate at the end of their service lives, but the factories in North America were turning out guns and shells as fast as the troops could use them up.

In the "every man a rifleman" culture of the Marine Corps, artillerymen are often overlooked, but the "cannon cockers" were there from the very beginning. The field piece pictured here is an M3 75mm howitzer of a United States Marine Corps unit. This model was a development of the Army's pack howitzer, a piece originally designed to be broken down and loaded on seven mules for cross-country travel. The 75 was small enough to be towed by a jeep, and light enough that it could be manhandled into position by its crew. A howitzer as opposed to a gun, it was primarily an indirect-fire weapon that would lob a 14-pound (6.3kg) shell at a remote target not necessarily in sight of the gun position. Typically, the little howitzers would be sighted along logical enemy approach routes to

defend Marine rifle positions. On Guadalcanal, the 75s of the 3rd and 5th Battalions of the 11th Marines, as well as a battalion of larger 105mm howitzers, were instrumental in halting the mass night attacks on the Henderson Field perimeter.

As the war progressed, ever more Allied artillery was mounted on half-tracks or tank chassis, allowing for greater mobility and faster deployment. The M3 tank chassis was the basis for the M7 105mm self-propelled howitzer, as well as the M12 155mm gun carriage. Nearly 2,000 M5 light-tank chassis were mounted with 75mm howitzers. The Marines employed an amphibious tractor with a 75mm howitzer in a revolving turret. Although very lightly armored, the cannon-armed LVT (Landing Vehicle Tracked) was the closest thing to a truly amphibious tank that the United States fielded in World War II.

The impact of the overwhelming quantity and quality of American firepower was commented on by the German general who surrendered Aachen in 1944. "When the Americans start using 155s as sniper weapons, it is time to give up."

■

BELOW: The lightweight airborne version of the 75mm howitzer was a bare-bones weapon. In this *Guns from Heaven* study, glider artillerymen are wheeling one into firing position.

HUNTERS BY NIGHT

IT IS SOMETIME IN THE WINTER OF 1943–44, AND the luckiest man in the tableau at the *Nachtjagder* ("night fighter") base is the one who will be leaving in the big Mercedes with the motorcycle escort. The pilots will be taking off in Bf-110s to intercept a stream of RAF Lancasters and Halifaxes bound for some German city. The Messerschmitts sport the shark's mouth heraldry from an old day fighter group, but the good old days of night fighting are already over for the Luftwaffe.

The British and Germans fought a techno-logical war of attrition in the night skies over Germany. Radar bombing, radar interception, radio navigation, counter measures, frequency shifting, jamming, active homing, and passive detection—nearly all of the elements of modern electronic warfare had their genesis in the RAF Bomber Command's night campaign against German urban centers.

These NJG-2 planes are pictured with late model Lichtenstein radars, better able to isolate an aircraft in a sky full of aluminum foil. They probably have a Naxos passive receiver that detects the radar of British pathfinder bombers at a range of 30 miles (48km), or the Flensburg receiver to pick up the RAF tail-warning radar at a few hundred yards. All of this is just partial compensation for the fact that British radar-jamming has crippled the German ground control system.

The old Messerschmitt Bf-110-G with extra fuel tanks and a radar array was just fast enough to "work" a bomber stream, but it was a sitting duck for any de Havilland Mosquito lurking around the base waiting for the interceptors to take off. The Mosquito pilots also flew in the bomber stream, ready to pounce on the Bf-110s, Dorniers, and Junkers searching by night for prey.

This painting was not planned as a compan-ion piece to *Tough Day*, but was instead commis-sioned after the collector saw the day fighter painting at a special exhibition of Dietz's work at the EAA Museum in Oshkosh, Wisconsin.

■

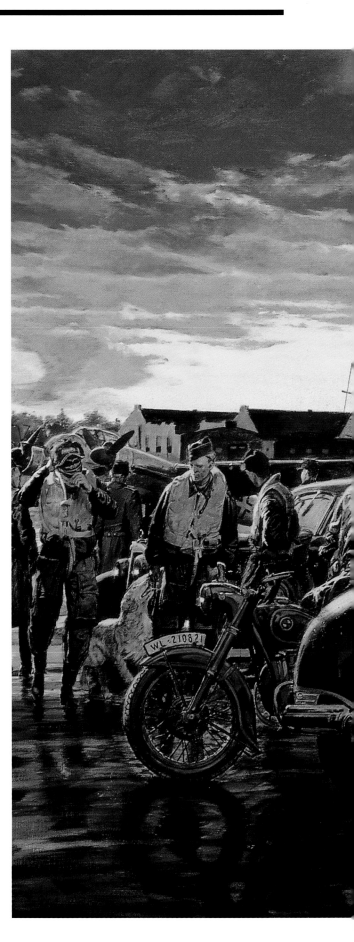

LEFT: This little Lancaster detail avoids a problem common to any painting of night fighter action. In darkness, only the parts of the aircraft lit by flames would be visible.

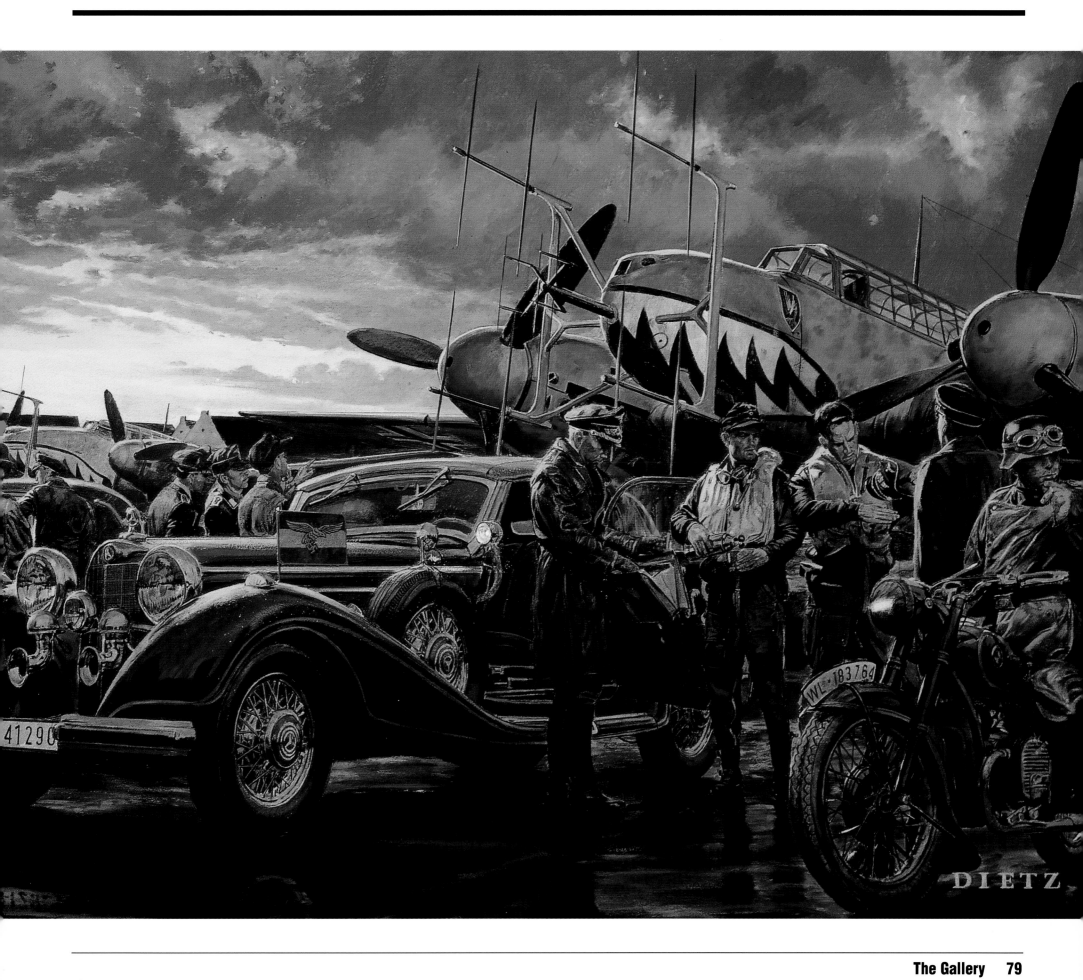

INCREDIBLE 305TH AT SCHWEINFURT

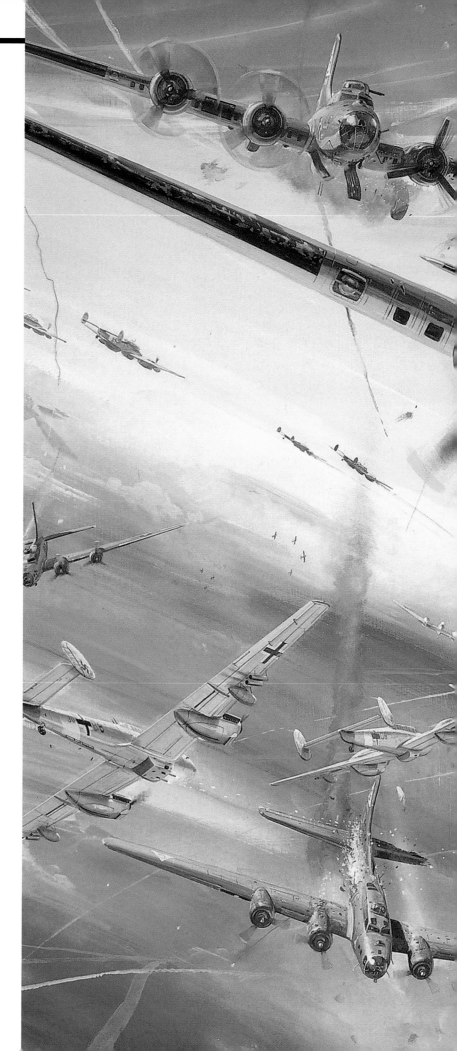

AT AN EXPERIMENTAL AIRCRAFT ASSOCIATION FLY-IN, retired General Robin Olds was asked his opinion of a painting depicting a mission he had flown in Southeast Asia near the end of his long career. He said he was very pleased with the image, but noted that it wasn't quite accurate. "As I remember it," he said with a bleak smile, "there was no sky at all, just black bursts of flak. An artist couldn't paint it as thick as it was, it would just be all black puffs."

The 8th Air Force crews that survived the long, dangerous raids against Schweinfurt and Regensburg must have had the same experience. In 1943, the 8th Air Force was out to prove that precision daylight bombing could materially affect the war effort; the deadly raids into the heart of Germany were test cases. Postwar reports from Luftwaffe pilots and even Nazi production minister Albert Speer confirmed that the raids did measurable damage to the German war production and strained the Luftwaffe's day and night fighter commands. Unfortunately, the missions were far more destructive to the 8th Air Force.

The 305th Bomb Group, pictured here in a sky full of planes, sent fifteen bombers on the October 14 raid against Schweinfurt; two returned to their English base. The strike force as a whole suffered greater than 20 percent losses, and nearly 75 percent of the planes that returned were damaged. The outcomes of these lethal missions to Germany, along with the Ploesti and Vienna-Neustadt raids by the Mediterranean bomb groups, gave even the most avid strategic bombing advocates pause.

BELOW: The fuselage angle of the bellied-in B-17 gives it the look of a stricken animal rather than a crashed plane. This sketch was one of several thumbnails for a B-17 commission.

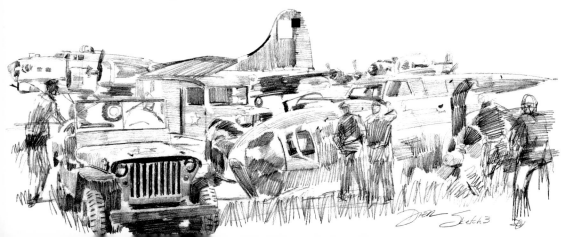

Though I Be the Lone Survivor

The Army Ranger units of World War II were closely modeled on the British Commando organization. Specialists in amphibious and small-unit actions, the Rangers under Colonel William O. Darby fought in North Africa, Sicily, and Salerno. When the Allies conceived of an amphibious assault at Anzio to threaten Rome and force the Germans to abandon their powerful positions around Cassino, the Ranger battalions were given a major role. Two of them were in the first American assault wave.

Historians argue whether the Anzio landings ever had sufficient force to push far from the beachhead. The commander of the force once opined that the whole plan had "the smell of Gallipoli about it." The Germans were able to throw defenders onto the open plain south of Rome faster than the Allies could land and supply attackers by sea, and any window of opportunity was quickly closed. Eight days after the landings, with stalemate threatening, the 1st and 3rd Ranger battalions set off at midnight to spearhead an American assault on the town of Cisterne, astride the road to Rome. Unknown to Allied planners, the Germans had doubled their forces in Cisterne the night before.

The Rangers had infiltrated to within a few hundred yards of their target when dawn began to burn away a covering fog. Daybreak found them surrounded on wide-open ground. They fought their way toward the town, where some dug in at the railway station. Follow-up companies from the 3rd Infantry Division were halted by the defenses that the Rangers had slipped past in the dark. The battle raged all morning. By noon, the ammunition was nearly gone and Panzers were roaming through the Ranger positions. Of the 767 Rangers committed to the attack, only six made it back to Allied lines. The rest died or were captured by the Germans.

∎

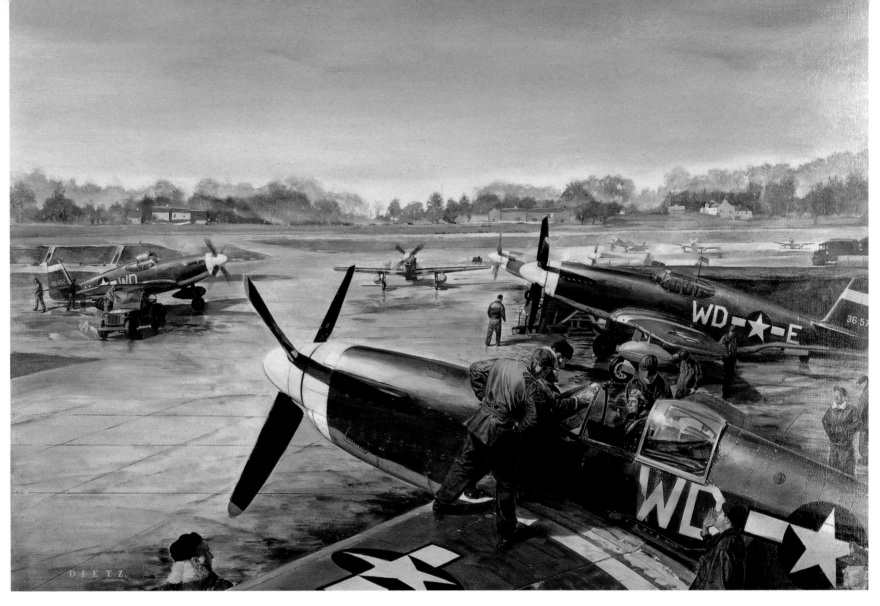

BLAKESLEE BEFORE BERLIN

"WHEN I SAW MUSTANGS OVER BERLIN... I KNEW the jig was up." These words are ascribed by a postwar interviewer to Luftwaffe chief Hermann Goering. The first day he could have seen those P-51 Mustangs was March 4, 1944, when the 4th Fighter Group led a long stream of B-17s and escorts across the German capital. Their appearance so deep inside Germany ended any hopes the Luftwaffe had of pulling a victorious rabbit out of its extremely battered hat.

Donald Blakeslee, commander of the 4th FG, had waited a long time for the chance to lead his forty-eight planes over Berlin. He arrived in Britain wearing a Royal Canadian Air Force uniform, and was assigned to one of the American-

manned "Eagle Squadrons" of the RAF. Blakeslee rose to the command of 121 Squadron. In September 1942, the Eagles were incorporated into the 8th Air Force, and Blakeslee accepted American rank along with a new pink and green uniform and a huge increase in pay. All of the Eagles traded their sleek Spitfires for massive P-47 Thunderbolts. The P-51 appeared sixteen months later and for the first time gave the 8th Air Force bomber crews the promise of fully escorted missions, wherever they were going.

The first Berlin mission was a ragged affair for the long-legged escorts. Nearly half of the new planes had to turn back for mechanical reasons. In addition, it was -50 degrees

Fahrenheit (-46°C) at escort altitude, and pilots were scraping ice off the insides of their canopies. Of course, the German pilots flying Bf-109s and Fw 190s did not know these things. What they saw were brown fighter planes diving at them where none had ever been before. For the beleaguered Luftwaffe, the German skies no longer offered refuge.

■

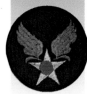

B-17

IN AN ERA OF KEVLAR ARMOR, BLACK PLASTIC rifles, and laser sights, photographs of GIs probing hedgerows with their M-1s have an unmistakably antique air about them. And in an era when a handful of dead servicemen can inspire a national policy reversal, the idea of sending men on missions with an expectation of a 10 or 20 percent casualty rate is almost inconceivable.

Given this historical perspective, the World War II strategic bombing campaign may be the most difficult part of the war for later generations of Americans to understand. The droning formations of B-17s and B-24s pressing on to drop their payloads from high altitude are far removed from a world of global positioning satellites, cruise missiles, stealth aircraft, and smart bombs. The commitment of men and materiel to the daylight bombing of heavily defended strategic targets was huge, and the cost both in funds and human lives, astronomical. Until the late summer of 1944, the heavy bomb group aircrews knew that they had slim chances of completing a tour of duty.

Their acceptance of the job and the odds are a significant part of what separates their generation from the ones that have followed.

The B-17 first flew in 1935. The Army Air Corps was not convinced it needed a four-engine bomber, but the plane was available and was embraced as a defensive weapon system. A force of B-17s ranging far out to sea was proposed as an efficient way to protect an isolationist America from enemy invasion. The Air Corps, not the coastal artillery, was the U.S. Army's force of the future, and the new defenses would be the flying fortresses, not the concrete ones. Given time and world events, the philosophical shift from maritime defense to strategic bombing was easy. With a great new bombsight and improved B-17 models, planners were confident that the Air Corps could select and destroy industrial targets that would cripple an enemy's ability to

wage war. It was an almost humanitarian theory of warfare, and tens of thousands of airmen went overseas to prove that it would work.

The B-17s of the 8th Air Force were sent across the English Channel in tens, then hundreds, and finally thousands. The airplane was slower than the B-24 and had a shorter range and smaller payload, but it made up for all this in ruggedness. Bristling with heavy machine guns and stacked in tight defensive formations, B-17s fought their way to the end of their escorts' ranges, then continued on. The lore surrounding the battered bombers returning to base helped mask the bruising that the bomb groups were taking, and it ennobled the sacrifices of their crews.

The men in B-17s and B-24s rode their bombers to altitudes well beyond the range of human habitation. Wrapped in wool, sheepskin, and electric heating wires,

ABOVE: Comparing this B-17 sketch to the B-24 studies for *Maximum Effort* (see pages 12–17) shows how the low wing of the Flying Fortress drops a curtain across any ground scene. The plane is beautiful in flight, but an artistic problem on the ground.

they breathed bottled oxygen and moved through their planes on aluminum catwalks. They stood at open windows 30,000 feet (9,120m) above the ground to aim machine guns in a 200 mph (320kph) slipstream. They were tucked into spaces too small to accommodate a parachute, they knelt behind tablet-sized armor plates, and stared at attacking fighters through clear, fragile bubbles of Plexiglas. The bomber crews fought a stand-up war against flak and fighters and all the offensive technology the enemy could muster.

The Luftwaffe first met the *Viermotoren* with standard day fighters. With the Allied bombers beyond escort range, the Germans could specialize. They hung extra cannon under their wings, they employed twin-engine night fighters, they tried antitank guns on heavy day fighters, and they mounted rocket tubes on interceptors. Their grisly gun-camera footage shows the awful effect of these ever-larger weapons on plodding B-17s.

The German pilots learned to attack head-on, en masse. They attacked as the bombers were inbound for their targets; occasionally they could land and rearm for a second sortie before the bombers' trip home. The Luftwaffe finally used jet interceptors against the big bombers. Of course, the entire route was marked with flak. Meanwhile, inside the B-17s, the aircrews stood in their sheepskin suits and aimed their machine guns and dropped their bombs.

Long-range escorts entirely turned the tables on the Luftwaffe fighter arm. The defenders soon became the prey who could be attacked anywhere and anytime. The heavily armed German interceptors were easy meat, and their bases became regular targets for homeward-bound escorts. Little swastikas (representing kills) blossomed under the cockpit rails of American fighter planes. Yet in almost every fighter pilot's memoir, a heartfelt tribute is paid to the guys in the bombers. They were the heroes who flew slow, and straight, and upright—right to the end.

■

FOURTH DOWN

THE 415TH FIGHTER SQUADRON ARRIVED IN Britain on April 1, 1943, to begin flight training in the Bristol Beaufighter. The Beau was intended to be an interim mount for the unit, but the 415th was still flying the planes at the end of the war. In fact, the squadron scored all of its confirmed kills in the big British fighter. Though the planes were seldom fresh from the factory, they served in campaigns over North Africa, Sicily, Italy, Corsica, France, and finally Germany. The squadron's job was protecting Allied targets from German night bombers, and it moved forward with the front, from one tent camp to the next.

Research for this painting offered Jim a privileged look into the past. Informal squadron histories and diary entries told a private story of the war. He learned that the mud puddles froze over in BSSI ("Beautiful Sunny Southern Italy"). The line crews stood in knee-deep mud to get coffee and donuts from the American girls in the Red Cross truck. March 1944 offered mixed blessings: the sun briefly appeared, but the rotation of combat crews was canceled, leaving those who had finished their designated operational tours still on duty. The squadron lost a Beau without a trace the same night a nearby bomber group claimed that a Ju-88 intruder was shot down. No more was heard about either incident. The liberated cognac at their Pomigliano field-tested positive for cyanide, so the squadron bar was closed.

A carton of cigarettes would liberate a salvageable Indian motorcycle from an Army dump. Some crews built motor scooters out of war debris. The 415th's Corsican airfield came with a freshwater swimming hole, where in a pinch you could swim your laundry clean. The squadron liberated a used B-25 as a utility plane. The welcome in the south of France was "oo-la-la," and somehow the same Red Cross girls

brought donuts and coffee, this time without the mud. In Dijon, the billeting officer found the squadron the ultimate luxury: it was a former seminary with steam heat and running water, *chaud et froid*. The previous residents had painted the dining room walls with cartoon scenes of Luftwaffe life.

Fourth Down was commissioned by the nephew of Lieutenant Austin Petry, the radar operator of the plane pictured, and it commemorates "Uncle Pete's" fourth confirmed kill, on the night of September 29–30, 1944. While working the skies over southern France, the night fighters had noted regular unidentified traffic on routes to the Spanish frontier. Lieutenant Petry had an eye for an airborne radar display, and he and Major Harold Augsburger, the squadron commander, intercepted and downed two of those planes. One was a Focke-Wulf 200, the other a Heinkel He-111, and both had been transporting officers and documents to the safety of Franco's Spain.

Augsburger and Petry were a regular pair in the Beaufighter. Late in the war, they were hit by German ground fire while flying a night intruder mission, but both men survived. After VE-Day, Augsburger's bride, one of the Red Cross girls who had kept the 415th in coffee and donuts, wore a wedding dress made from his old parachute. And years later, Austin Petry was instrumental in organizing the association of former World War II night fighters.

A print of *Fourth Down* hangs beside a restored Beaufighter at the Air Force Museum in Dayton, Ohio.

■

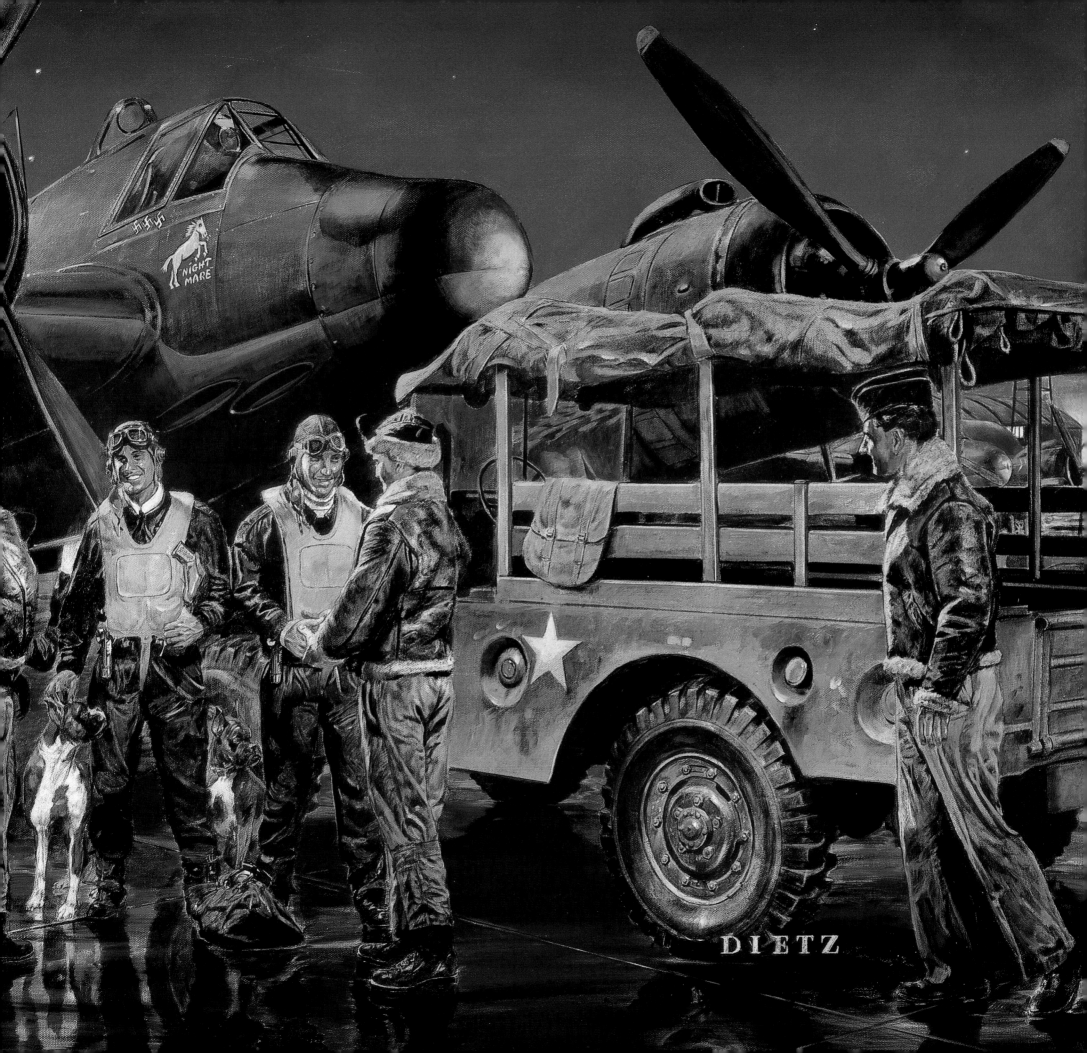

NIGHT DROP

Of all the calculated risks of the Normandy invasion, none had odds as long as the airborne assaults at either flank of the invasion beaches. Nearly 20,000 men were sent on a one-way trip to France between nightfall and the first light of false dawn. Three airborne divisions were ordered to land, assemble in the dark, and move to their battalion or regimental objectives. It was a very big job, and it took 1,200 planes and 700 gliders to transport the assigned men to France.

To create this book cover, Dietz had sketched paratroopers loading up and landing, but the historical event cried out for an in-flight scene. A mass paratroop drop is one of the few aviation events where the subjects of a painting are actually grouped as closely together as an artistic composition requires. In *Night Drop*, the moonlit sky over Normandy is jammed with C-47s and paratroopers; very little artistic license was required to fill the canvas.

A Jim Dietz painting of a World War II aircraft in flight is something of a rarity. When he first began his career there were recognized greats in aviation art who set the standard for everyone else. Frank Wooten had been painting airplanes since the 1930s, and R.G. Smith was already an acknowledged master of atmospherics, achieving depth and detail with a minimum of brush strokes. There are also wonderful painters of skyscapes among Dietz's contemporaries—artists for whom the airplane is the icing on the cake of clouds. Whether it was a Dakota, a Skytrain, or a Gooney Bird, this plane is an artist's favorite. As Dietz says, "The Douglas C-47 is one of the prettiest shapes ever to fly. Like a lovely figure model, you just want to keep drawing her."

■

LEFT: The 101st troopers in this sketch are part of the workup for a painting commemorating their bayonet charge across the causeway leading to the crucial crossroads town of Carentan.

DIETZ

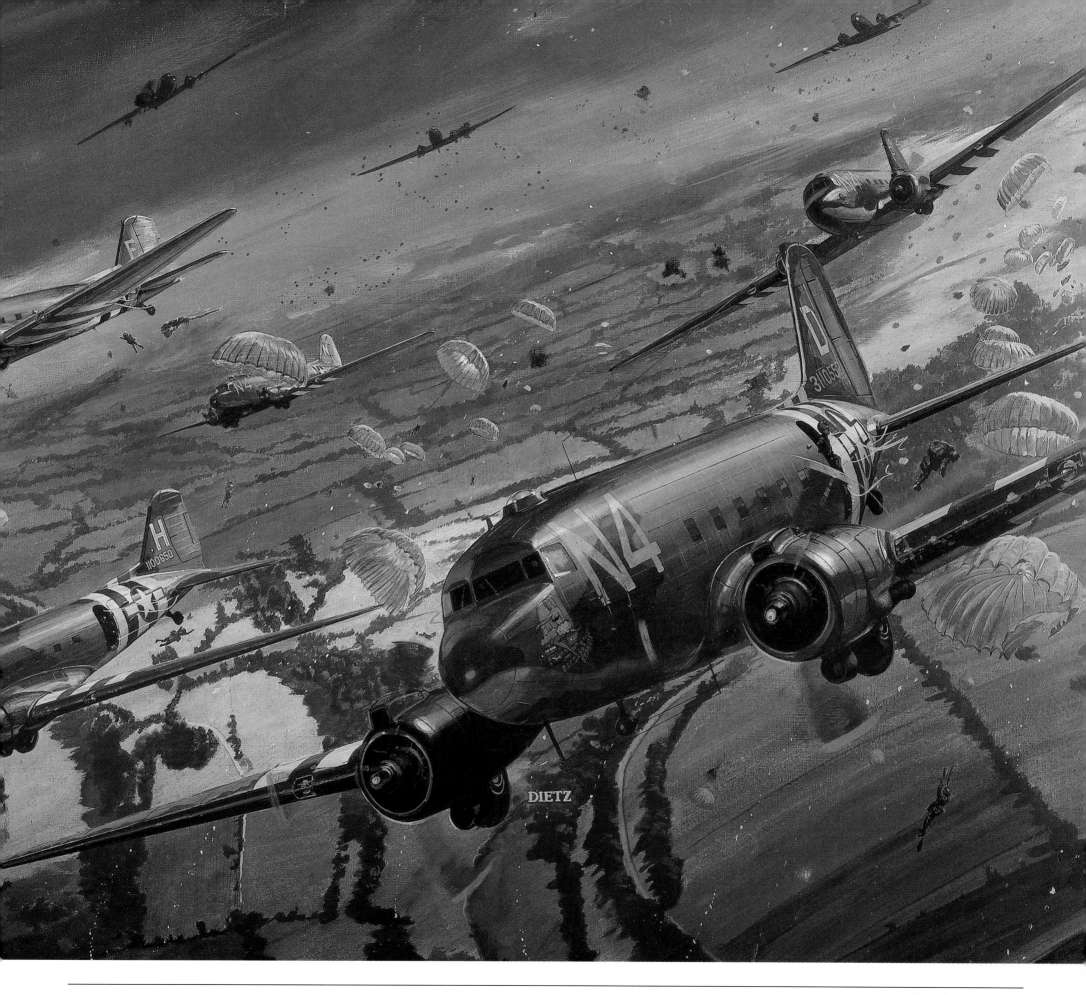

OVERLORD

THE COMBINATION OF LUCK, COURAGE, SKILL, AND leadership was unbeatable on Utah Beach. Utah was the American success story of the D-Day landings, despite the loss of most of the landing control teams, the unexpectedly strong tide, the sinking of numerous vessels by mines, and terrible visibility due to fog, mist, and smoke. The 4th Division went ashore on the heels of a good preliminary bombardment, and enjoyed effective naval gunfire support after they arrived.

The 4th's Assistant Commander, Brigadier General Theodore Roosevelt, Jr. was in the first wave of infantry. Roosevelt, the 8th Infantry Regiment's CO, James Van Fleet, and their battalion commanders were able to ad lib the invasion almost from their first steps up the beach. Utah's low-lying terrain made it an easier air bombardment target than the bluffs further up the coast, and wave after wave of low-level B-26 Marauders obliterated much of the Germans' fixed fortifications. Inland, beyond flooded lowlands and beach exit causeways, roaming bands of paratroopers were attacking artillery units that would have otherwise been shelling the beaches.

Although it included the grim carnage of the American landings on Omaha Beach, the amphibious combined-arms assault against prepared fortifications known as Operation Overlord was an astounding success. Perhaps 165,000 Americans, British, and Canadians reached France before midnight on June 6, with approximately 6,000 casualties. The British on Sword Beach had fewer than 1,000 casualties landing 29,000 troops, and at Utah Beach the Americans brought 20,000 ashore and lost around 250 dead, wounded, and missing. While the grief of the friends and families of the dead GIs was undeniable, training for the D-Day invasion had been more dangerous for the 4th Division than the actual landings on Utah Beach.

∎

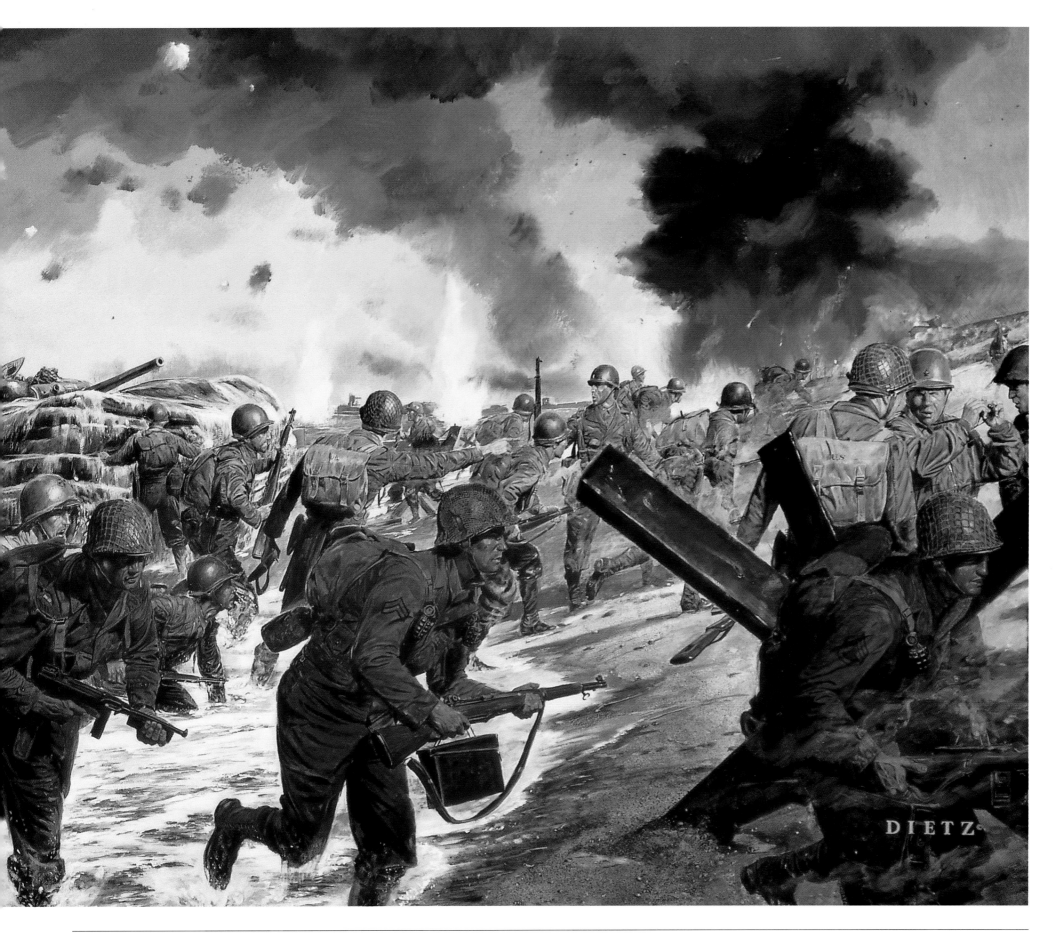

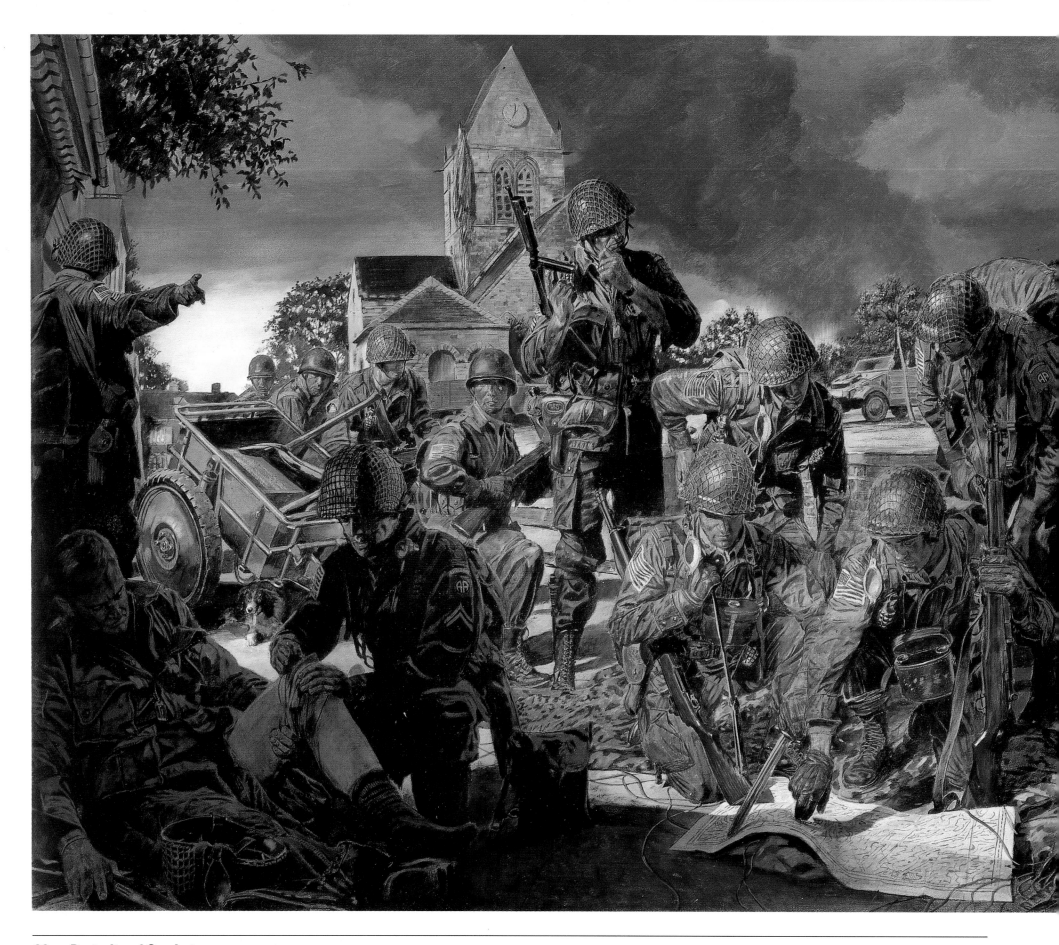

SEIZE THE DAY

THE VILLAGE OF ST. MERE-EGLISE WAS A PRIMARY objective of the 82nd Airborne's drop into Normandy, and is symbolic of the entire parachute and glider assault. Lifeless troopers hanging from trees, a soldier snagged by the church steeple, the tocsin bell, parachutists descending into burning buildings, crashed gliders, and brutal fights in alleys, gardens, and hedgerows— all these images were typical of the struggle for St. Mere-Eglise.

The town's German garrison never realized that they were the objective of several thousand paratroopers. One stick of the 101st Airborne, miles away from their drop zone, came down right on top of them. Half an hour later, another planeload, this time from the 505th Parachute Infantry of the 82nd Airborne, dropped into the glare of a burning barn nearby. The Germans drove off the Americans and returned to their billets, confident that the odd little night raid was over.

In the hedgerows and fields, however, the scattered paratroopers were moving toward the village. It was the assigned target of many of

these men, and its church steeple was the divisional rallying point for the lost and separated. Twenty men here, eighty there, ten led by a sergeant, a hundred gathered by a colonel—all began to carry out the mission. A group that was organized around the 3rd Battalion of the 505th crept into town before dawn. Parts of the 2nd Battalion arrived and more men came in from the gliders, bringing ammunition and equipment. Together, they fought off German artillery and infantry throughout the afternoon and into the darkness.

When the first large parties of Americans appeared in the village, a nervous Frenchman asked officers of the 3rd Battalion if they were the real invasion or just a raid. The response to his question, in one lieutenant's high school French, could have been the watchword for all of Overlord: "Nous restons ici." ("We are staying here.")

■

BELOW: This alternate version of the 82nd Airborne painting posed the troopers against a hedgerow, searching for the route to St. Mere-Eglise. In the final version, the identifying village church had to be included and the troopers are instead plotting their route out of town.

SOUVENIRS

A SMALL FRACTION OF THE TENS OF MILLIONS OF MEN mobilized by the warring powers during World War II were airborne soldiers, yet American and German parachutists fought each other in almost every European campaign. The American airborne formations were created after the Army hierarchy witnessed the success of German parachute and glider units in the Low Countries. The U.S. Army planners were not deterred by the near disaster that befell the Germans during the invasion of Crete.

The *Fallschirmjaeger* ("paratrooper") had virtually turned in his silk by the time he met his American opposite number. The Luftwaffe never recovered from the massive transport losses on the Eastern Front, but was loathe to surrender its highly trained and superbly equipped infantry.

The 82nd Airborne met Luftwaffe combat personnel for the first time when the Americans jumped into Sicily. In Normandy, the first organized counterattack of D-Day was made against American paratroopers by Colonel Frederick von der Heydte's 6th Parachute Regiment. The 101st and 82nd faced German II Parachute Corps during the fight to keep the road to Nijmegen open at Operation Market Garden. Airborne divisions of both armies were heavily involved in the Battle of the Bulge, and it was there that the Germans staged their last airborne assault, an unsuccessful battalion-sized jump commanded by von der Heydte.

One American paratrooper pictured here is wearing a Mae West to commemorate the jump at Sicily, where the life vest was standard equipment. His German counterparts are uniformed and equipped as they would have been in their fights with the Americans. They sport the semi-automatic K43 carbine and an MG42. The man in the center holds a StG44, which proved the concept of the medium cartridge assault rifle.

■

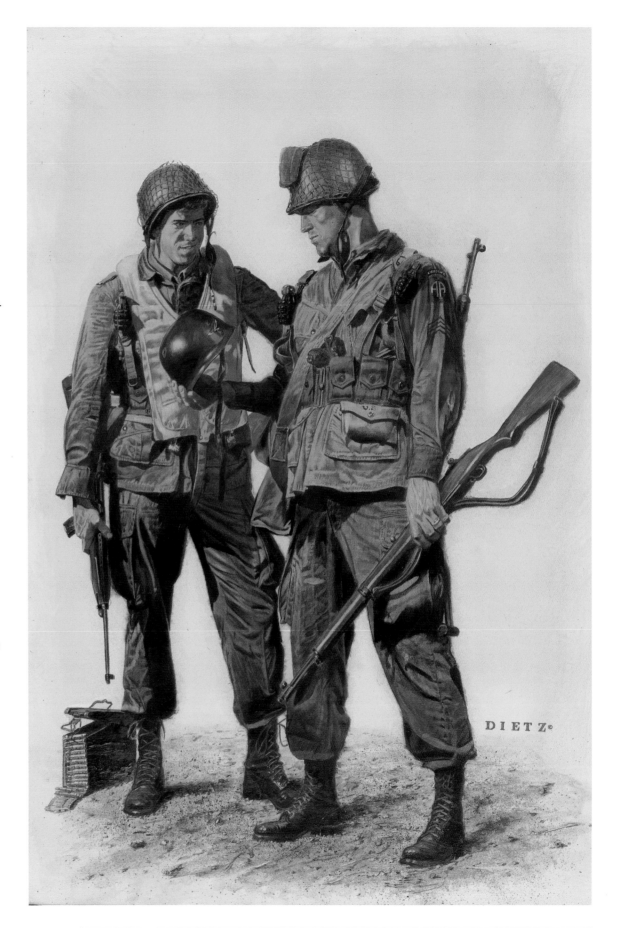

DIETZ©

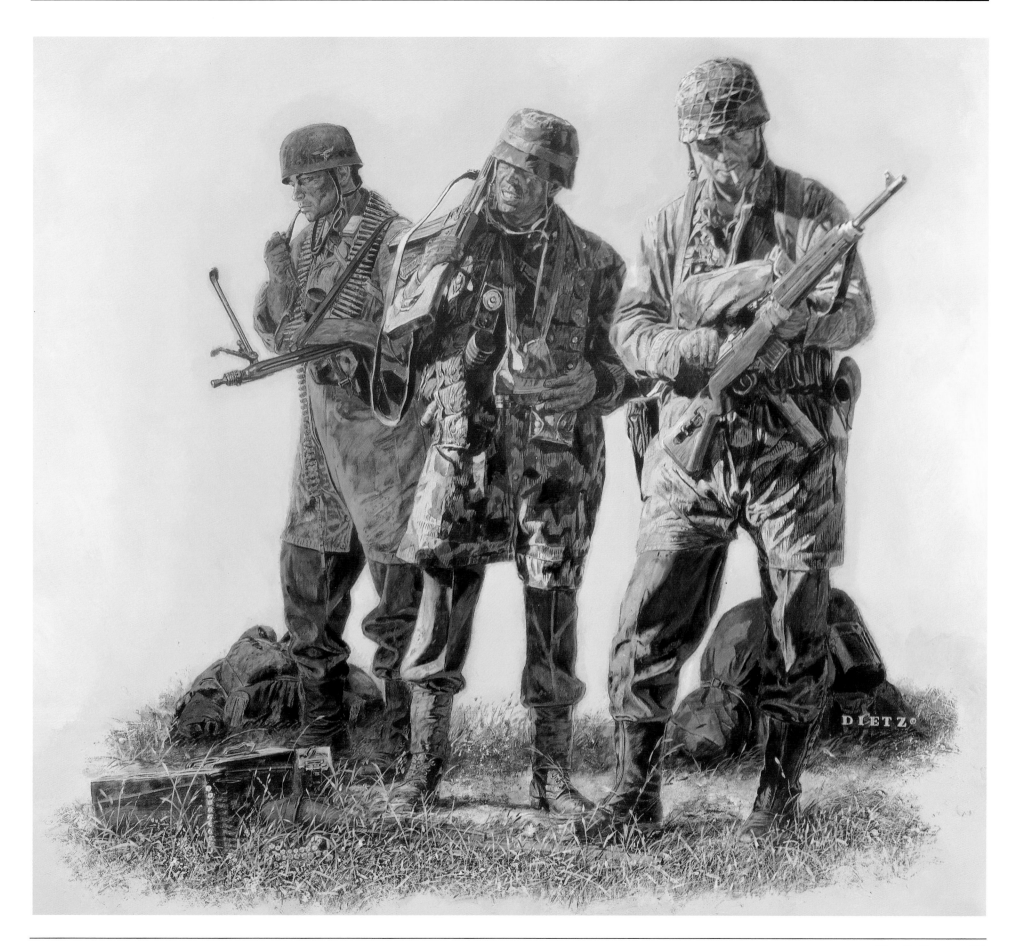

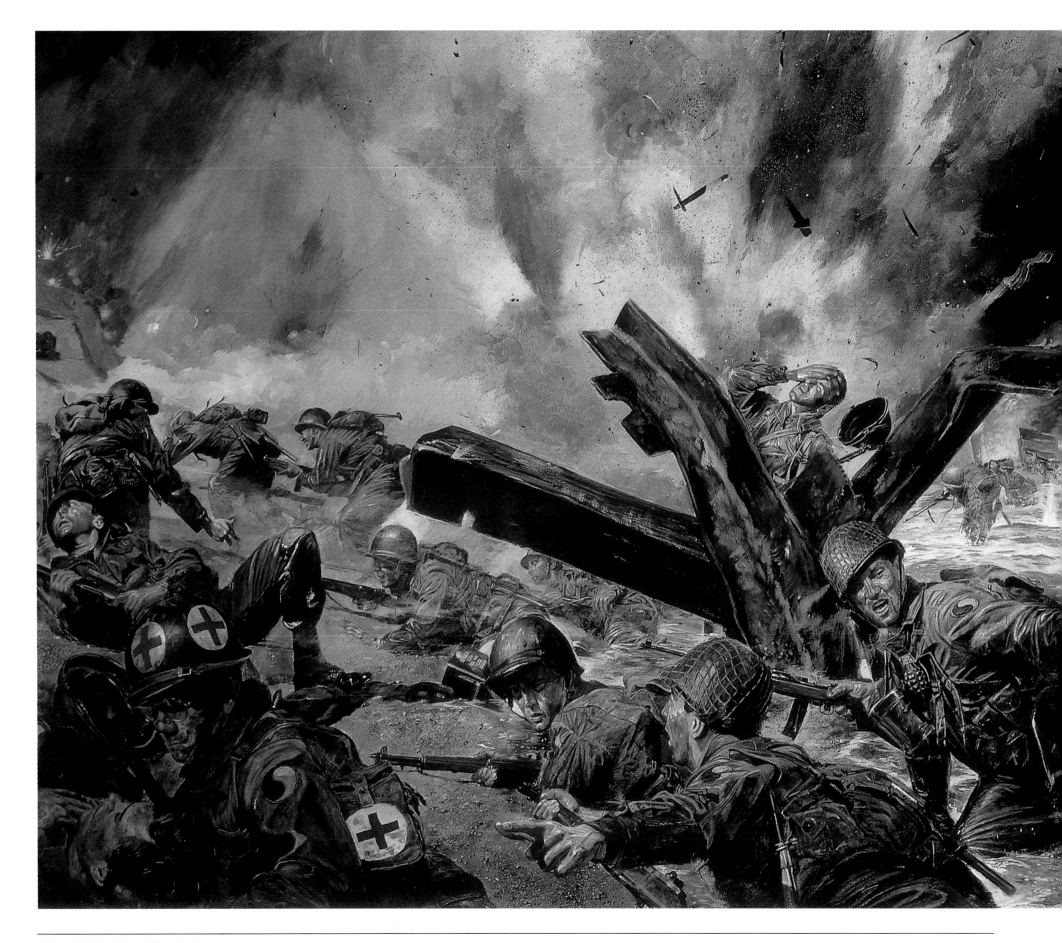

29TH, LET'S GO!

ALL THE HORRORS OF D-DAY WERE VISITED ON THE 116th and 16th Regimental Combat Teams, the two units that led the assault on Omaha Beach. The defenders at Omaha, unscathed by the pre-invasion naval and aerial bombardments, virtually destroyed the first wave of attackers. One assault company from the 29th Division's 116th RCT had 90 percent casualties. The second wave lost even more landing craft in the obstacles as the tide rose, and faced the same heavy fire on the beach.

At 0730 the command elements of the 116th came ashore, as did the assistant commander of the 29th Division, Brigadier General Norman "Dutch" Cota. Many of their boats dropped ramps into direct machine-gun fire or were blown up at the water's edge. Still, many men made it through the obstacles, past the wreckage, and up to the sparse shelter of the low seawall. They may have been spared simply because the beach and off-shore waters were so crowded that the defenders were finding it increasingly difficult to focus on specific targets.

The arriving commanders realized that the troops had to get out of the killing zone, but with the fortifications in the designated beach exits still intact, the only possible way forward was up the face of the overhanging bluff. General Cota organized and led a mixed group of infantrymen and engineers through the mines and barbed wire to the top of the bank.

The appearance of Cota's men on the high ground was the first shaky step toward victory on Omaha Beach. More men followed, and in hastily formed groups they began to engage the infantry positions that were firing down into the mass of men and equipment below. The brigadier, his duties as a platoon leader carried out, fought his way back down to the beach to get on with organizing the push inland.

■

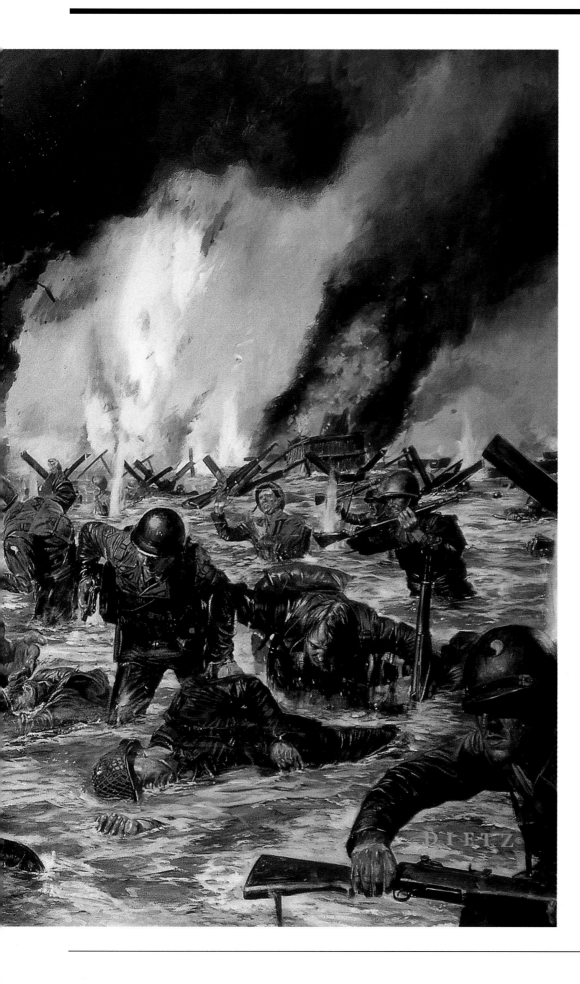

RANGERS LEAD THE WAY

NO DAY LOOMS AS LARGE IN THE HISTORY OF THE United States Army Rangers as June 6, 1944. Two battalions of Rangers, the 2nd and 5th, were assigned the most difficult tasks in what turned out to be the most difficult part of the invasion area. Three Ranger companies were ordered to scale a sheer cliff at Pointe-du-Hoc and neutralize a heavy-gun battery on the west flank of Omaha Beach. Another was assigned a first-wave landing to clear the beach fortifications up the Vierville draw with the 116th Infantry Regiment. Two compa-nies were in reserve, either to assist in the cliff assault or the Omaha landing. The 5th Battalion was ordered to exploit the beach exit and attack the big emplacements from the rear. In actuality, nothing went according to plan, but on that day, the Rangers could do no wrong.

The Rangers at Pointe-du-Hoc suffered 50 percent casualties scaling the cliffs. The guns had been moved, but were located and neutral-ized anyway. On Omaha beach, "C" Company Rangers were supposed to leapfrog the first company of the 116th Infantry after it reached the Vierville draw. That first company was landed out of position and wiped out before it reached the seawall. The Rangers landed alone, below a thirty-three-foot (30m) cliff. Half of the Rangers made it across the beach. These men found a narrow crease in the cliff, scaled it under fire, and may have been the first U.S. troops to reach the heights.

The two reserve companies steered for Omaha after receiving an overconfident signal regarding the Pointe-du-Hoc operation. They arrived with the 5th Rangers in front of the Vierville draw when the chaos on the beach was at its height. Men, alive and dead, were packed down on the sand, amid tons of scattered equip-ment. The 5th Rangers came ashore as a body, with leadership and went to work. Within min-utes, Brigadier General Norman "Dutch" Cota found them. Having already been to the top of the bluff, Cota understood that the only way to move a regiment off the beach was through the fortifications. There are various ver-sions of what he said to Lieutenant Colonel Max Schneider of the 5th Rangers, but as a comment, an order, or an exclamation, all of them include the words "Rangers lead the way." That they did, right up the Vierville draw. Sixty years later, that is still the motto of the United States Army Rangers.

■

BELOW: This GI splashing through shallow water was one of two dozen figures spilling out of a landing craft. The sketch provided a quick study figure for a D-Day book cover, without all the details of light, shadow, and water.

DIETZ

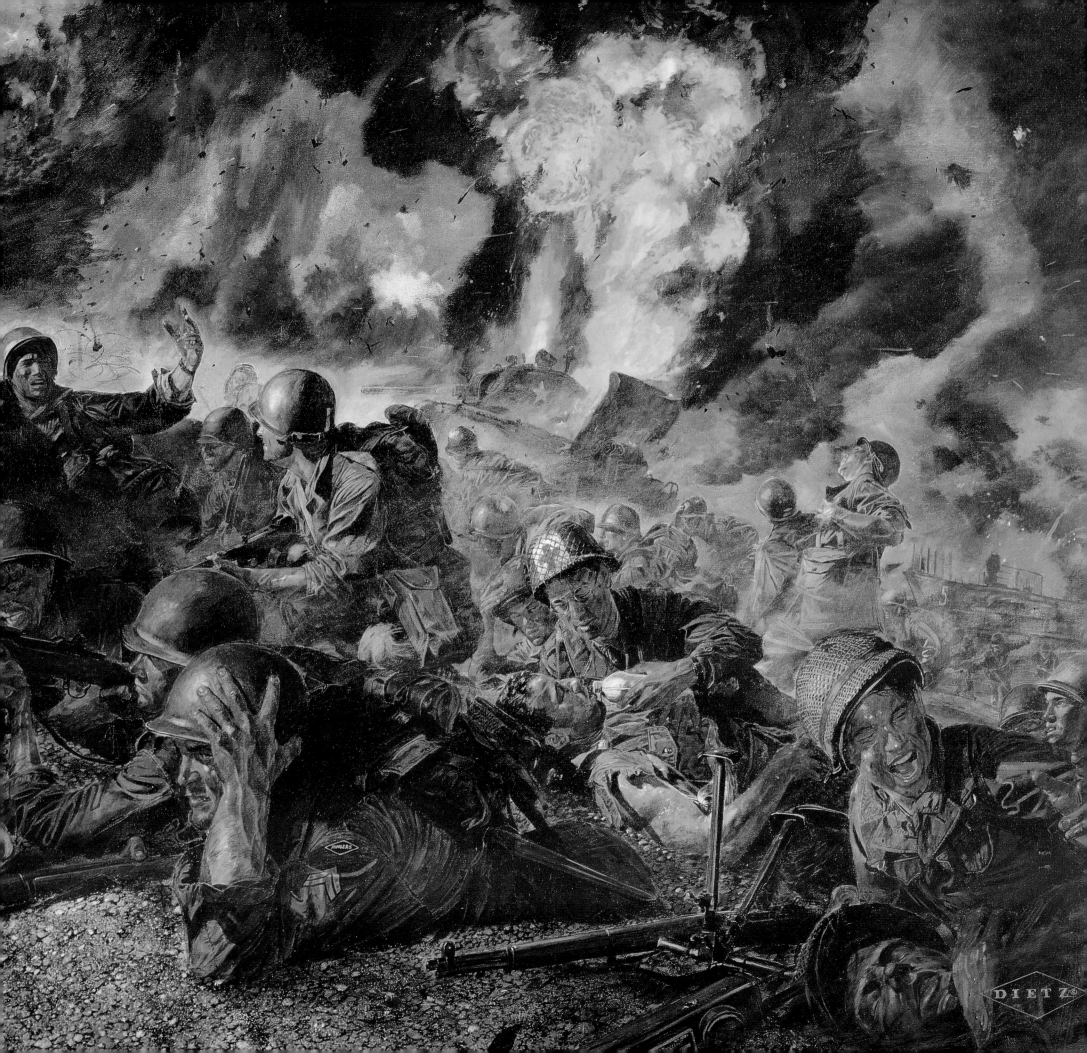

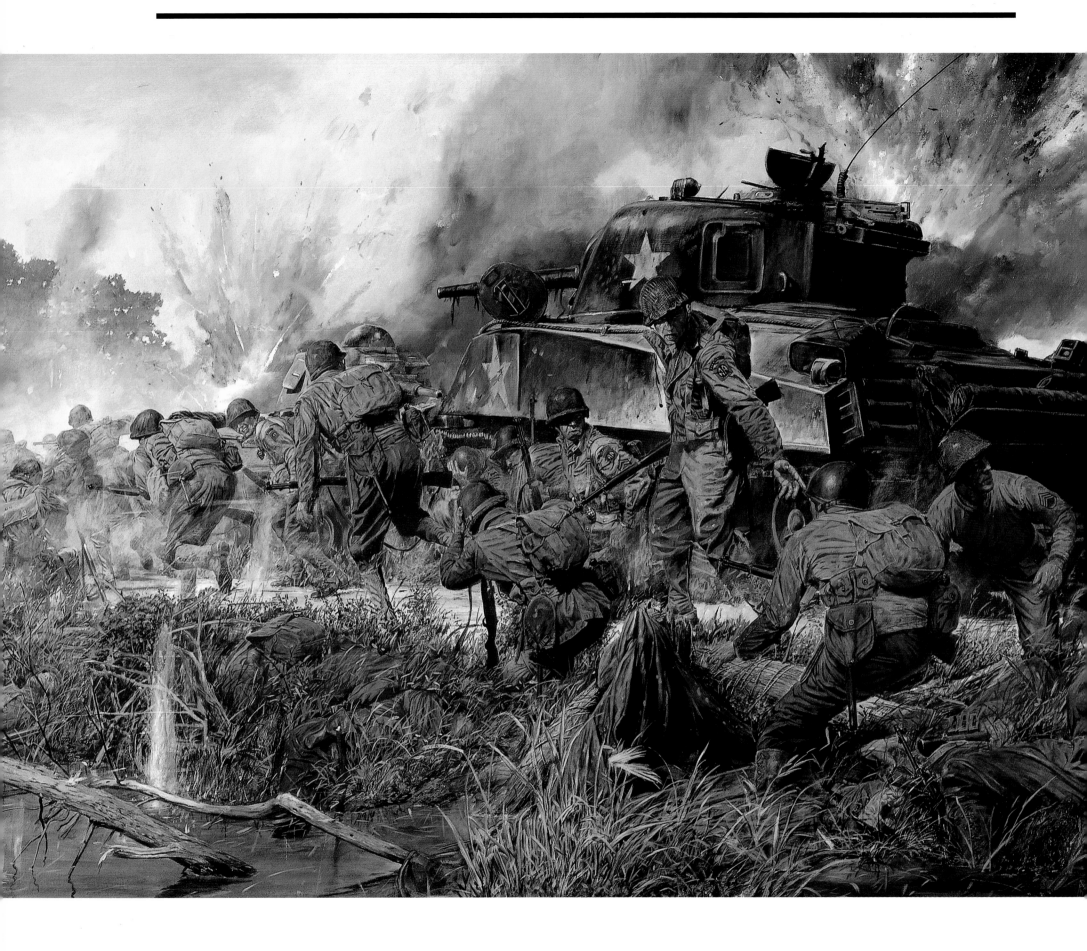

DIETZ®

AGAINST ALL ODDS

UTAH BEACH OPENED ONTO THE FLATTEST PIECE OF the Cotentin Peninsula. The land behind it was veined with country roads raised above the level of flooded fields, marshes, and rivers. If the tens of thousands of troops crossing the invasion beaches each day were going to get on with the war, these causeways had to be taken. Taking them was a mission for the Airborne.

The 550 yards (500m) of raised road across the Merderet River at La Fiére was a prime objective on the route to Cherbourg. On June 9, 1944, the troops of the 82nd charged across the exposed roadway under the command of Brigadier General James Gavin. Raised a few feet above the flood plain, and devoid of cover other than shell holes and blasted vehicles, the line of advance looked impossible, and the first rush by the 325th Glider Infantry met a withering hail of fire. The regiment's commander, Colonel Harry Lewis, stood on the causeway exhorting his men forward, but the sleet of shell fire drove them to hunker down behind the meager cover of disabled tanks in the roadway. A battalion of para-troopers started in the wake of the glider infantry, and with them went Gavin as well as Major General Matthew Ridgeway, commander of the 82nd.

The sight of generals and colonels standing in the open, directing fire, pulling men out of craters, and organizing the fight galvanized the infantry squads. The attackers swept the cause-way with their own covering fire, and cleared the defenders from the far banks. The effect of such apparently fearless leadership from the "old man" was incalculable, and such heroism became the standard against which any junior officer in the Airborne would have to measure himself.

■

BELOW: This group of figures was taken from book cover studies for a story of the battles around Cassino. Is the man on the right trying to exhort the others to action or is he just glad to be the only one in this tableau who isn't dead or wounded?

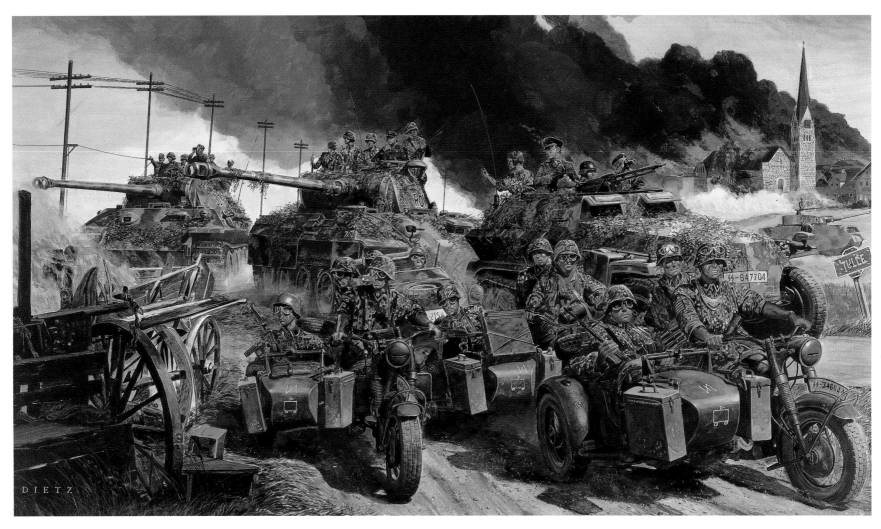

DAS REICH

HITLER'S SS UNITS WERE ORGANIZED TO PROVIDE the Nazi Party with an armed force under its direct control—an army that could operate outside the Wehrmacht's command structure. The SS took part in the invasion of Poland at the regimental level, and division-sized SS units fought in France. These units, renamed Waffen SS in early 1940, were well trained, extremely well equipped, and were the most zealous of Hitler's soldiers—zealous enough, in fact, to consider themselves above the rules of war that governed the regular Wehrmact troops. Despite their significant military accomplishments in five years of constant warfare, the SS units are remembered more for their excesses than their successes.

The 2nd SS Panzer Division, "Das Reich," was responsible for the worst "reprisals" during the occupation of France. On June 9, 1944, during their march to the Normandy beachhead, troops of this division hanged ninety-eight men of the village of Tulle, where the Resistance had besieged the German garrison. The next day they shot or burned to death more than 500 residents of Oradour-sur-Glane, most of them women and children.

Waffen SS divisions suffered high casualty rates in the last year of the war as the Allied armies pressed in on Germany. At some time or another, British, Canadian, American, and Russian army prisoners had all been murdered by Waffen SS units, and many Allied soldiers had

scores to settle. German accounts report that in the last days of the war, the cuff bands that decorated SS uniform tunics were being ripped off to improve the wearer's chances of a safe passage to a POW camp.

Das Reich was done for the cover of Max Hasting's book of the same name, and depicts the heavily armed SS troops roaring away from a burning French village on their way to Normandy. In actuality, the tanks of the division were sent by slow train to the Cotentin Peninsula.

■

NORMANDY TANK BATTLE

AMERICAN TANK OFFICERS WHO CAME TO NORMANDY expecting a mobile armored campaign were quickly and rudely disillusioned. The typical tank fight in Normandy was a short brutish affair that favored the defense, a point-blank ambush on a narrow road with no chance at all for maneuver. Worse, it became clear that the improved Shermans could not puncture the frontal armor of the Panzer Mk V and VI, while the defenders' high-velocity guns, towed and tank-mounted, readily perforated the American tanks. The enclosed hedgerow country made it unlikely that the Germans could be outflanked, and American tankers were stymied until they installed big

hedge-cutting plows on their vehicles. These allowed the tanks to get off the roads and out of the firing lanes, and contest Normandy one little field at a time.

The British tankers fared as poorly, despite having a much better version of the Sherman in their inventory. In late July, the British attempted to break out of Caen with a two-division frontal assault, codenamed Operation Goodwood. After three years of fighting the Red Army, there was little the Wehrmacht did not know about massed tank attacks, and the British had no new tricks. The Brits' massive armored charge resulted in scores of Allied tanks burning in the fields

below Bourgebus Ridge, effectively destroying the offensive capability of the British 29th and 11th Armored Divisions. The Allies finally bested the German defenses with overwhelming fire-power. The breakouts from Normandy followed aerial bombardment by RAF and USAAF heavy and medium bombers, and flanking barrages from massed artillery. The Allied armor advanced across cratered, ravaged corridors.

This book cover illustration combines a hedgerow ambush in the foreground and an open-field shooting gallery in the background.

∎

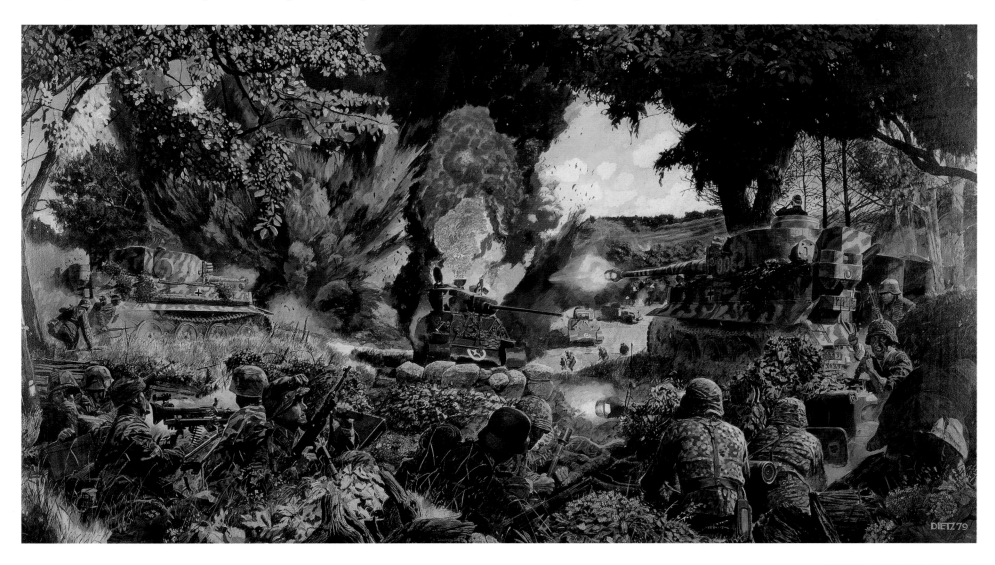

OUT OF HARM'S WAY

THE PASSING OF THE WORLD WAR II GENERATION has prompted a new appreciation of the sacrifices that these men and women made in their youth. Through movies, memoirs, and oral histories, the war has entered the consciousness of the grandchildren of the people who experienced it. This painting is a small part of that appreciation.

Fred Hoppe was an infantryman with "F" company, 141st Infantry Regiment, part of the 36th Division campaigning in Italy. In June 1944, his battalion was heavily engaged near Rome, butting heads with the German rear guard as the Wehrmacht backed up the peninsula to its next defensive line. Hoppe's platoon was up front, and he stuck close to his lieutenant, Ralph

McMorrow, as they probed the enemy defenses. Once during the day's action Hoppe pulled him out of the line of fire, but McMorrow had his orders, and the platoon kept moving forward.

The Germans let the GIs advance right to the verge of their positions before opening fire. The platoon reeled back to cover, and as mortar and artillery rounds began to fall, withdrew to their starting position. That was when Hoppe realized that his CO was missing. He crawled 400 yards (365.6m) back through the mortar barrage, and spotted McMorrow just sixty feet (18.2m) from the first German foxholes. As he continued closer the small arms fire became sporadic, and stopped entirely when he began to drag the wounded officer back. The Germans watched

the soldier recover his wounded comrade, and they did not fire as Hoppe rose to carry the Lieutenant back to friendly lines. Apparently, everyone had seen enough killing for one day.

This painting was commissioned by Fred Hoppe's son, and will be a reminder to his children of where grandpa was way back then, and what he did when he was there.

■

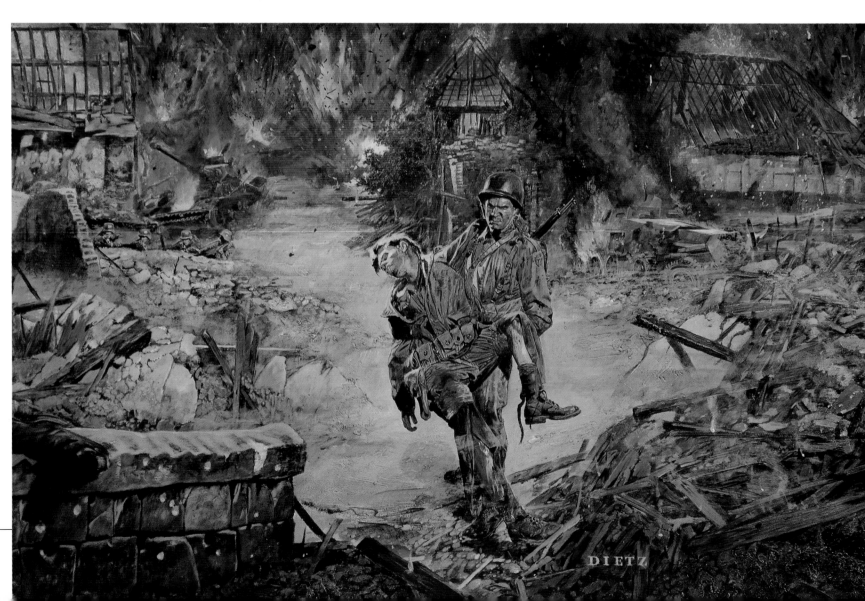

DIETZ

INTO THE SHADOW

THE M-4 SHERMAN TANK WAS A CONTROVERSIAL weapon. In contemporary comparisons of Allied and German materiel, as well as in postwar analyses, the area in which American forces showed a distinct disadvantage was the main battle tank. Nonetheless, the M-4 Sherman were manufactured in massive quantities, production that outstripped all German Panzer production from the first day of the war to the last. Because the American effort depended heavily on manufacturing speed, the production of the M-4 was rarely interrupted to introduce critical modifications to the design; ironically, Sherman crews were the victims of America's manufacturing prowess.

The Army's Ordnance Committee studied the lessons of the German victory in France, and in August 1940 called for a new tank. It would have a turret-mounted big gun on the chassis and track system of the prototype T-5, the same that was going under the M-3 Lee/Grant tank. The new tank would have a synchromesh transmission, a power-operated turret, and better protection than any of its predecessors. It would be small enough to ship overseas efficiently, and at around 34 tons (30.8t), light enough to cross rivers on mobile bridging equipment. This tank, the M-4, was in mock-ups in the summer of 1941 and in production by the summer of 1942. If foreign tank development had stood still, the Sherman might have been the best tank in the entire world.

The Russians introduced a new tank while the Sherman was being finalized. Their T-34 was a simple low-profile vehicle with steeply sloped armor and a high-velocity gun, and it shocked the Germans during the winter of 1941–42. The Germans hurriedly drew up plans for two heavily armored and heavily gunned ripostes, the Panzer Mk V and Mk VI, more commonly known as the Panther and Tiger. The Americans first saw the Mk VI in North Africa and knew that they had to improve the Sherman. Unfortunately, the ongoing improvements were never quite enough.

In many ways, the war for which the Sherman was designed had ended before the M-4 reached the battlefield. Every European army had upgraded its antitank guns from the 1940 standards, so the lessons of France no longer applied. Even the Americans were replacing their little 37mm gun with a 57mm, and moving up from there. Naturally, the gun caliber of tanks increased as well, with the Soviet's T-34 leading

LEFT: The high angle of this preliminary sketch for *Into the Shadow* produced a composition that depended on the figures for depth. The final version was lower, with more background, dramatic building perspectives, and the dark foreground.

DIETZ

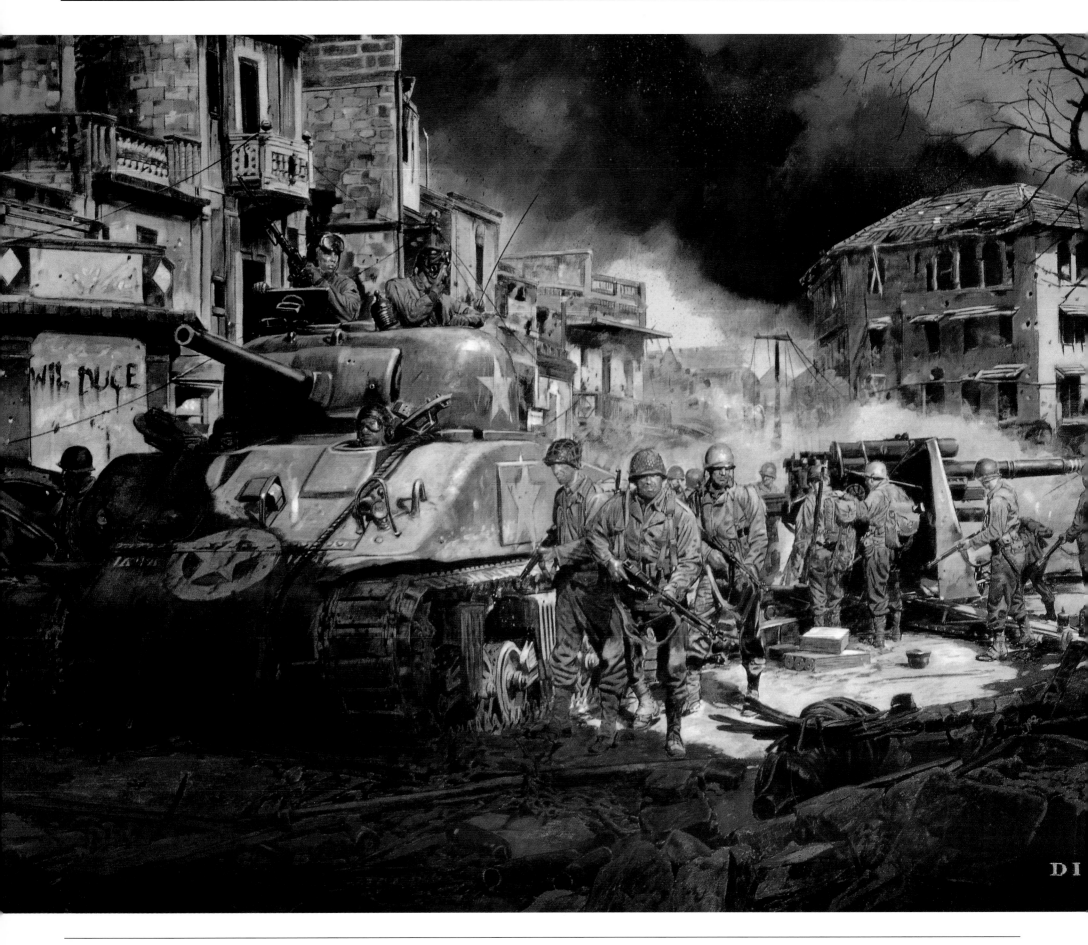

the way. The big German 88mm dual-purpose gun could penetrate any armored vehicle in the world, and it went into their huge 54-ton (49t) Tiger. For an opposing tank to survive, it had to be able to knock out a Tiger or Panther with its first shot, face-to-face. This was almost impossible for the standard Sherman to do.

The Sherman was upgraded with a high-velocity 76mm gun, but despite constant assurances from the officers at Army Ground Forces, the gun would not penetrate the front armor of its German opponents. The Army shelved a 90mm version of the Sherman and turned down a British offer of their 17-Pounder antitank gun for the M-4. These decisions were made in part because no one wanted to interrupt the production lines for the standard Sherman, which were running day and night. Tank destroyers were rapidly introduced with a 90mm gun, but it took an entirely new kind of 76mm ammunition to bring the Sherman up to lethal parity with the opposition. Thousands of American, British, Canadian, French, and Polish tankers would die in the meantime.

Other aspects of the tank war were changing as well. Blitzkrieg had given way to methodical combined-arms operations. More tanks served with American infantry divisions than in armored divisions. In the armored divisions, the self-propelled artillery grew into a crucial combat arm, and throughout the Army, the tank destroyer was the prime "first shot" defensive weapon. The Allied race across France following the St. Lo breakout was exactly the kind of action the Sherman was designed for, and there, its speed and reliability proved to be much more important than its firepower.

Into the Shadow was commissioned by the son of a Sherman tank gunner who fought in the Italian campaign. It depicts the typical use of the Sherman, as part of an armor/infantry team. On the piazzo of the Italian town is an 88mm gun, the bane of all Allied tanks.

◼

TIGER TANK

The *Panzerkampfwagen* MkVI began life as a portmanteau weapon system. The first Tiger combined a Krupp turret originally intended for an experimental Porsche vehicle, a Henschel chassis originally drawn up for a weapon that never appeared, and an 88mm gun that was superb no matter where it was mounted. The resulting tank was the most fearsome land weapon the Germans fielded during the war.

The massively armored Tiger I immediately redressed the firepower balance on the Eastern Front. Wehrmacht veterans have said that odds of one to six were considered about even in fights against the Russian T-34, and Tiger commanders quickly gained "kill" stats like those of fighter pilots. When the bigger Tiger II came on the scene, with its upgraded version of the 88, the crew could confidently expect to destroy any target they could see. Of course, the Tiger's protection and firepower came at the cost of immense weight, up to 70 tons (63.5t), and the slow-moving tank's motive machinery was never the match of its weapons. Mechanical failure was more common than destruction in combat.

The American and British counters to the Tiger began with big-gun versions of existing chassis. They had a chance if they fired the first accurate shot, but the surest Allied answer to the German machine was complete mastery of the air. The fighter-bomber and the spotter plane were the nemeses of any tank, the Tiger included.

JULY 20

THE CONSPIRACIES TO KILL ADOLF HITLER FILL A "through a glass darkly" area of World War II history. There were more than a dozen different assassination or coup plots hatched within the ranks of the German army and intelligence services, beginning in the mid-1930s. The plotters were often motivated by class issues and by professional disgust with Nazi military or social policies. Nearly all of the conspirators were sure that Hitler was on a course to destroy Germany.

July 20 was commissioned by an art director who wanted a painting that somehow addressed the assassination conspiracies. Dietz worked up sketches representing the three best-known plots: Munich in November 1939, Smolensk in March 1943, and at the Wolf's Lair in 1944. In Munich, a lone assassin nearly succeeded in blowing up Hitler. Over the course of a year, he arranged to place and detonate a powerful bomb in the *Burgerbraukellar* on the

anniversary of the Nazis' failed putsch of 1923. He failed when Hitler made an unusually short speech and left the beer hall minutes before the bomb exploded. The Munich bomb generated world headlines. The sketch looks like a party rally.

Numerous plots were hatched by Wehrmacht officers on the Eastern Front as the enormity of the war with Russia became apparent. The one that came closest to fruition was

the plan to place a time bomb, disguised as a liquor bottle, on board Hitler's personal aircraft while he was visiting Army Group Center headquarters in Smolensk. The bomb was transported to Russia by *Abwehr* officials, and was successfully placed on the plane. The bomb failed to explode and the generals ready to seize power from the Nazi hierarchy slipped back into the shadows. The Smolensk sketch has many officers who might be the plotters, but it is not specific to the plot.

The briefcase bombing at Hitler's eastern headquarters on July 20, 1944, is the best known of the attempts on Hitler's life. A scene in the briefing room as the bomb is introduced had great possibilities for dramatic placement and lighting. This was the sketch the art director preferred. In the finished painting, the composition draws the viewer's eye to a haggard Hitler at the end of the table. A second read reveals the arrow of light, perhaps from an open door, that passes behind the black boots of the assembled officers, then comes to rest on the briefcase being placed under the table.

The Wolf's Lair bomb was not as devastating as expected. Hitler was only slightly wounded, and the merciless investigation that followed the blast uncovered the extent of the complicity within the upper ranks of the Army. Scores of officers, from field marshals on down, died in its aftermath.

■

OPPOSITE: The Burgerbraukellar sketch for *July 20*. ABOVE: The Smolensk sketch for *July 20*.

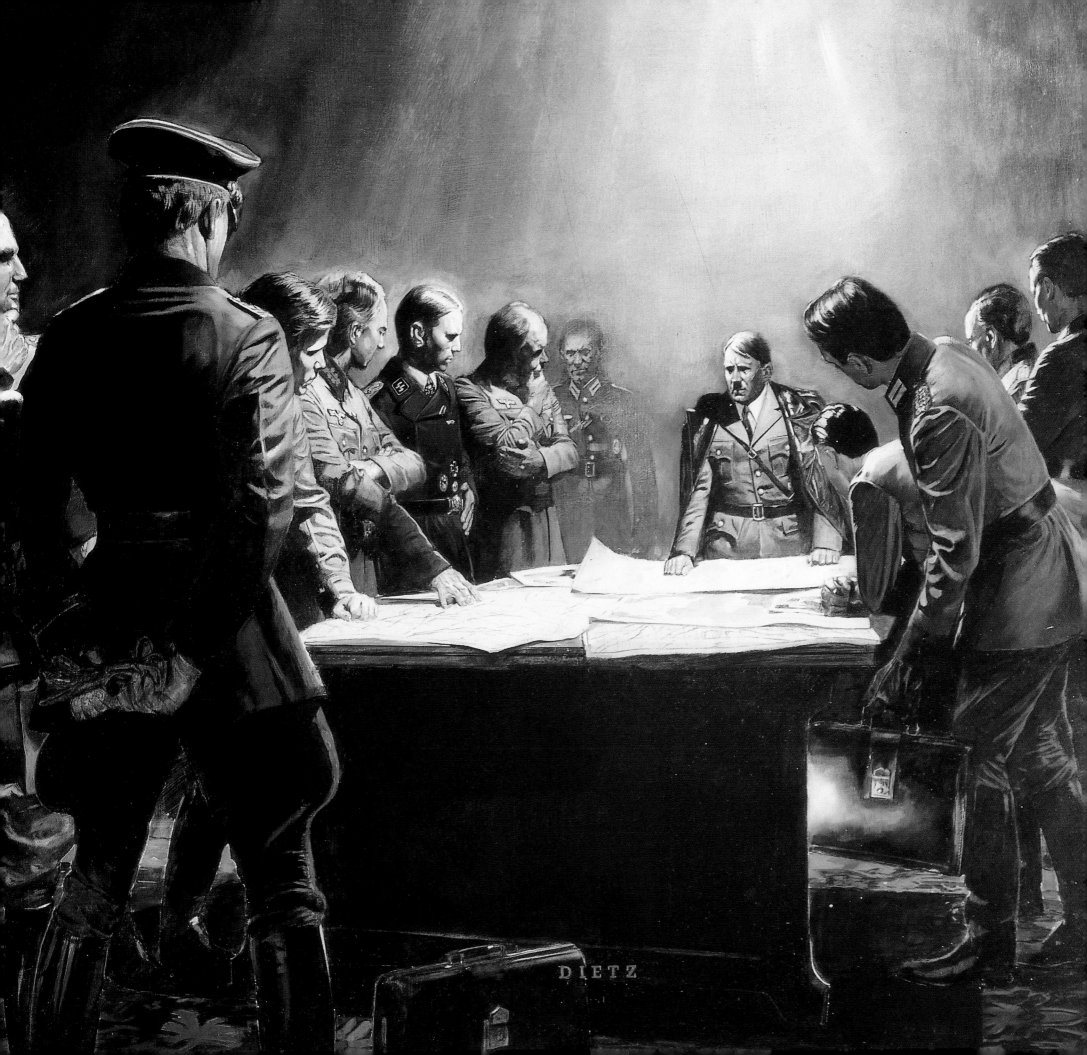

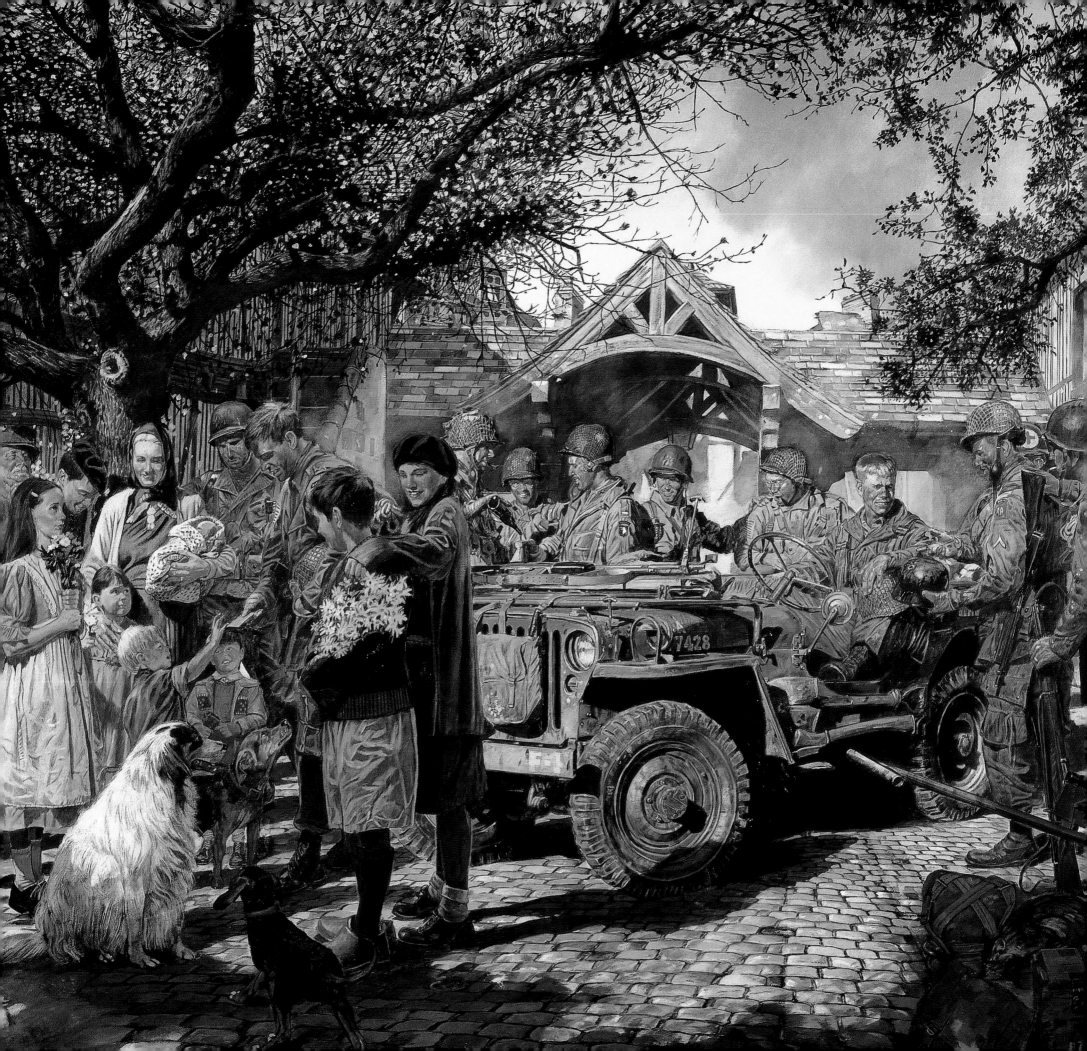

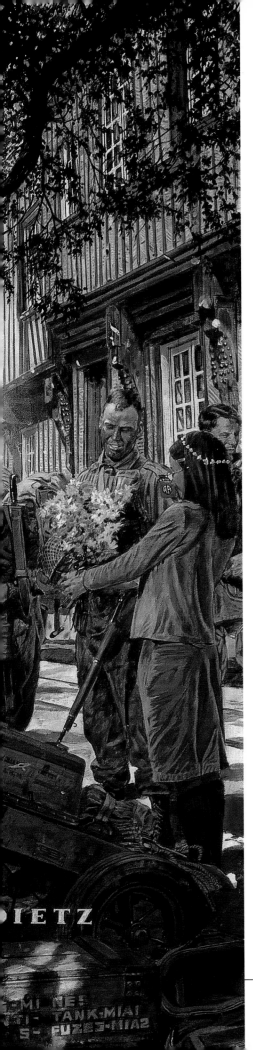

LE GRAND MOMENT

SOMEWHERE ON THE OUTSKIRTS OF CARENTAN, A mixed-force American infantry is surrounded and overwhelmed. In this painting, it is not *Fallschirmjaeger* or *Panzergrenadiers* they are fending off, but citizens who fervently hope they have seen the last of the German occupation. The scene was repeated countless times from country crossroads to the Champs Élysées. The implicit understanding was that whatever civilian tragedies accompanied the advance of the Allied armies, driving the occupying Wehrmacht out was worth the price. Who today can imagine the emotional release of liberation or its cost? Old soldiers always recall the response of the civilian population, whether it was an old man on the roadside with a jug of calvados or the cheering crowds of Paris or Rome. Even in a gutted village with freshly dug graves, people would turn out to celebrate the arrival of the American, Free French, or British troops.

The liberators in this painting arrive on the humblest but most recognizable vehicle of the war. Built in the hundreds of thousands, the jeep went everywhere that Americans and their Allies went. As the old saying put it, a jeep would take you anywhere you could walk back from. It certainly did more than was ever expected of it. Small enough to fit in a transport plane or glider, it was often the only vehicle available to airborne or special unit troops. In North Africa, it was heavily armed and laden for desert patrol, and in Holland, paratroops hung it with steel plates and used it as a makeshift scout car. The jeep evacuated wounded, hauled ammunition, and chauffeured generals. It lugged radios and laid hundreds of miles of telephone wire. Jeeps in British service pulled trains of light trailers. Yellow AAF jeeps guided aircraft across airfields. In a worldwide conflict, getting to the war at all was half the battle, and along with the C-47 and the Liberty ship, the jeep was a stalwart performer.

GUNS FROM HEAVEN

THE WESTERN ALLIES WERE CONFIDENT IN September 1944. They had liberated France and their armies were probing the German frontier. The Wehrmacht had been mauled during the summer and the commander of every Allied army was eager to stab into Germany. Dwight Eisenhower was one of the few who believed there was still some fight in the enemy, and he wanted to press forward on a wide front. His problem was logistics. His armies had outrun their supplies. They were on the threshold of Germany's last prepared defenses, but until the line of supply was secure, their headlong rush had ended.

Field Marshal Bernard Montgomery's plan for "ending the war by Christmas" promised to relieve two of Eisenhower's headaches. Montgomery's idea of dashing across southern Holland would send Allied forces around the flank of the Siegfried Line and cut off German defenders holding Belgian and Dutch ports. The advancing army might even overrun the bases for the V-2 rockets aimed at London. The entire scheme was so out of character with the methodical Montgomery's usual doctrine that it was bound to surprise the Germans.

The plan that became Operation Market Garden assigned three airborne divisions to capture a series of bridgeheads all the way to the Dutch town of Arnhem, on the Rhine River. The idea of using 35,000 airborne troops to open a narrow corridor to the far side of the Rhine was technically feasible, given the tremendous airlift capability of the 1st Allied Airborne Army, but it bordered on reckless. Each airborne division would have to fulfill all of its tasks, in sequence, if the armored forces were to reach the north German plains.

The two American divisions at Market Garden were responsible for the bridges leading to the Rhine. The 101st had to take crossings on the Wilhelmina Canal and the Zuid-Willems Canal and protect miles of the highway corridor. The 82nd was given the Mass River Bridge at Grave, the bridge over the Mass-Waal Canal, and two bridges over the wide Waal River at Nijmegan. The British 1st Airborne Division would drop around Arnhem itself and hold the Rhine crossing for the British 30th Corps coming up the road from Belgium. Above all, the armored forces punching through the line and fighting from captured bridge to captured bridge would have to be strong enough to win a battle at the end of the trip. If they couldn't continue across the open plain into Germany, the entire operation would be pointless.

The airlift plan was daunting and there were myriad ways it could go awry. The first day's airdrop would be heavily weighted toward the troops at the far end of the road. The British would be holding out the longest and would need the most equipment, so they had the lion's share of glider transport for antitank guns, ammunition, supplies, and light vehicles. The American 101st was closest to the front lines and therefore more likely to receive artillery and armor support from advancing British units. Planners gave it the lightest drop, with heavy equipment to come later. The 82nd had so many objectives that planners scheduled two glider formations in their assault, including one for the guns and jeeps of the 376th Parachute Field Artillery Battalion. The rest of the divisions' guns, their resupply, and any additional reinforcements would have to drop on the following days. The transport plan assumed that there would be suitable weather at the takeoff and drop-zone ends of the flight.

The biggest assumption of the Market Garden plan was that the German army was a spent force in Holland. Earlier in the summer, the Germans had begun their withdrawal from Holland, but reconsidered when the British advance ran out of gas on the Belgian frontier.

Allied intelligence had identified all kinds of second-string troops behind the Wehrmacht's tough but thin front line. These service battalions, transport companies, and recuperation and training units were not considered a match for an army of paratroopers. Air reconnaissance did show more German combat troops evacuating Belgium along the North Sea coast in the days leading up to the attack, and more vehicles than usual in Holland. News from the Dutch underground in September should have raised alarms when tanks were reported in the vicinity of Arnhem. The final decision to proceed was made on September 16, and the next day the parachutists and glider pilots were in the air. Waiting for them on the Rhine were the newly arrived troops of the 2nd SS Panzer Korps.

Hitler's war machine was capable of surprising rehabilitation, more so as the front moved closer to Germany. The Wehrmacht left most of its heavy equipment in France, but it was retreating toward its source of supply. The Germans lost hundreds of thousands of men as well, but the units that fought their way past the American and British columns were among their best. The 2nd SS Panzer Korps had been battered in France, but its 9th and 10th SS Panzer Divisions were coming back to form when they were ordered up the Rhine to finish their refit in Holland. Most importantly, they were led by veteran officers and NCOs who knew how to conduct a battle. If Allied planners identified these units or considered them a threat, they did not share the information with the commanders on the ground. The Germans attacked the road corridor many times during the battle with any troops they could muster, but most historians credit the two SS divisions near Arnhem with keeping the Allies out of northern Germany in 1944.

Market Garden became one of the operational dramas of the war. British paratroopers

nearly dropped on top of the German headquarters, and at first, the generals there assumed the attack was a huge commando raid. Some parachutists were mobbed by jubilant Dutch civilians, others jumped into German anti-aircraft fire. Some of the bridges were blown before the troops reached them; others stayed intact through days of fighting. Fog kept reinforcements on the ground in England, while skies were clear in Holland. Engineers repaired spans and threw together alternate crossings, while every day the Germans tried to cut the road link. Through it all, the paratroopers of the British 1st Airborne Division, later joined by the Polish Brigade, held out at the end of the road, waiting for the armor to arrive. It never did, and in the dark of night on September 25, the last British paratroopers escaped from Arnhem. It would be late March 1945 before Montgomery crossed the Rhine.

The British and Poles lost more than 8,000 men, dead, wounded, and captured around Arnhem. The two American airborne divisions suffered less than half that many casualties, but for them, Market Garden was a bittersweet success: they accomplished their difficult missions with great daring, but in a lost cause.

Guns from Heaven was commissioned by the 319th Parachute Field Artillery Association to commemorate the four American airborne artillery battalions in Holland: the 319th, 320th, 376th, and 456th.

■

MAKING IT HAPPEN

The seizure of the bridge over the Maas River at Grave was a textbook small-unit action. That was not how the mission plan had been written, but when Lieutenant John Thompson and one stick of fourteen men from the 508th PIR came down a little more than a half-mile (0.8km) from their battalion objective, they made the best of a good thing. Most of E Company, the designated assault group, dropped on the wrong side of Grave and had to fight its way past the town. Thompson, who could clearly see Germans running back and forth on the span, decided to lead his lone squad along drainage ditches and canals towards the bridge. Although under fire from various positions, they were able to ambush trucks bringing reinforcements up the road. They used a bazooka to knock out a machine-gun team in a concrete tower on their end of the span and rushed the bridge. Firing at the north end of the span with their newly captured machine gun, they stopped all traffic out of Grave. Before long, a patrol of paratroopers was sighted on the north side of the Maas, and the bridge was quickly in American hands.

Thompson's attack was a classic example of how a small unit can gain total local superiority, and is a victory that the 82nd Airborne still honors. The original of this painting hangs in the 82nd Airborne Museum, at Fort Bragg.

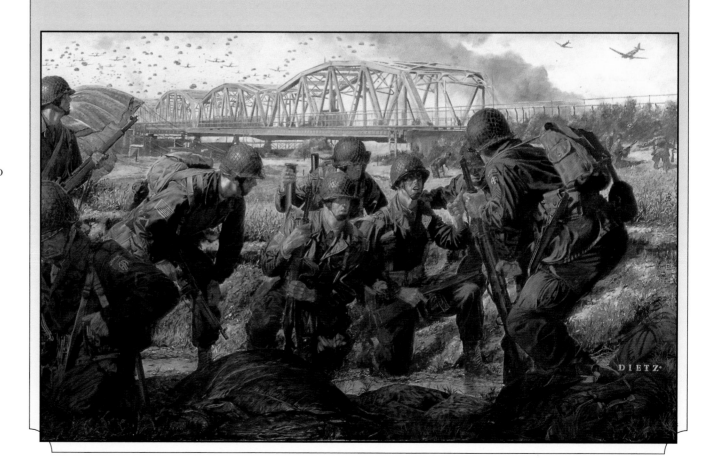

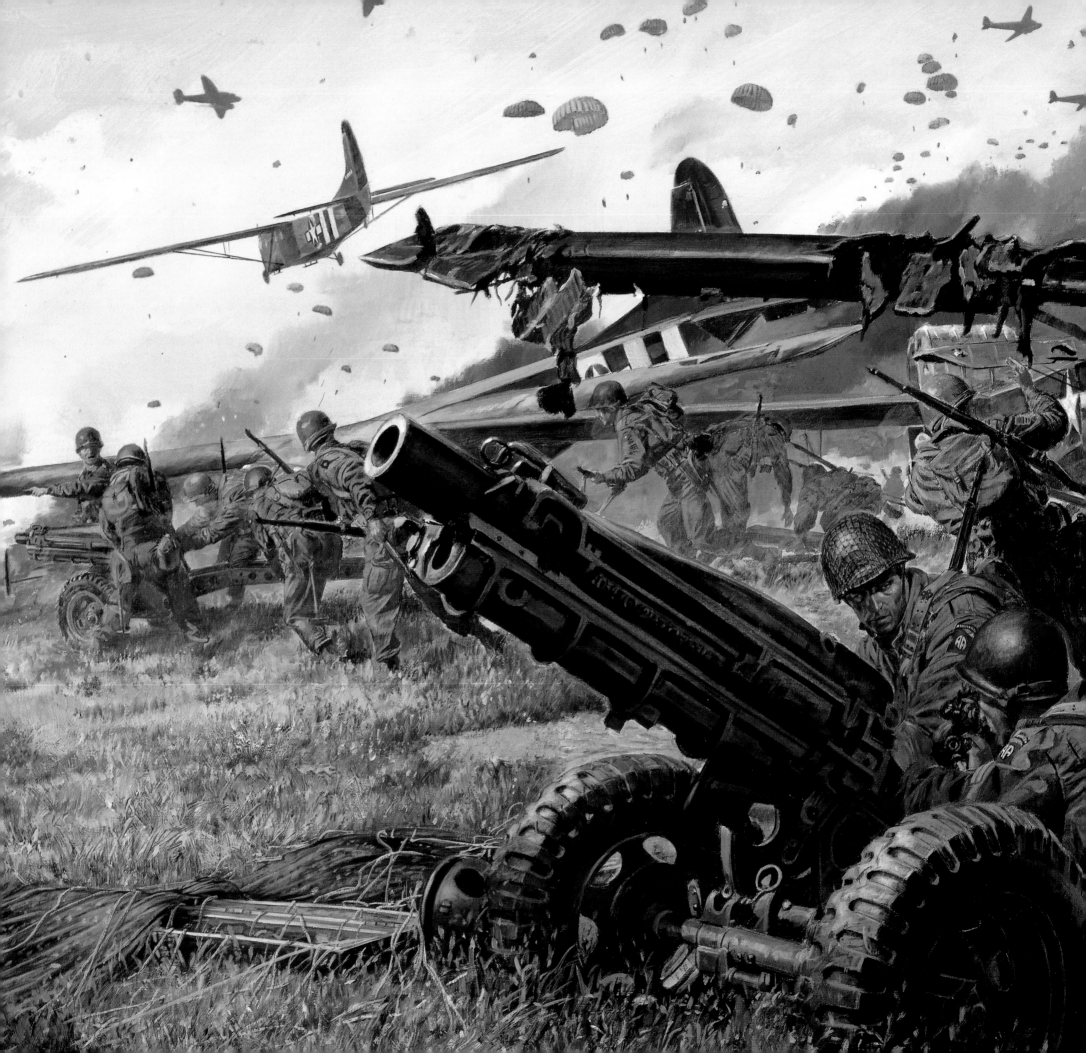

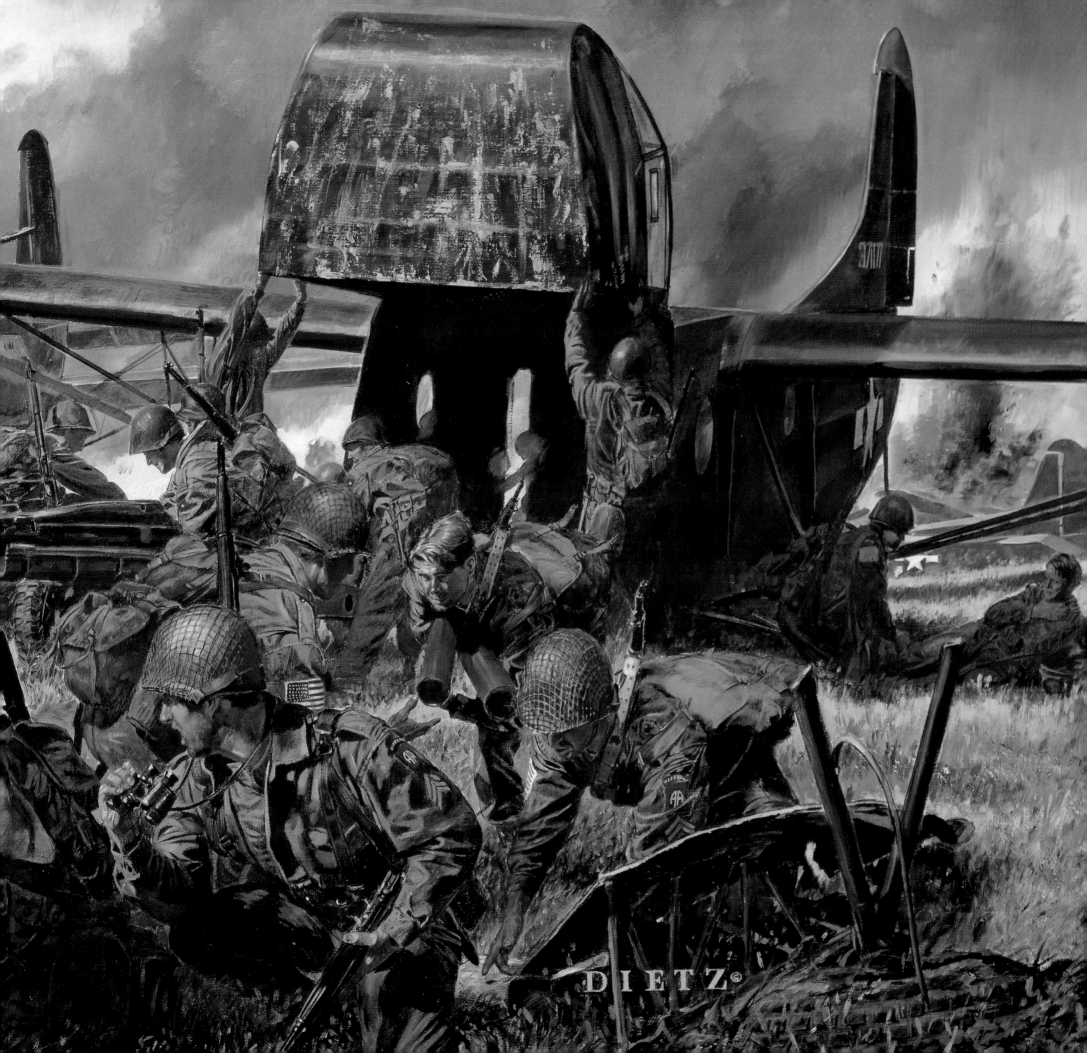

DIETZ©

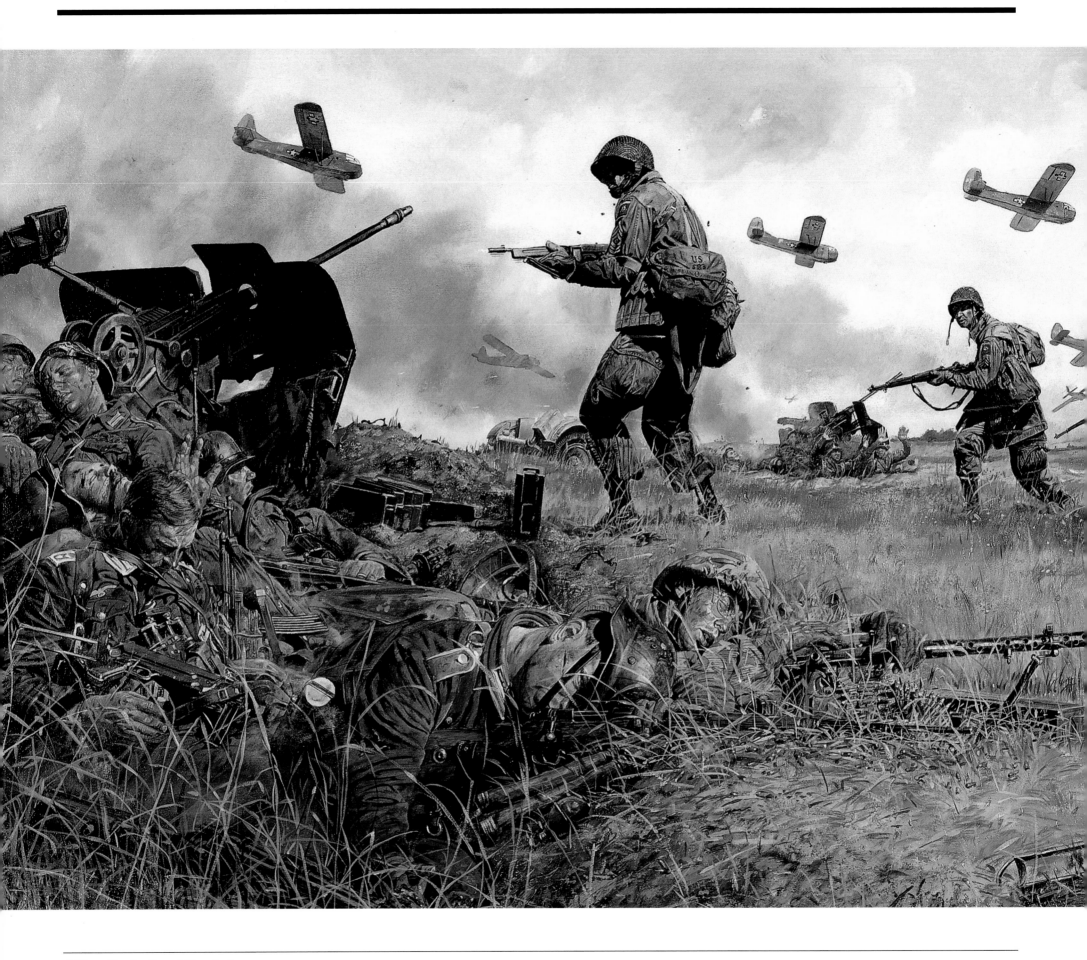

WRATH OF THE RED DEVILS

THE FAMOUS CBS CORRESPONDENT EDWARD R. Murrow rode along in the transport stream for Operation Market Garden. Looking out at the massed transports in tight formation over Holland, at the escorts above, and at the fighter-bombers attacking German positions below, he told his radio audience, "This is the real meaning of air power."

In September 1944, the Allied air forces no longer had to sneak parachute troops in by night. Complete control of the air meant that the airborne units arrived en masse, on target. Of course, what they would find once they landed was another matter.

The Red Devils of the 508th Parachute Infantry Regiment of the 82nd Airborne dropped on the Groesbeek Heights, its battalions spread between the town of Nijmegen (and its vital bridges) and the Reichswald Forest just across the German border. The regiment had a three-fold mission: take the bridges, prevent a counter-attack from German territory, and keep the heights secure for a massive glider reinforcement. For the 508th, the battle turned into a three-day scramble to stay ahead of German countermoves. Patrols confirmed that the forest was free of surprises, but as para-troopers approached the Waal

River Bridge on the evening of September 17, they ran into advance elements of the 10th SS Panzer Division. A confusing night fight ensued. More troops were added to the bridge attack at daylight, only to find anti-aircraft units of the 9th SS Panzer Division barring their way. Then word came that German forces had attacked on the heights with heavy automatic weapons and were overrunning the landing zone (LZ). General James Gavin, commanding the 82nd, immediately turned the bridge attackers around and countermarched to the LZ.

"C" Company of the 508th found more than a dozen German 20mm anti-aircraft guns and supporting infantry already set up when they reached the landing zone. Paratroopers of "B" and "C" companies charged the flak battery at a run, across the open ground. The hastily assembled German force wavered in the face of this obvious madness, then their infantry broke and ran, followed by some of the gunners. The first of hundreds of gliders were already landing as the last of the anti-aircraft positions were taken.

■

BELOW: This sketch is a preliminary study for a painting of the afternoon glider reinforcement of the American airborne divisions on D-Day. Glider assaults were a defining event of World War II. In postwar years, bigger transport planes and helicopters eliminated the need for gliders to bring in equipment and troops.

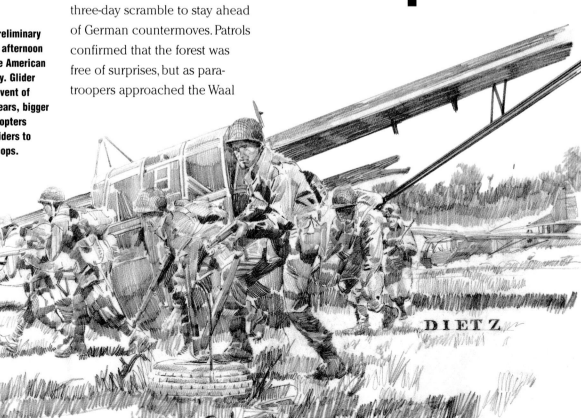

DECISIVE POINT

THE BROAD WAAL RIVER AT NIJMEGEN WAS THE last natural obstacle on the road to the Dutch town of Arnhem. The highway and railroad bridges in Nijmegen had to be taken if Operation Market Garden was to succeed. The capture of these structures was the responsibility of the 82nd Airborne Division.

The 82nd narrowly lost the race to the Waal bridges on the night of September 17, and attackers found heavy guns barring their way the next day. Acting on the advice of the local Resistance, a patrol of the 508th Parachute Infantry Regiment located and disabled the presumed demolition controls for the bridges. Then the glider-landing fields came under attack; taking the bridges would have to wait until British forces arrived with heavy weapons and assault boats. Soldiers of the 10th SS Panzer Division spent September 18 reinforcing the defenses on the southern approaches to the bridges and an adjacent park. The next day, their dug-in antitank and machine guns beat back an attack by the 505th PIR and the Grenadier Guards.

Canvas-and-frame assault boats finally arrived on the afternoon of September 20, and H and I companies of the 504th PIR were quickly sent across the Waal. The shifting wind blew away their protective smoke screen midstream, and they came under heavy fire. Paratroopers pressed on, splashed ashore, and rushed the trenches at the top of the dyke, supported by tank fire from the Irish Guards. The surviving boats went back for more men. By 1900 the advancing paratroopers had taken the north sides of both bridges. The Grenadier Guards and men of the 82nd stormed the southern defenses. The lead British tanks were hit, but others physically knocked aside the German guns and raced the paratroopers across the river. The last bridge on the way to Arnhem was taken.

■

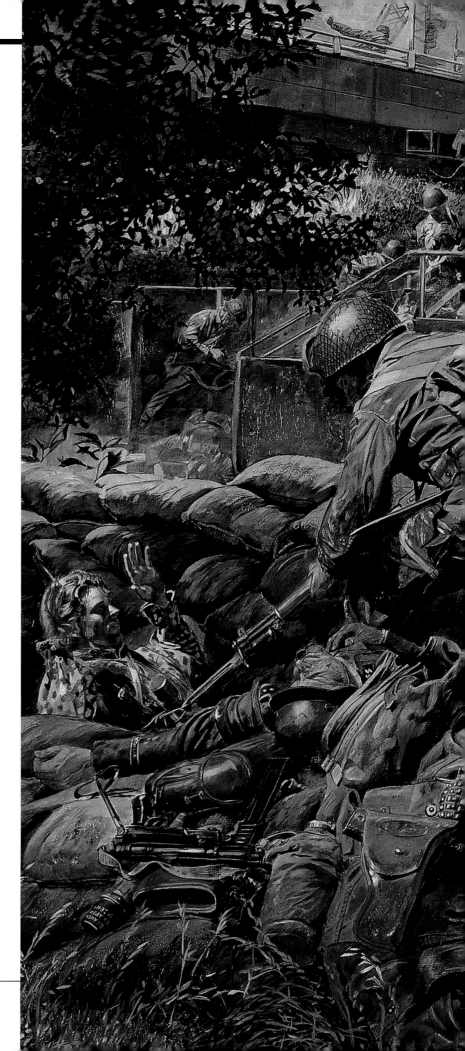

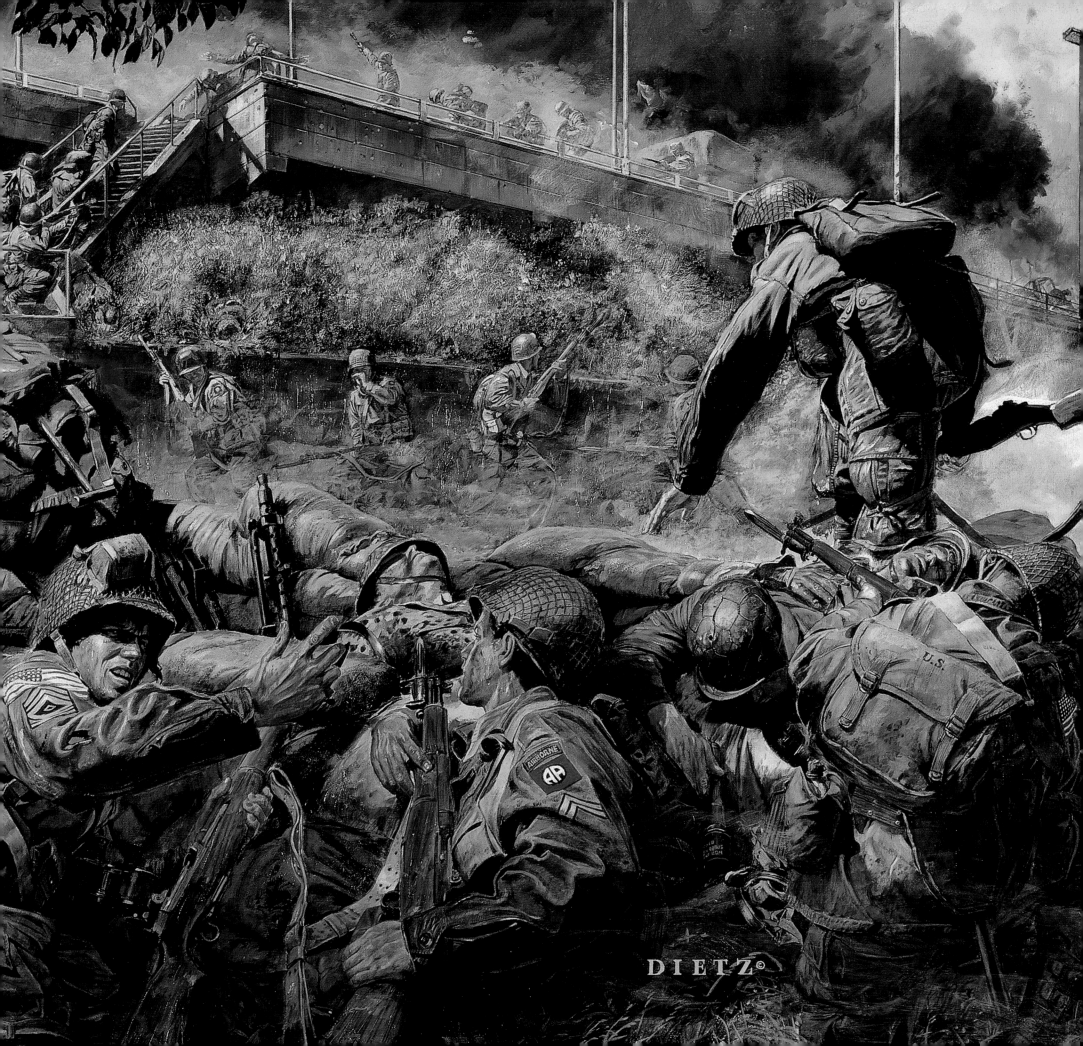

BATTLE FOR LEYTE GULF

THE BATTLE FOR LEYTE GULF WAS THE LARGEST naval engagement in history. The massive striking force of the American Pacific fleet, from PT boats to attack carriers, met virtually every remaining combatant of the Japanese Imperial Navy. The prize for the Japanese was the invasion armada off Leyte. For the Americans, it was the chance to destroy the enemy's remaining naval forces. Neither side imagined that the battle would turn on a chance meeting between a

small group of baby flattops and the largest ships of the Japanese Imperial Navy.

Japanese plans were characteristically complicated, with four major task forces approaching the invasion fleet from three directions. Two of these groups were wiped out, and one lured the most powerful U.S. Navy units away from the scene. The fourth, which had suffered heavy air attack the previous day, arrived north of Leyte Gulf at dawn on October 25. That force consisted

of four battleships (including the world's largest), six cruisers, and eleven destroyers, all commanded by Admiral Takeo Kurita. Before him, maneuvering off the coast of Samar, was an invasion support group of six U.S. escort carriers, three destroyers, and four destroyer escorts, commanded by Rear Admiral Clifton Sprague. It represented half of the total screen between Kurita's battleships and the U.S. invasion fleet. The Japanese began firing around 0700 at a

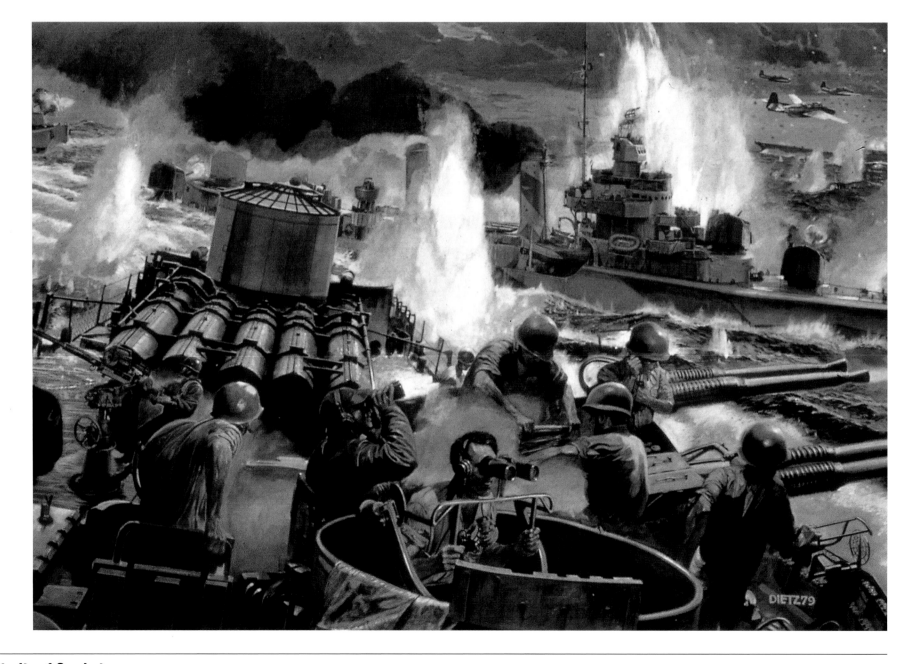

range of seventeen miles (27.2km). They quickly ran down the slow carrier group and began scoring hits on the U.S. ships.

Sprague launched every available plane, regardless of weapons load, to annoy the attackers, but the hopeless task of defense fell to the escorts. They made smoke to screen the task group, then attacked. First, the destroyers charged at the Japanese battleships and cruisers, then the slower destroyer escorts came out of the smoke. After launching torpedoes, the escorts engaged their huge targets in lopsided gunnery duels. They were mice among the elephants, but their torpedoes broke up the enemy's formations and their gunfire distracted the Japanese commanders.

Three of the little ships escaped the storm of shells almost untouched, two were badly smashed, and three, the *Hoel, Johnstone,* and *Samuel B. Roberts,* were pounded into wreckage; the last of these three sank at 1010. By that time, though, Kurita had had enough. He turned the last effective Japanese formation of the Pacific war around and fled. The vaunted "climactic battle" that the Imperial Navy had always sought with the U.S. fleet had been ended by Wildcats and Avengers scrambled from baby flattops and by seven little escorts whose total tonnage matched just one of Kurita's battleships.

There was a sinister consequence to the U.S. victory at Leyte Gulf. With Japan's surface forces thwarted, her pilots began a new phase of the war. Organized kamikaze units appeared at Leyte. Within an hour of Kurita's parting shots, suicide planes crashed into two of Sprague's surviving flattops, and just to the south of the Samar battle, two escort carriers in another support group were also struck by kamikazes. From that point forward, the most dangerous weapon a surface fleet had ever faced was deployed against the U.S. Navy at every stop on the way to Japan.

■

THE JAPANESE FLEET

The Imperial Japanese Navy may have been the most capable naval force in the world in the days before Pearl Harbor. The IJN had modern cruisers and aircraft carriers, huge battleships, long-range submarines, and superb carrier and land-based naval air arms. Despite these material advantages and the benefit of a first-strike strategy, the Japanese Navy had ceased to exist as a military force within three and a half years after Pearl Harbor.

The grim determinants of gross national product explain much of the Japanese decline. The United States had ten times the war-making potential of Japan. America built ships and planes, and deployed trained manpower at rates that most Japanese admirals could barely imagine.

A conqueror's hubris also sped the destruction of the IJN. Trusting that no foe would dare attack, the Japanese had meager plans for keeping their island nation supplied with the necessities of industrial life in times of serious naval combat. Control of the sea lanes was not in the Imperial task book. Japan built one-sixth as many anti-submarine escorts as the United States, and one-eighth as many merchant hulls. The result was a nation starved by submarines and an immobilized fleet. The strategy for keeping the fleet in fuel oil was to station much of it near the oil resources of the Dutch East Indies. Admiral Isoruko Yamamoto accurately predicted that the IJN would have roughly six months, no more, to run wild in the Pacific. He did not survive to see just how prophetic his words were.

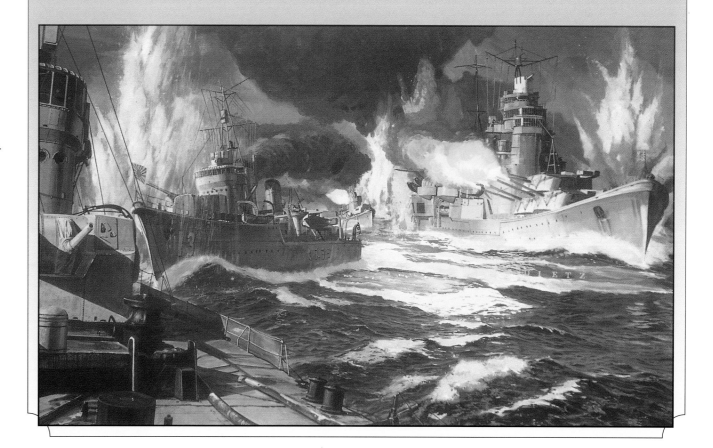

DESPERATE JOURNEY

COLONEL JAMES GUNN, ACTING COMMANDER OF THE 454th Bomb Group, was shot down over the Ploesti oil installations of Romania, on August 17, 1944. Colonel Gunn bailed out of his B-24 and landed in one of those imbroglios for which the Balkans are famous. Romania was in the process of changing hands, and most of the American Army Air Force POWs in the country were caught between the retreating Germans and the advancing Russians. The Romanian royal family, the War Ministry, and the Romanian Air Force all wanted to make quick and friendly contact with the American forces in Italy before their would-be Soviet "allies" arrived. The American prisoners—who were now largely guarding themselves against a starving populace—needed food, medical supplies, and a way out of Romania. A daring flight by Colonel Gunn and Romania's leading fighter pilot, Captain Constantine Cantacuzino, who was related to the Romanian royal family, would provide the solution to these problems.

Ten days after being shot down, Colonel Gunn stuffed himself into the radio compartment of Cantacuzino's specially marked Me 109-G. Wearing a fleece jacket and the remains of his high-altitude underwear, Gunn counted off the minutes as the German-built plane droned across the dangerous skies of Eastern Europe toward an uncertain reception in Italy. Once back at his own air base at San Giovanni, the colonel was instrumental in organizing the supply airlift and air evacuation of the American POWs in Romania.

Desperate Journey was commissioned by Colonel Gunn's son, and the artist tried to make it the emotional opposite of *Maximum Effort.* Bright summer sun, relieved faces, a curious crowd, and a Romanian ace happy to have survived a difficult mission lend the painting a festive air.

■

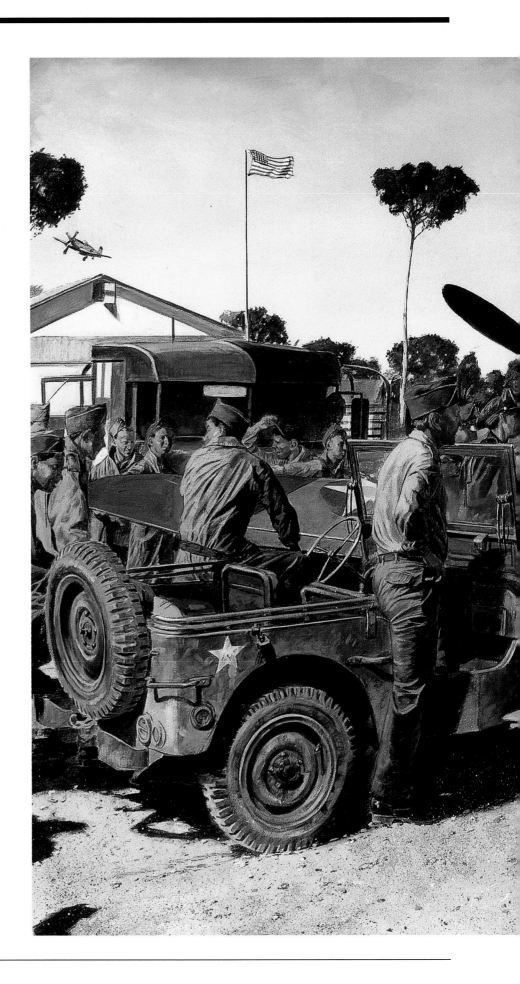

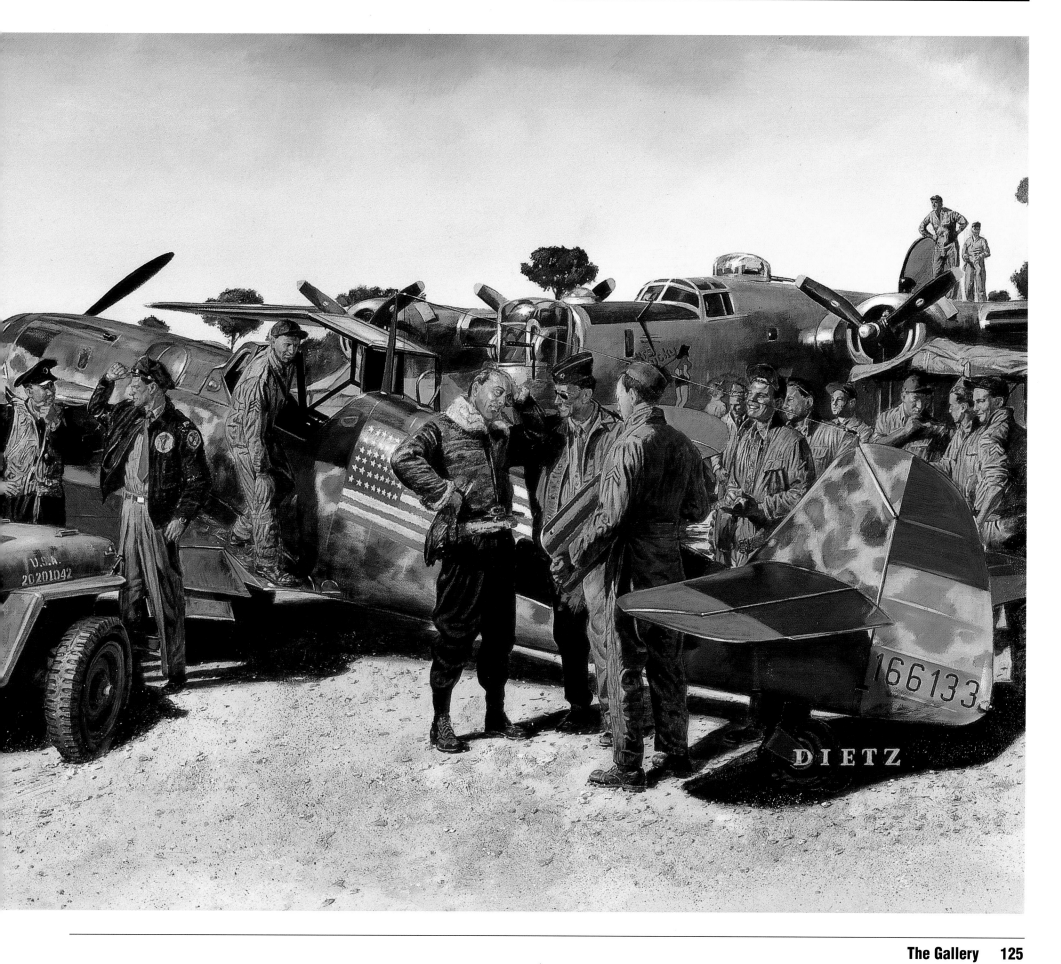

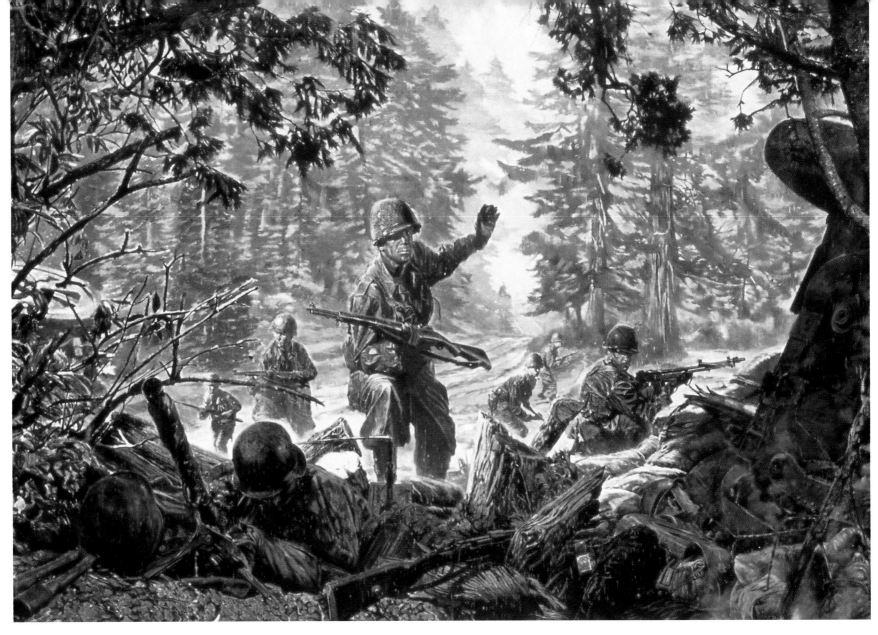

HÜRTGEN FOREST

FIGHTING IN THE HÜRTGEN FOREST WAS AS CLOSE to jungle warfare as U.S. troops in Europe could get. It may be hard to relate this snowy scene painted for the 1st Division Association to the fetid swamps of the South Pacific, but the tactical situation was the same. The American formations that entered the darkness of the Hürtgen were soon broken down into isolated company, platoon, and finally squad levels. Fog, mist, and snow combined with dense foliage to negate the importance of Allied air superiority. The trees made artillery and mortar spotting difficult, and shells bursting in the high branches were more dangerous to the attackers than to dug-in defenders. Line-of-sight shooting became the rule, but the scarcity of roads through the forest made it difficult to bring up the guns. The fight for the forest became a small-unit action that engulfed eight separate U.S. divisions.

The Americans probed into the woods in mid-September. The fortified forest was perfect ground for defense, but once sucked into a fight, the U.S. commanders were unable to disengage without the impression of defeat. The battle went on, week after week, and devoured regiments that had fought all the way from the Normandy beaches. Rain and mud gave way to snow and mud. Trench foot and frostbite were added to the deadly miseries of the frontline units. Losses were equally staggering for veteran divisions and green units just in from the States, but the replacement depots kept sending new men forward to fill the ranks.

It was early December before the Americans reached the eastern edge of the woods. They had suffered more than five hundred casualties for each square mile ($2.6km^2$) of the forest. In a cruel twist of fate, some badly battered units from the Hürtgen were sent south to a sleepy sector of the Belgian Ardennes to rehabilitate and reequip in relative peace.

■

HOLD TO THE LAST ROUND

THE GERMAN OFFENSIVE IN THE ARDENNES MARKED the only instance in World War II when an American command endured the sustained fury of an army-sized mechanized offensive. On December 16, four U.S. divisions and ancillary formations received the direct assault of a dozen Wehrmacht divisions, with a further eight in immediate reserve. The blow fell on two green units fresh from the States, the 99th and 106th Infantry Divisions, and two that were resting and rebuilding after the Hürtgen Forest battles, the 28th and 4th. The 106th and 28th were directly in the path of two Panzer corps, and for them the question was not if, but where and how quickly they would succumb.

The American divisions were arrayed in a thin line between the frontier and important road junctions that channeled traffic out to the Belgian interior. The 106th was actually on the German side of the border, in the Schnee Eifel hills. They were all placeholders, filling a sleepy section of the line and looking forward to a white Christmas. Some units reported unusual activity across the front, but for most, the surprise of the German attack was complete. German infantry fought ferociously to open the

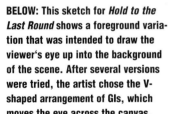

BELOW: This sketch for *Hold to the Last Round* shows a foreground variation that was intended to draw the viewer's eye up into the background of the scene. After several versions were tried, the artist chose the V-shaped arrangement of GIs, which moves the eye across the canvas.

way for the tanks on the first day, and each American withdrawal or defeat brought the Panzers closer to breakout. The appearance of German mechanized forces in the rear areas of the line battalions spread panic among many supporting units, rending the fabric of divisional command and control. Roads filled with traffic streaming away from the battle even as the first American reinforcements were attempting to march toward the fight. Convoys in either direction were liable to be cut off and wiped out by advancing German tanks. Some rear echelon commanders refused to believe there was really a battle underway at all, but on the front lines, there was no doubt about it.

Regiments were reduced to separate pockets of resistance surrounded by a tide of German armor and infantry. In many cases, the self-sacrifice of company and platoon-size units held up the attacking juggernaut for crucial hours, causing traffic jams on the attackers' road net as tangled as those on the defenders'. A stubborn engineer unit at a bridge or well-placed antitank guns covering a village intersection would stop the advance, forcing German units to regroup and organize clearing attacks. In the north, the 99th held up the 1st SS Panzer Korps for one vital day. The 106th had two regiments

completely engulfed, and the third was barely holding the road junction at St. Vith when the first help arrived.

The infantry regiments of the veteran 28th Division occupied the road net leading to the town of Bastogne. Commanded by the fiery "Dutch" Cota, the soldiers of the 28th had orders to hold at all costs. Right on the German border, the 110th Infantry Regiment, a Pennsylvania National Guard unit, occupied the valley town of Clervaux and the villages around it, Hosingen, Holzthum, Heinerscheid, Merscheid, Weiler, and Consthum. They were assaulted by elements of three divisions of the 47th Panzer Korps. The regimental commander, Colonel Hurley Fuller, stood his ground until a German tank pulled up outside his window. *Panzergrenadiers* filled the lower floors of the HQ as he led the last of his staff out an upper window. Fighting in Clervaux did not end until the morning of December 18, when the last small groups of Americans started through the woods for the next line of resistance. The 110th had purchased one day for the rest of the Army. Farther west, the success of roadblocks and strong points on the way to Bastogne would be measured in hours.

Hold to the Last Round honors the 110th and its attached engineers. It depicts the fight in the village of Hosingen, where the surrounded Keystoners held the road until there were, in fact, no more bullets to be fired.

■

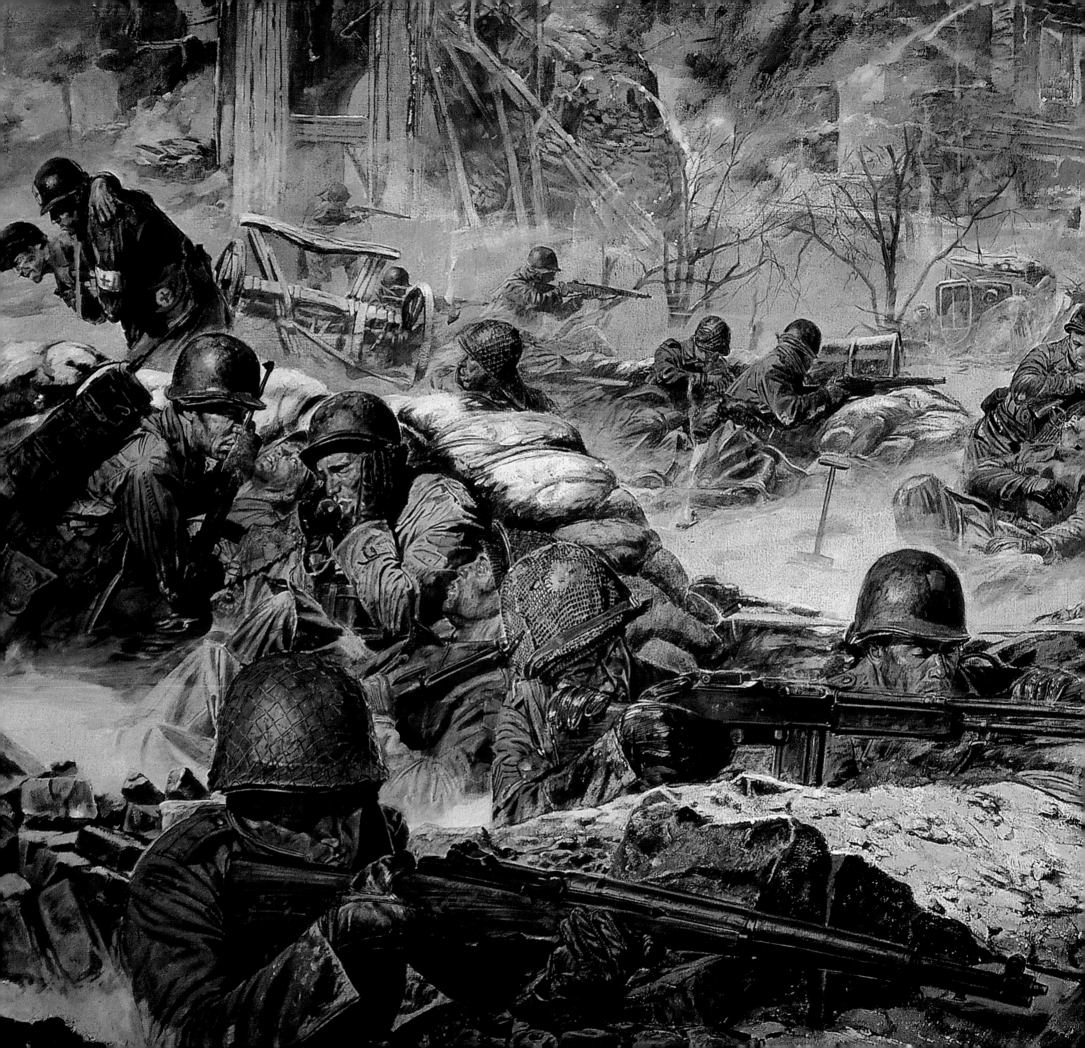

PATTON AT THE BULGE

IN LATE NOVEMBER 1944, HUGE ALLIED FORMATIONS were arrayed on the borders of Germany, ready to drive into the Fatherland. The 9th and 1st armies were preparing to encircle the Ruhr, and the 3rd was poised for a December 19 attack through the Saar. There was, however, some troubling intelligence regarding their supposedly vanquished enemy. During a December 9 staff meeting at George Patton's 3rd Army HQ, Colonel Oscar Koch pointed out that a number of SS Panzer, Panzer, and Panzer Grenadier units had been identified just to the north of the 3rd Army front. If his intelligence analysis was correct, the Wehrmacht had at least a three-to-one advantage over the American VIII Corps in the Ardennes.

Patton was focused on the upcoming drive on Germany, but he recognized the possibility of a spoiling attack. He ordered his staff to draw up contingency plans for a flank defense and possible counterattack to the north, "just in case." The hammer fell in the Ardennes one week after that meeting, and less than seventy-two hours after the opening German barrage, almost an entire corps of the 3rd Army was pivoting to the north. The unfolding drama of bold German successes and a stubborn American defense pushed Patton and his army into the limelight. His 4th Armored Division would famously relieve the encircled defenders of Bastogne.

Allies and Germans alike were amazed by the speed of Patton's riposte. The 3rd Army's swift attack to the north was an example of diligent staff work combined with mechanized mobility, and above all tremendous esprit de corps. Patton was subsequently stunned when he was not ordered northward from Bastogne, to cut the entire Bulge off from the German border. Armchair strategists still debate that decision nearly sixty years later.

■

PATTON TAKES CHARGE

Dwight Eisenhower gave command of his II Corps to George S. Patton after the debacle at Kasserine Pass. He charged Patton with restoring American prestige and the U.S. Army's self-confidence. Well aware of Patton's belief in leading from the front, Ike reminded him that "I want you as a corps commander, not as a casualty."

An old-school cavalry officer, Patton believed in the hardest blow, the fastest move, the most daring objectives. His devotees point out that because II Corps was held on a short leash in Tunisia, a chance to cut off most of Rommel's retreating Afrika Korps was lost. They credit his Nelsonian disregard of official plans with shortening the Sicilian campaign. His orders were countermanded during the breakout from Normandy, arguably at the cost of a swift capture of Brest with all of the logistical implications that huge port could have had for the European theater. His 3rd Army swept across France in an offensive that was the equal of any attack, by any army, on any front of the war. Patton's admirers always point out that his 3rd Army was closest to the heart of Germany, with inconsequential forces before it, when its commander was reigned in. No one knows how different things might have been in December 1944 with Patton's Armored divisions on the central German plains, but his admirers maintain that the situation could not have gotten worse.

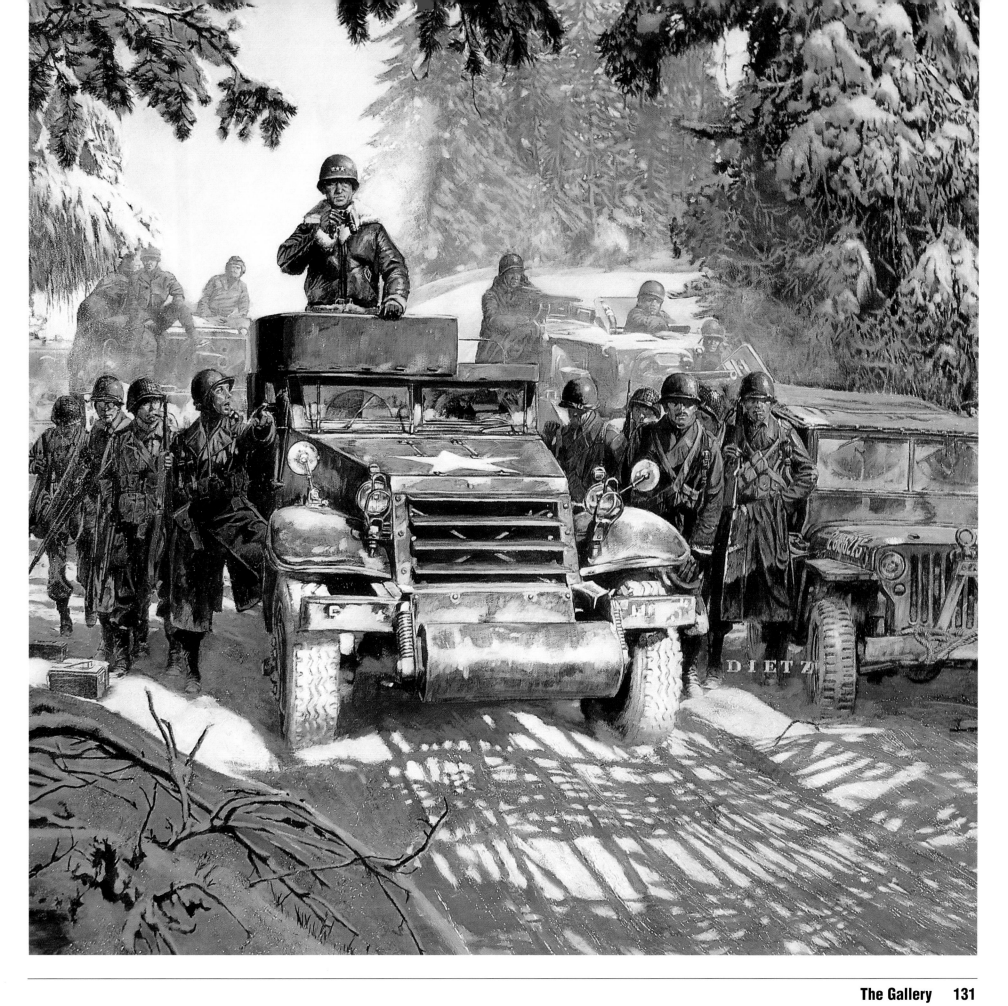

STOPPED COLD

THE ALLIED GROUND FORCES WERE FULLY COMMITTED in early December 1944. The only divisions available in Dwight Eisenhower's strategic reserve were the 82nd Airborne and the 101st Airborne, both reequipping in France after their hard campaign in Holland. These soldiers were experienced, competent, and justifiably confident that they could beat anyone Hitler had in uniform. They were the perfect troops to throw into the path of the onrushing, victory-flushed German army.

The first units of the 101st rolled into the key junction town of Bastogne on December 18, under the command of the divisional artillery officer, Brigadier General Anthony McAuliffe. They joined elements of the 10th Armored Division and whatever intact units could be extracted from the stream of retreating traffic. German Panzer forces could be heard battering roadblocks just to the east. The entire 101st was in Bastogne by December 20, along with the 705th Tank Destroyer Battalion. Then the onrushing 47th Panzer Korps cut the last road to the

west and the Allied defenders of Bastogne were surrounded.

Stopped Cold treats the most dangerous breakthrough made by the Germans during the encirclement of Bastogne. On Christmas Day, a force of German Mk IV tanks broke through from the west and advanced across snowy fields to the edge of town. There, they confronted tank destroyers of the 705th as well as the guns of the 321st Glider Field Artillery Battalion, firing 105mm field pieces over open sights.

The painting was commissioned by the military descendants of the 101st Airborne's artillery unit. They wanted to honor the GIs, feature the unusual field pieces, and show the action. The artist has played some tricks with perspective and point of view to prevent the foreground figures from obscuring the battery area, while still keeping the targets within the frame of the painting.

■

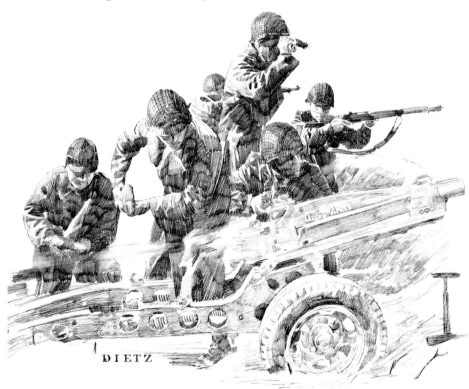

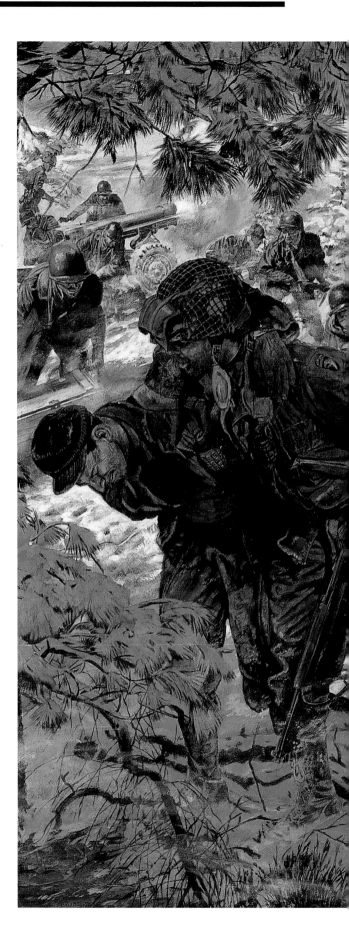

LEFT: This preliminary detail sketch for *Stopped Cold* was based on the "standard" 75mm airborne artillery piece. Research revealed that the 321st was equipped with the relatively rare lightweight 105mm howitzers. This 105 is so unusual that many viewers think the right field pieces in the finished painting look all wrong.

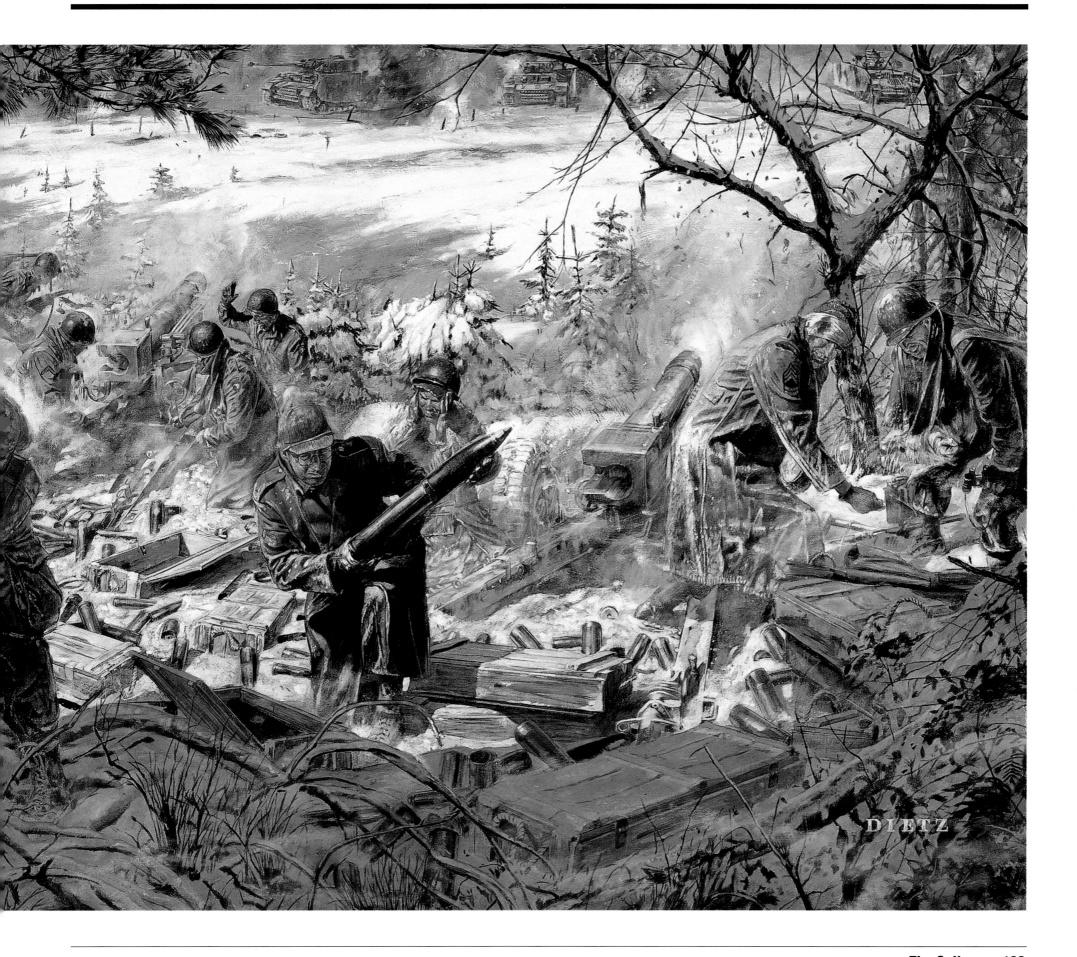

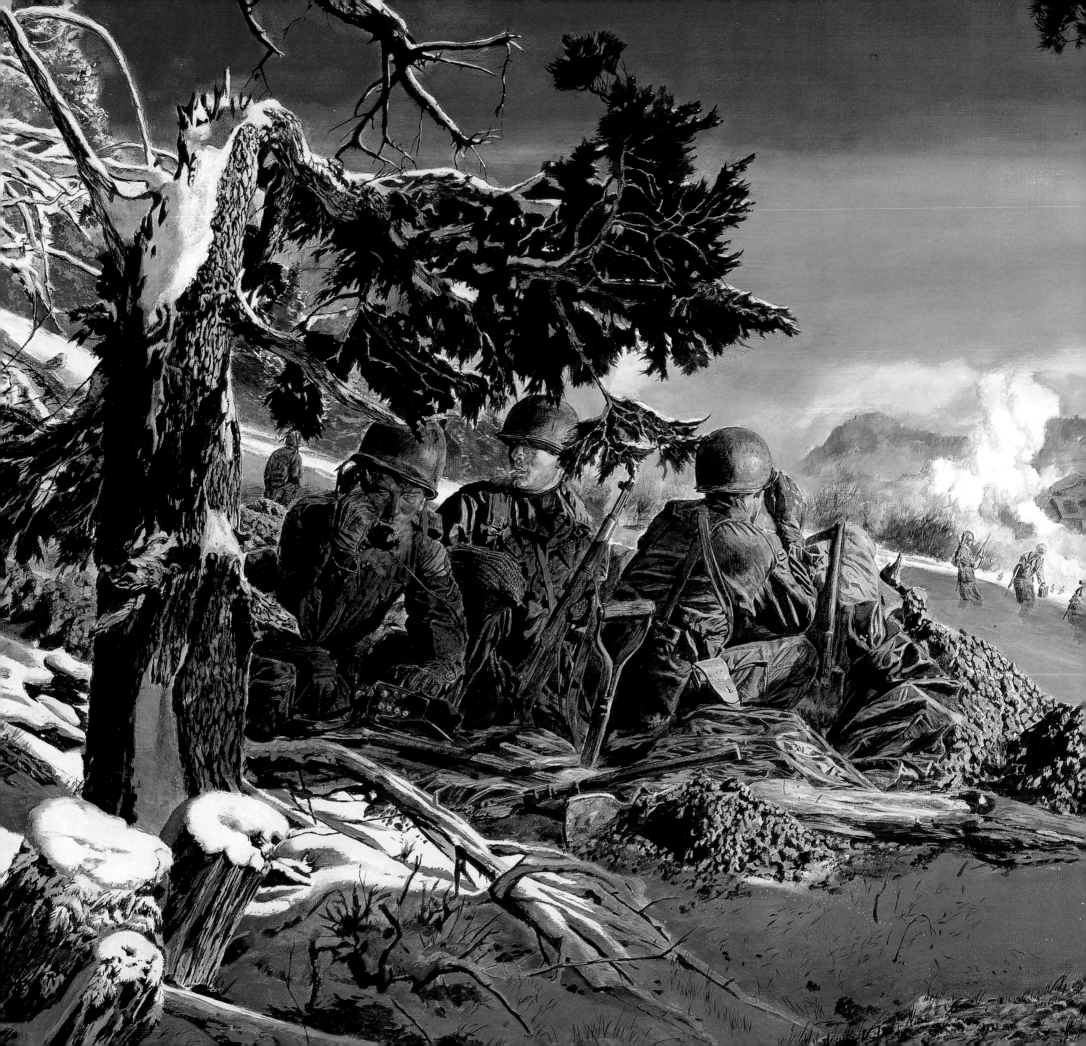

ARTILLERY OBSERVER

SUCCESSFUL FORWARD ARTILLERY-SPOTTING ENTAILED finding a clear view of the enemy, while staying out of sight. That was easy for the Germans in Italy, where ample preparation time and local labor provided comfortable camouflaged positions from which to watch the valleys below. In the hedgerow country of Normandy, two men in a church steeple with a field telephone and a pair of binoculars could control considerable expanses.

Things were not so simple in the Ardennes. The hilly forested border country was cut with river valleys in which entire regiments could be hidden, and winter weather grounded both attack and spotter planes during much of the Bulge campaign. Making the most of the Allies' predominance in artillery required men up front to call the "fall of shot."

This painting shows observers of Patton's 3rd Army supporting a river crossing on the southern shoulder of the Bulge. The attack across the Sauer River began when engineers slid bridge pontoons down to the river under cover of darkness. The infantry pushed off under a light morning mist. The Germans in the town of Diekirch saw the artillery spotters and sprayed them with machine-gun fire. The spotters called in smoke shells to hide the crossing, and high explosives to punish the defenders.

Years later, the young officer depicted here was asked about the long battle in the Ardennes. After a brief moment of thought, he recalled his most enduring impression. "The only good thing about that winter was the cold. You didn't have to smell the dead all around you."

■

SILVER WINGS

THE ITEMS PICTURED IN *SILVER WINGS* WERE THE things that small boys of James Dietz's generation dreamed of. Now they are precious artifacts hoarded by collectors or donated to museums. At one time, the memorabilia of World War II was everywhere, as were the veterans themselves. College professors and bus drivers, mailmen and machinists all seemed to have stories from the early 1940s. The baseball coach would never talk about Omaha Beach, but the mechanic on the corner could gab all day about tank repair. Small boys' fathers deferred to the men who smoked cigarettes held in hooks or skied on one leg.

Early in his career, James Dietz worked with an art director named Al Isaacs. Al had been a B-24 pilot with the 15th Air Force. He flew Ploesti missions, Budapest missions, and Vienna missions. He checked out new pilots when they transferred into the group. The memorabilia in *Silver Wings* all belongs to Al. His good luck .45 round is still in the pocket of the A2 jacket, as is the bit of flak that came through the fuselage and the pilot's seat to earn him a Purple Heart. Al painted the nose art on his B-24, *Racy Tomato*, and when the war ended he was ready to get out of uniform, get back to real life, and get into college to study art.

James Dietz painted *Silver Wings* as a tribute to the man who flew combat missions over Eastern Europe and taught him how to get an overnight freelance job out on schedule. It is also a tribute the refinery-accountant rifleman, the clothier flight instructor, the plumber Seabee, and his best friend's dad, who manned a coastal artillery battery at Golden Gate Park. They all lived in the neighborhood—any neighborhood, really. They filled the U.S. Senate and the firehouse, they were elected president of the United States, and they ran Boy Scout troops. And they all had some immensely valuable experience to pass on.

■

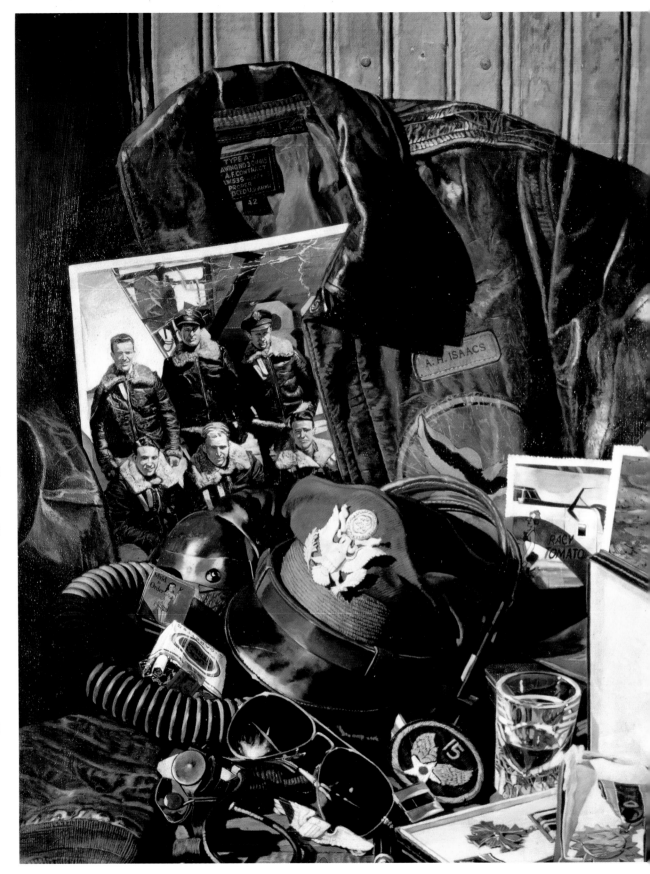

RADAR APPROACH

PEOPLE SERVING IN OPERATIONAL UNITS HAD VARIOUS names for them. Americans might use "eggheads," "whiz kids," or "slide-rule jockeys." The catchall British term was "boffins." The names refer to the scientists, engineers, and mathematicians who converted theoretical possibilities into actual tools and weapons. Winston Churchill captured the importance of their contribution to victory with the term "wizard's war."

America's most famous practitioners of the wizard's art were Alfred Loomis and Vannevar Bush, names that crop up in conjunction with many of the war's technological breakthroughs. Loomis was a financier who retired into technology. Bush was head of the National Defense Research Committee, then formed the Office of Scientific Research and Development. There were hundreds of men like them working around the world.

Radar, in all its permutations, was a classic triumph of the boffins. In 1939, the British and Americans were slightly ahead of the Germans in the development of radio detection systems, although the difference was more in application than theory. The British had a chain of air warning radars in place by 1940 and the RAF defeated the Luftwaffe in the Battle of Britain. The cause-and-effect relationship was not necessarily one to one, but the British knew they were on to a good thing. The next step was a miniature radar that could be mounted on aircraft for interception or anti-submarine search. The secret to size turned out to be an item that its British inventors described as an "electronic whistle." This small device, the cavity magnetron, produced radio waves in the 10-centimeter range that returned remarkably sharp radar images. The British shared the discovery with the Americans well before the United States entered the war, and the two countries never relinquished the technological edge over the Axis. Airborne intercept radar, air search radars, anti-aircraft gun laying radar,

naval fire control radar, and airborne sea search radar were improved and enhanced throughout the war.

The proximity fuse was a boffin's delight. Using the simple concept of electronic interference, the kind that makes a public address systems screech, American scientists were able to produce a shell that would explode when it came within lethal range of its target. The proximity shell replaced complex clockwork fuses for anti-aircraft use, and was five times as effective. When adapted for use against ground targets, it became a lethal anti-personnel weapon. Patton credited the "funny fuse" with winning the Battle of the Bulge.

High Frequency Direction Finding, or Huff-Duff, was another egghead project. It was the system that allowed Allied navies to pinpoint the sources of short bursts of radio waves emanating from the mid-Atlantic. The broadcasters were U-boats. The HF-DF equipment first required a land base, then was made small enough to be installed in a mobile hut with two trained operators. By mid-1943, it was just another antenna on the masts of small escort vessels. Like centimetric radar, Huff-Duff had been declared impossible by the men running Hitler's research and development apparatus.

The Germans were also represented in the wizard's war, but their most notable contributions were in mechanical and chemical engineering. The pulse jet engine was a simple wonder, as was the radio-controlled flying bomb, and the ballistic missile was an entirely new kind of weapon. Pressed on all sides by enemies, and from the top by the Führer, the Germans were prone to deploy weapons before they were fully developed, often with fatal results for the operators. The respective rates of development and uses of jet planes by Germany, Great Britain, and the United States are a good example of this phenomenon.

British and American scientists came up with similar versions of an armor-piercing shell to counter heavy German tanks. The shells used a very lightweight plug, or sabot, that fell away when the round left the barrel of the gun. When it did, a small and very heavy tungsten dart continued on to the target at high velocity. Operational reports indicated the only real problem with the round was its scarcity.

The eggheads were not all electricians and engineers. Mathematicians "proved" that fewer RAF night bombers would be lost if all their defensive armament and gunners were removed. The resulting lighter and more streamlined bomber would spend less time in the killing zone of the Luftwaffe night fighters. Bomber Command did not accept this argument, although their Mosquito seemed to illustrate it on a nightly basis. The Royal Navy did understand when the boffins showed that losses to submarines were not a function of convoy size, but wolf pack size. This had a major impact on the utilization of escorts. The American 10th Fleet, an anti-submarine planning and coordination organization, had a civilian team called Anti Submarine Warfare Operations Research Group (ASWORG), whose sole job was to analyze the U-boat war from nontraditional points of view.

Radar Approach honors the development of the Ground Control Approach system. GCA started with anti-aircraft targeting radar, and grew into a system of four separate radars and an analog computer, all mounted in two large trucks. It enabled operators on the ground to talk pilots down to a landing in adverse weather. GCA was deployed late in the war and was a vital element in the postwar Berlin Airlift.

■

DIETZ

OF THEIR OWN ACCORD

IT IS SAID THAT WAR BREAKS THE WEAK, HARDENS THE strong, and in the end grinds down everyone. That cliché could have been written about the men pictured in *Of Their Own Accord*. They were "hazardous duty" volunteers, originally designated the 1688th Casual Detachment. Colonel Charles Hunter trained them in India as the 5307th Composite Unit (Provisional), and he led them into action under the command of Brigadier General Frank Merrill. His three battalions of long-range penetration troops were the only U.S. Army maneuver units in the China-Burma-India theater and are remembered as "Merrill's Marauders."

The 5307th went into the jungles of upper Burma in February 1944, leading hundreds of mules and horses. By June, it had ceased to exist as a unit. Most of the intervening weeks were spent in Japanese-held territory, where the battalions were hunted, pursued, shelled, and besieged. They were supplied entirely by air, when any supply was possible at all, and suffered all the trials of living in the monsoon jungle. Despite the countless rivers they forded and ridges they crossed while attacking and evading the Japanese, they somehow always managed to fight their way free or hold out until other units arrived.

The month of May found them slithering along muddy mountain trails with the unlikely objective of Myitkyina, on the northern edge of the Burmese plain. Their job was to seize the Japanese airfield there and hold it, in company with Chinese soldiers who followed in their wake, as an airhead for Allied troops and supplies. The unit—down to one-third strength and riddled with disease—was barely combat-worthy when it set out, but Merrill's Marauders not only reached their objective, they took it and held it. Unfortunately, the price was the total annihilation of Hunter's three battalions.

■

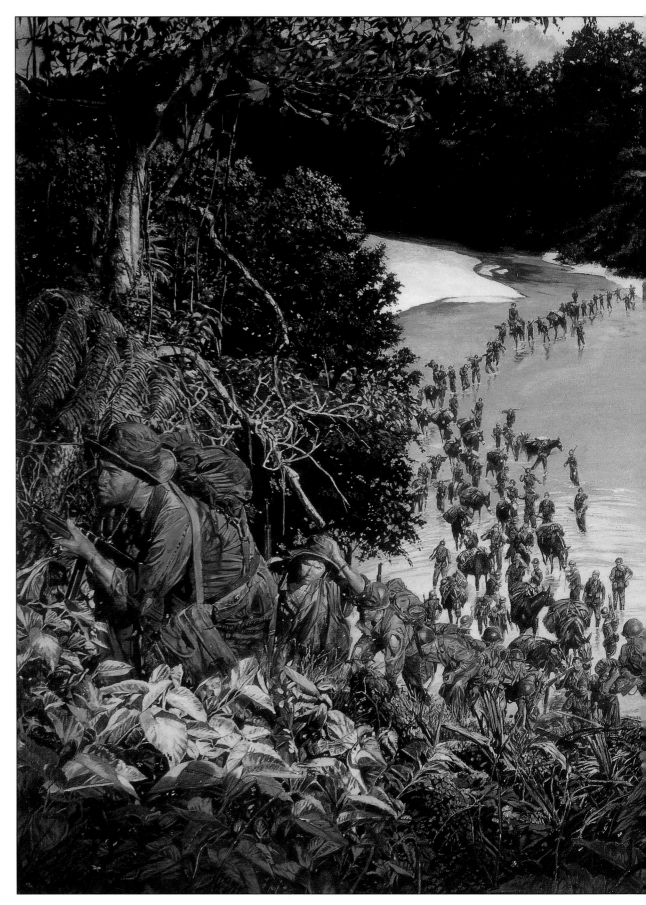

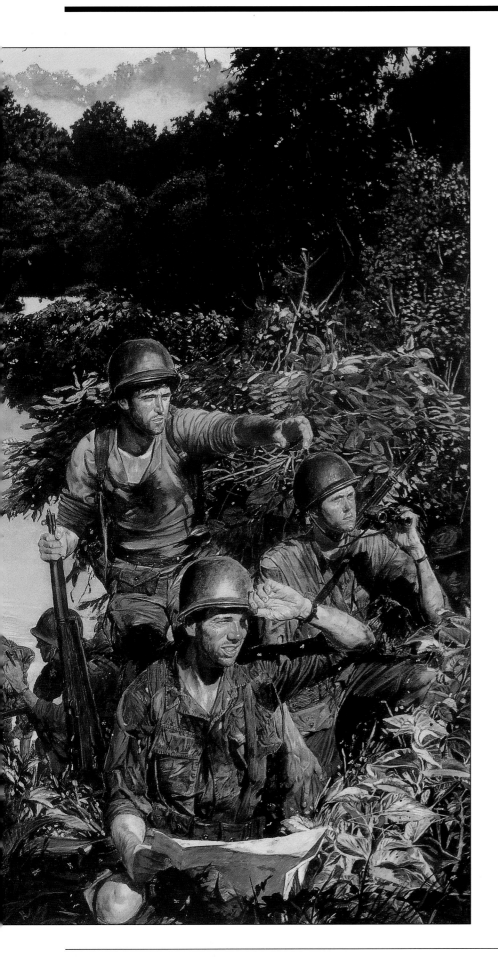

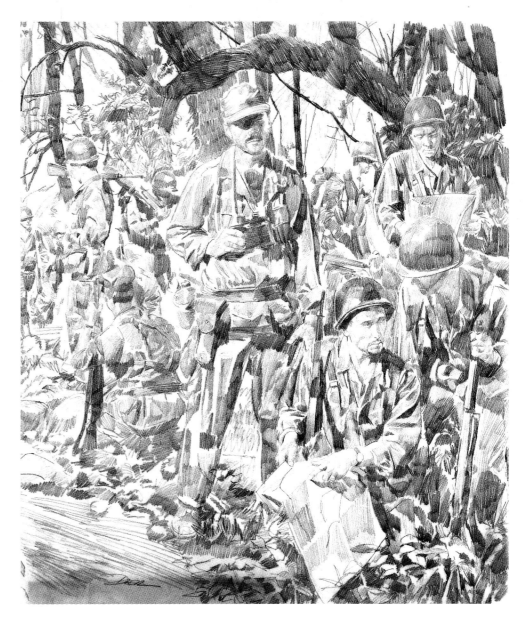

ABOVE: This large sketch was a lowland version of *Of Their Own Accord*, and was nearly all foreground. The setting for the finished piece was found while the artist was walking along a railroad track in Georgia. A brown water river passing under a trestle was the model for the jungle-rimmed Burmese stream, the perfect setting for a winding train of men and mules.

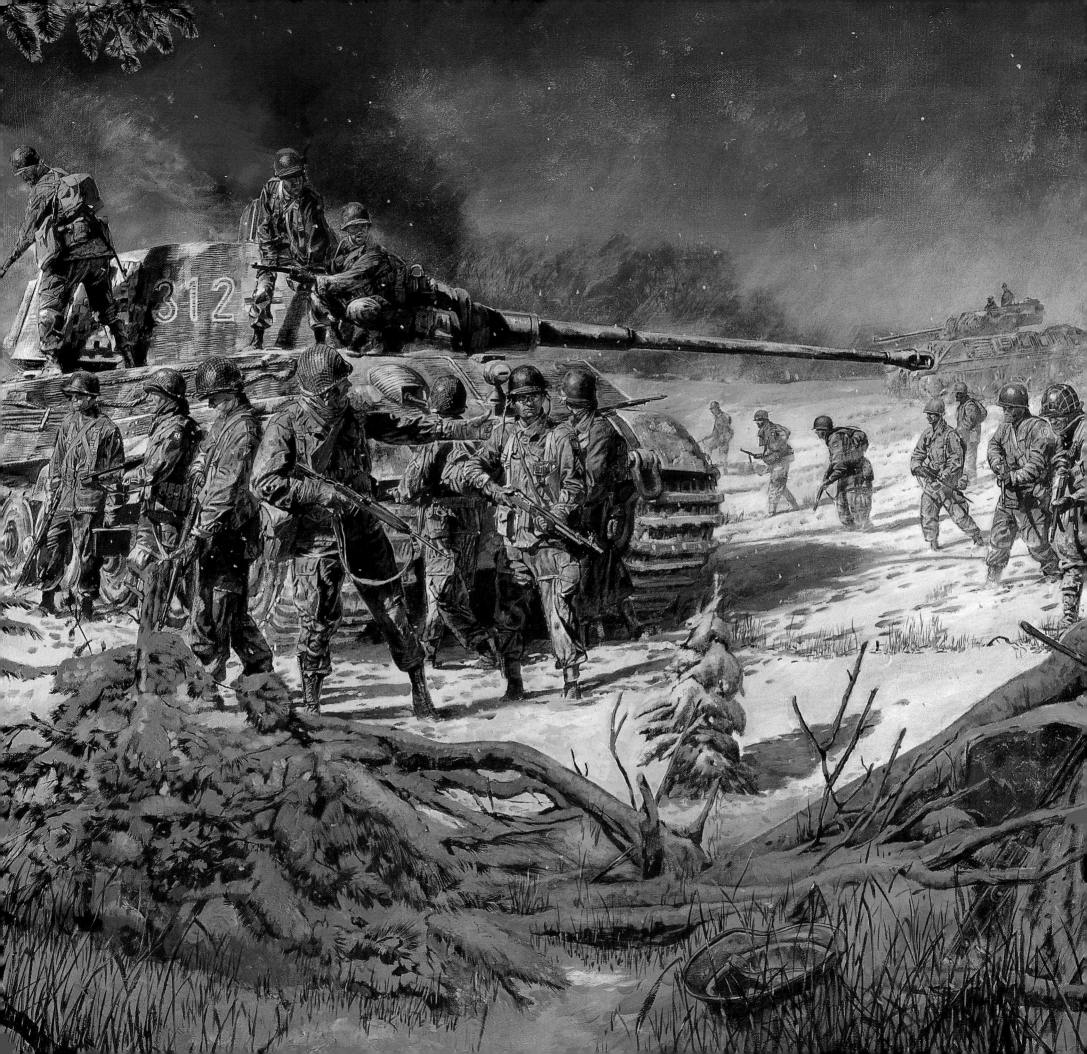

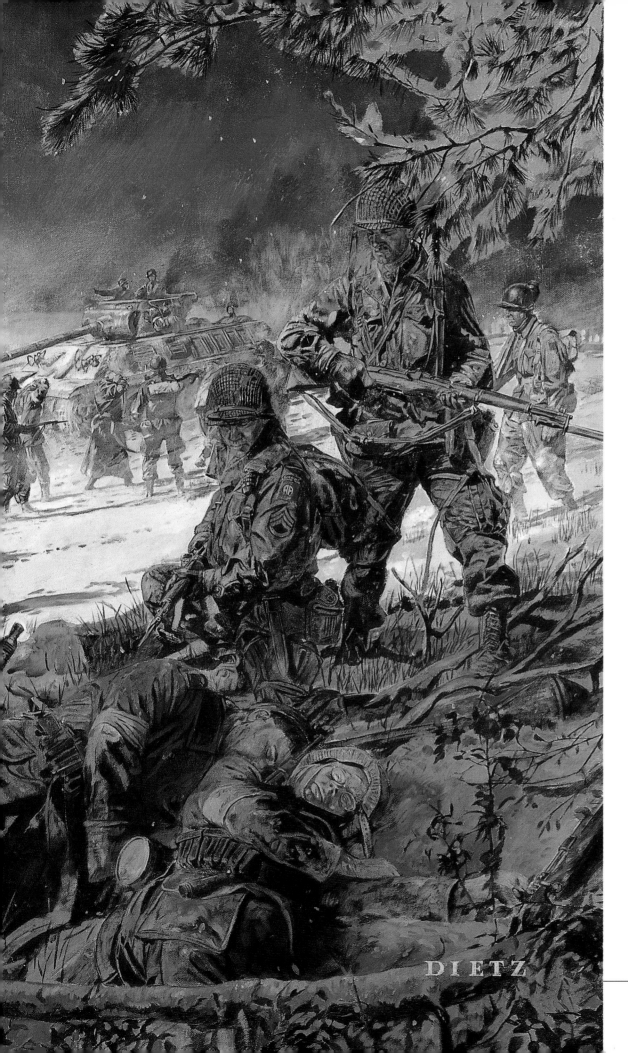

STOPPED DEAD IN THEIR TRACKS

THE U.S. ARMY IN THE EUROPEAN THEATER OF Operations was as flexibly organized, well supplied, and mobile as any the world had ever seen. These qualities were crucial to halting the German attack at the Bulge.

In the first confused days of the battle, when entire regiments were being swept away, American units were able to reach important crossroads and vital defensive positions ahead of their attackers. The structure of the forces allowed arriving battalions to pick up supporting arms and coordinate with the existing commands on the fly. It seemed to the advancing Wehrmacht and SS commanders that they would never run out of Americans to fight.

In the north, the 2nd Infantry Division was attacking the Siegfried Line. On December 17, its reserve regiment suddenly became the last line of defense behind the remains of the 99th Division. Orders went out to reverse direction, and the commanding general, Walter Robinson, found himself directing company-sized formations as they appeared on the road.

The 7th Armored Division was ordered south as a precaution on December 17, and, along with remnants of the 106th Infantry Division, held the crossroads town of St. Vith until the sixth day of the battle. In that interval, the 82nd Airborne was brought all the way from its re-equipment depots in France to keep a route of withdrawal open for the nearly surrounded tankers. The paratroopers were mated with tank destroyer units and artillery formations and stood their ground against elements of three SS Panzer divisions.

A month later, the 82nd was still on the shoulder of the Bulge. The paratroopers in this painting are advancing past a Tiger that was knocked out by the gunners of the 628th Tank Destroyer battalion near Vielsalm, Belgium.

■

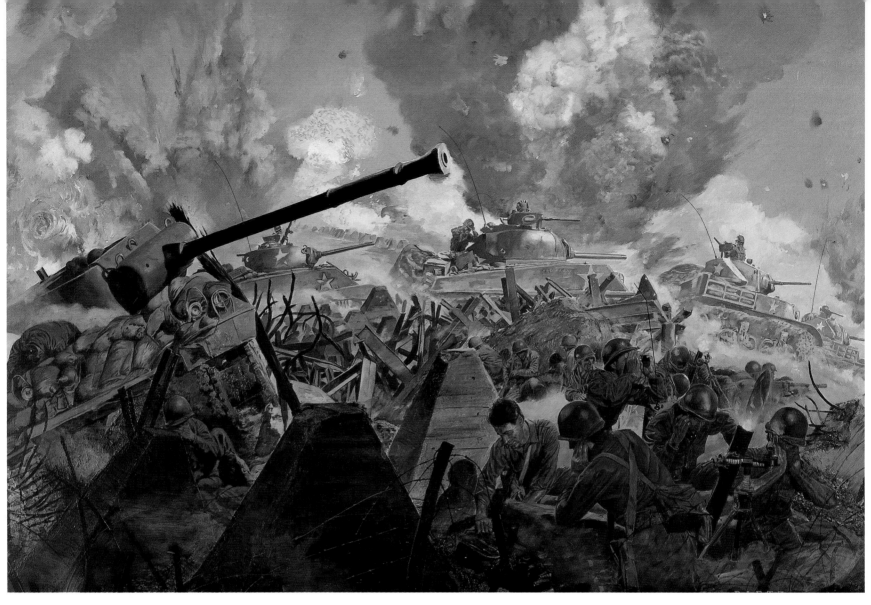

Into Germany

The ranks of white concrete "dragons' teeth" seen here were the unmistakable symbol of the Siegfried Line, though they proved an insufficient dam against a torrent of American tanks. In the spring of 1945, the mobile Allied armies outnumbered, outgunned, and outmaneuvered the remains of the German war machine. Nature provided the biggest barriers to the Americans and British: the flooded Roer River valley behind the Siegfried Line was a greater obstacle than the concrete on the frontier and the Rhine girded the entire western border of the Reich. The battered Ludendorf Bridge at Remagen, captured almost by mistake, became a symbol of the attack into Germany.

Other, darker symbols recall the spring of 1945 as well. Rows of sheds behind stretched barbed wire, mass graves, and emaciated prisoners in striped uniforms seared the minds of the invading Allies more than the concrete tank traps left behind. The camps, the starved slave laborers, and the sheer number of dead bodies elicited revulsion from and inspired revenge in the Allied troops. After the discovery of the death camps, tales of atrocities began to circulate among the Allied armies; as a result, treatment of the Wehrmacht prisoners began to deteriorate. Typically, the farther from the fight a prisoner was sent, the harder he found the hearts of his captors. For many, the end of the

line was a huge barbed wire pen on an open hillside, with no shelter, no sanitation, no medical care, and almost no food. The needs of surrendering Germans had dropped to the bottom the bottom of the Allied priority list, and thousands of the sick and wounded died before a relief system was organized.

The armies that charged into Germany were slowly converted into armies of occupation, with all of the travails that entailed. The luckiest GIs missed that duty—they were already on the big ships heading home.

■

MARINE CORSAIR

THE GRUMMAN WILDCAT WAS A TOUGH LITTLE AIRplane that fought the Mitsubishi Zero to a standstill during the first year of the Pacific War. The Chance-Vought F4U Corsair was the first U.S. Navy fighter that was measurably better than the planes it faced. The Corsair was faster, better armored, and more heavily armed than its Japanese opponent. It approached the Zero's range, was far more rugged, and could carry a significant ordnance load. The Corsair was instrumental in the destruction of Japan's naval air groups in the Solomon Islands.

The first Corsairs arrived in the South Pacific in early 1943, assigned to island-based Marine squadrons. The Marines rapidly replaced all of their Wildcats with the big new fighter, and the Corsair came to symbolize Marine aviation for the rest of the war. Marine Corsairs flew air superiority missions, close air support, escort flights, and combat air patrol across the Pacific. They wore down the Japanese air forces and kept the Japanese island garrisons isolated and impotent.

The Navy did not consider the Corsair a suitable carrier aircraft when it was introduced, in part because the plane was a handful to land, and in part because the carriers' logistic stream was entirely oriented to the new Grumman Hellcat. The first Corsairs to go to sea for the United States were in special night-fighter flights. The kamikaze campaign that began in 1944 changed everything. The Corsair's speed and rate of climb suddenly overcame its supposed drawbacks, and the ready supply of trained Marine pilots provided a quick solution to the Navy's need for interceptors in 1945. Marine squadrons took their planes aboard ship, but the lasting image of the Corsair is one of bell-tents, a jungle-fringed crushed-coral airstrip, and faded blue bent-wing planes in search of trouble.

∎

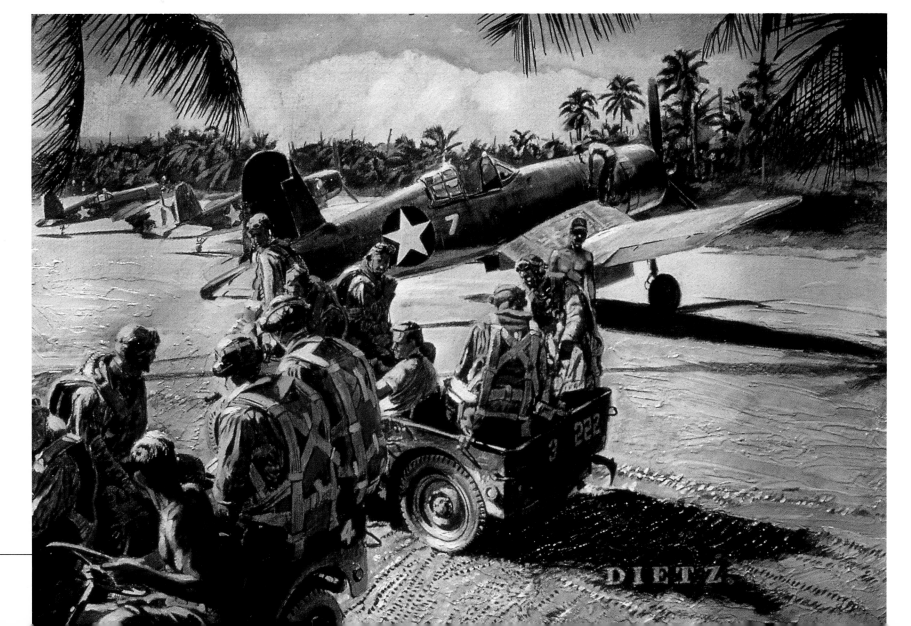

HIGH SEAS U-BOAT

The ships on these facing pages were adversaries in both a tactical and strategic sense. The basic surface attack U-boat was a weapon best suited to hunt cargo carriers, and the convoy escort was the natural vessel to protect those cargo ships. The fact that the U-boats were using a slightly improved World War I technology for most of the war made it relatively easy for their opponents to employ lethal new devices against them. Any little ship with a top speed greater than fifteen knots could effectively counter the U-boat. Detection gear and weapons systems could be upgraded during any dockyard visit.

Upgrading the U-boat was a much more complex proposition. The critical need for new boats prompted a full technical review in November 1942, and nearly a full year passed before contracts were set for a large and small version of what could be considered a true submarine. Even with prefabrication and accelerated production sequencing, the very first boats would not be commissioned until June 1944.

The Type XXI and Type XXIII U-boats represented a quantum leap in submarine performance. The new boats had huge battery capacity in their bulbous streamlined hulls. Their submerged speed was nearly as fast as the most common British convoy escorts, and their silent running speed was twice that of the conventional U-boat. Their snorkels were equipped with radar warning receivers, and they had improved underwater listening devices.

The new boats required a more extensive fitting out and training cycle, and every step of the process had to be carried out under the pressure of Allied bombing and advancing Allied armies. The Type XXIII claimed its first victim in mid-February 1945, and the last boats left Germany within earshot of Allied artillery. Like the cruise missile and jet fighter, the new U-boat appeared just in time to point the way to the future, but had no impact on the war at hand.

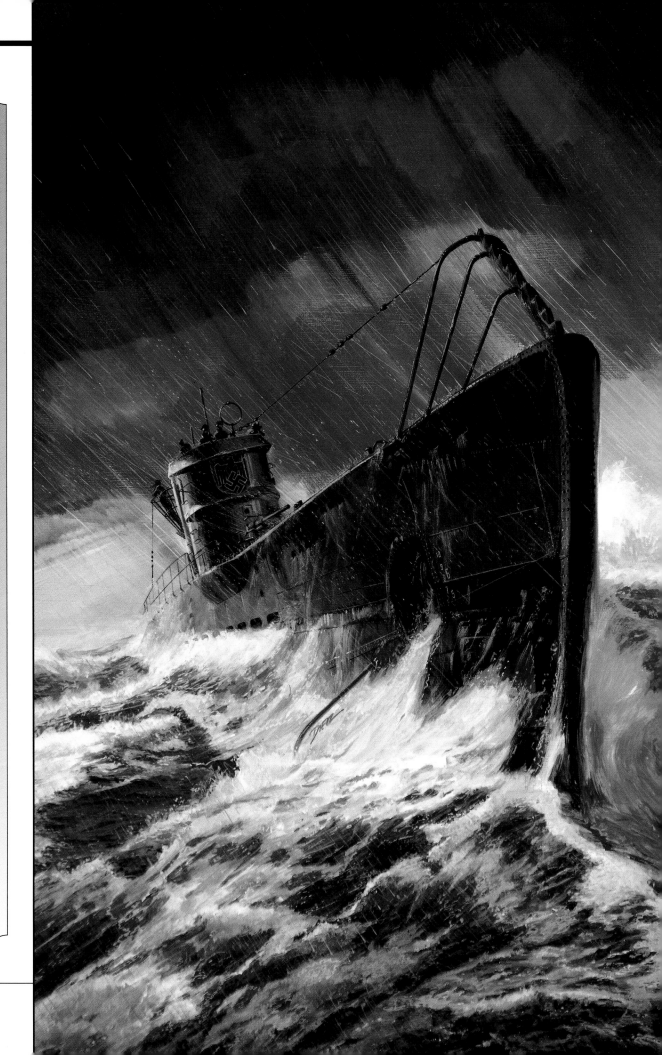

LITTLE SHIP, BIG WAR

THE USS *ABERCROMBIE* WAS ONE OF MORE THAN 560 destroyer escorts (DEs) ordered from U.S. shipyards during the war. DEs were originally imagined as austere convoy escorts, and early versions left much to be desired. Still, each new production run improved the breed and every campaign saw the little ships pressed farther to the front of the naval war by the sheer size and scope of worldwide operations.

The DEs had the primary role of convoy protection, a job they shared with smaller patrol frigates, older destroyers, and even reverse Lend-Lease corvettes. They were the killers in the Hunter-Killer groups built around escort-carriers. They made up anti-submarine and anti-aircraft screens for invasion fleets in all theaters. Fifty of them were rebuilt as "high speed" transports, able to carry a company of infantry and their landing craft on special missions. A handful were modified as mobile power plants, with extra generating equipment and large cable reels that enabled them to provide electricity to invasion beach facilities.

The vast scale of Pacific operations pushed the DEs directly into harm's way. One, the *England*, sank an incredible six Japanese submarines stationed on a picket line to warn of the American fleet's approach. DEs were natural companions for the escort-carrier task groups that supported amphibious landings, as well as for the huge fleet train that shuttled fuel and supplies to the combat formations. Those were deadly jobs in early 1945. One of the ships that was reduced to "destroyer dust" by Admiral Kurita's cruisers off Samar was a DE, and the little ships were the primary kamikaze targets from the Philippine invasion to the last days of the war.

Jim's painting of the *Abercrombie* maneuvering off Okinawa was for a book by one of her officers about the DEs' role in the naval victory.

■

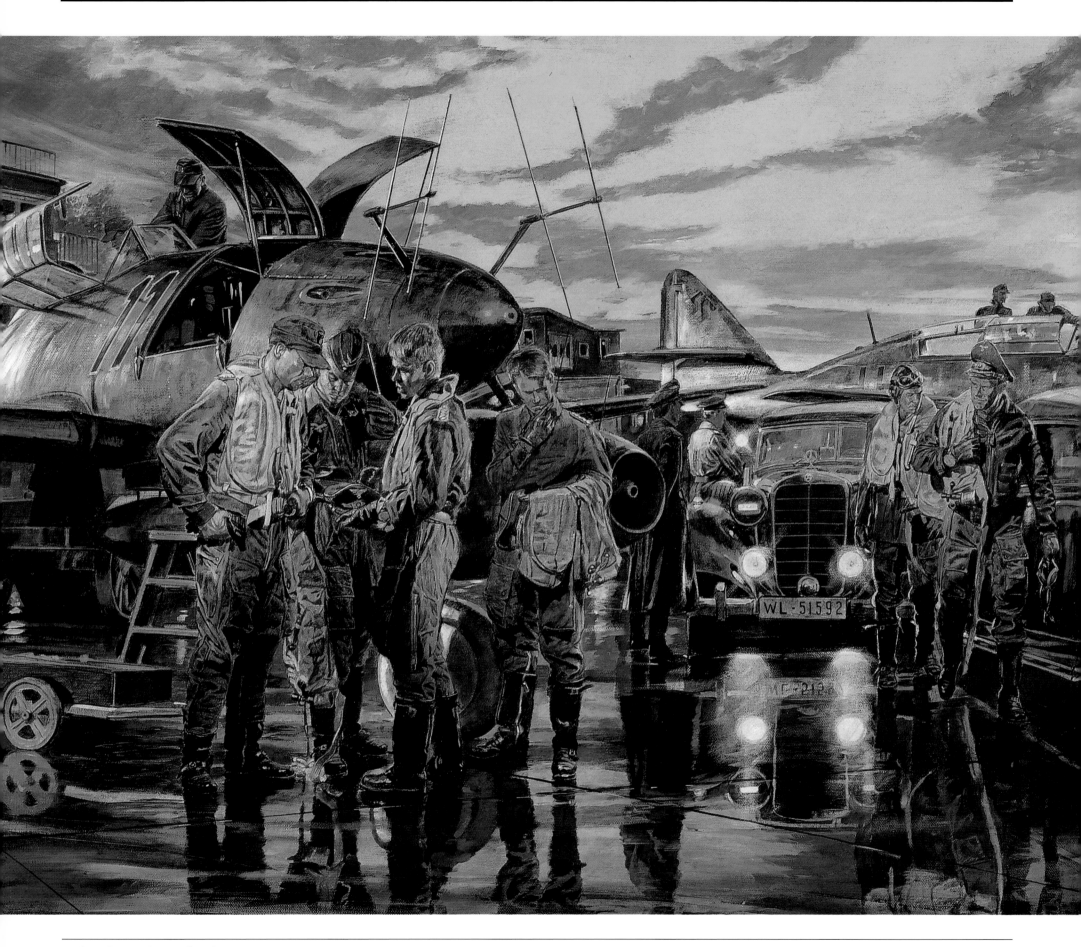

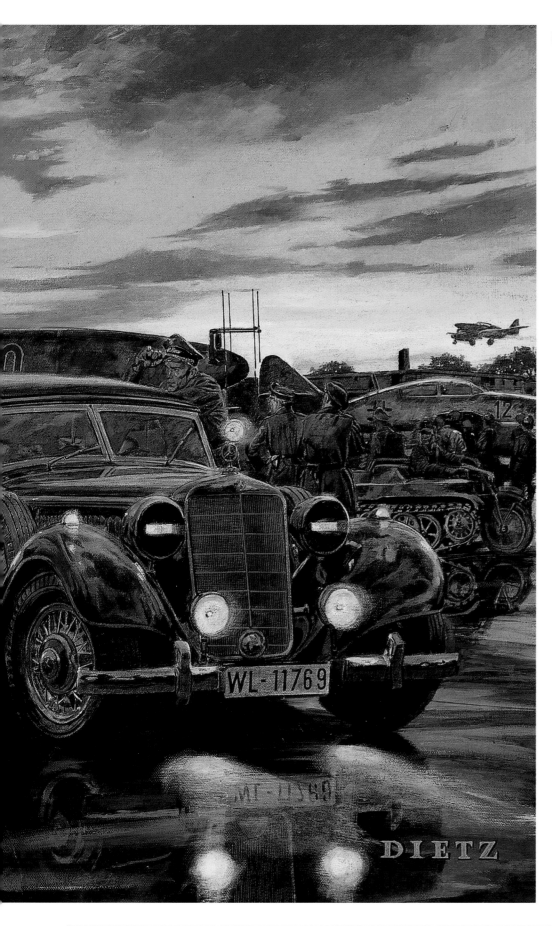

TOO LATE IN THE DAY

THROUGHOUT THE WAR THERE WERE CERTAIN WEAPONS that generated a psychological effect at least as great as their material impact. Early in the Pacific War, the Mitsubishi Zero-Sen fighter was such a weapon. Every Japanese fighter was an "invincible" Zero. In the Ardennes in 1944, hundreds of German tanks became "invincible" King Tigers. In the long night war over Germany, the Royal Air Force had such a weapon in the de Havilland Mosquito. The "Wooden Wonder" was fast, carried a useful bomb or target-marking load, was more agile than any regular Luftwaffe night fighter, and had tremendous operational range. Worst of all, it seemed to transit the skies of the Reich with impunity.

The Luftwaffe spent three years looking for a meaningful challenge to nocturnal Mosquitoes, even resorting to a plywood twin-engine fighter of its own, unsuccessfully. It took a quantum technological leap to create an aircraft that could reasonably expect to intercept the Mosquito. The two-seat Me-262 jet in Dietz's airport scene was that aircraft. If a competent pilot and radar officer could be vectored to the same region of sky as their foe, the 262 gave them enough speed advantage to run the enemy down and destroy his aircraft.

The artist has never read accounts of three radar-equipped 262s being ready for flight at any one time. Nor has he seen photographs of the big Mercedes-Benz convertibles on a *nachtjagdger* flight line, but the situation is evocative of the Reich's last dark hours. Are the big cars going back to Berlin, or turning west after this last briefing? The jet pilots have the same kind of choice if their mounts survive the intercept missions. Which bases will be equipped to service them? Which will even be operational? Which will have an angry Mosquito night fighter buzzing around it, eagerly awaiting the entrance of a low and slow jet into the landing pattern?

SAFE HARBOR

SAFE HARBOR COMMEMORATES THE NUMEROUS fleet auxiliaries that supported the fighting forces around the world. The auxiliaries ranged in size from the liner *America* (renamed *West Point* for the duration) to the lowliest yard barge, and the category contained all the transports, tenders, oilers, landing craft, tugs, hospital ships, dry docks, and floating repair shops that the U.S. Navy could muster. This vast body of supporting vessels was also known as the Fleet Train, but they were often found directly in the line of fire.

The big seaplane tender in this painting is floating on a peaceful bay, but the PBY taxiing out is on its way to war. Seaplane tenders themselves were liable to see action. They were submarine and bomber targets in the early days of the Solomon Island campaign, and at the end of the war, the tenders operating in the Okinawa anchorage were attacked by kamikazes. The Navy's 1,100 LSTs were auxiliaries that handled such jobs as landing tanks under fire, launching U.A. Army spotter planes, and tending PT boats. The attack transports off Sicily, Tarawa, Normandy, and Iwo Jima were officially part of the auxiliary fleet, as were the rocket-firing craft that came close to shore to bombard the beaches, the big self-propelled landing lighters, and even the floating headquarters for the amphibious forces. The repair and replenishment activity that went on in the atoll lagoons of the forward fleet anchorages was the work of auxiliary vessels.

A close look at the small cargo ship in the background of this painting reveals a tiny palm tree on the bridge. That is Jim's homage to the playwright Joshua Logan and the most famous auxiliary fleet officer of fact or fiction.

■

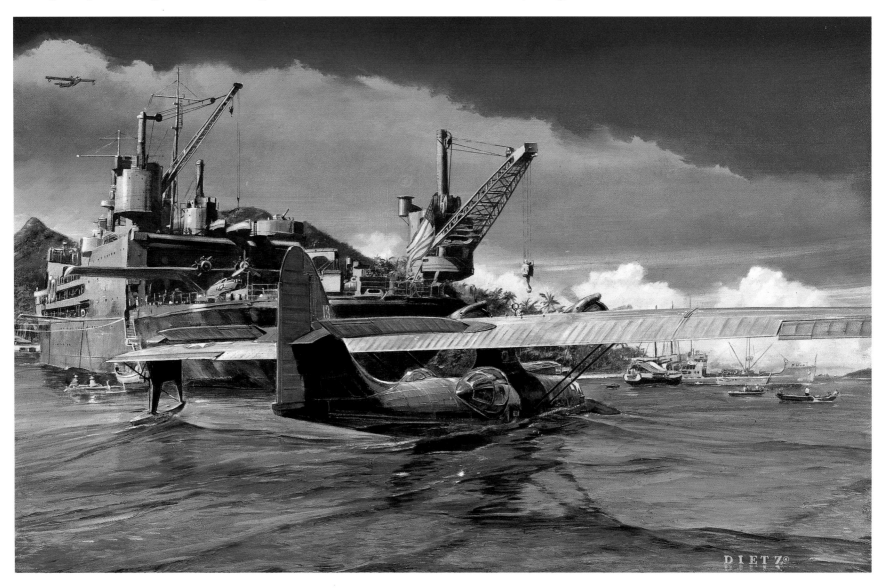

"The Warrior's Sword Had Come to Rest"

ADOLF GALLAND LEARNED TO FLY WITH A CIVILIAN glider club during the Versailles Treaty era. He was snapped up by the fledgling Luftwaffe, and later commanded a squadron of German biplanes in the Spanish Civil War. During the Battle of France, he led a Me-109 *Gruppe*, rising to command a *Geschwader* in the Battle of Britain. He finally became a general in the Luftwaffe while still in his twenties, and by the end of the war had claimed 104 aerial victories. A tireless champion of the fighter community and a bluntly opinionated man, he was kicked out of the Luftwaffe high command in early 1945. He spent the last months of the war leading a jet fighter group.

Galland's memoir, *The First and the Last*, caused a sensation when it was translated into English in 1954. It was an unapologetic soldier's story that provided a look into the heart of the German war machine. It revealed how hard-pressed the Luftwaffe was when Hitler began his war, and chronicled the growth of distrust between the fighting forces and the Berlin leadership as the war went on. He made stark analyses of the price Germany paid for its strategic lapses. His description of encountering hundreds of American four-engine bombers and their escorts deep inside Germany is a sobering portrayal of total industrial defeat.

His unrepentant stance may have cost Galland the job of leading the West German air force in the 1950s, but it did not detract from his reputation as a flyer. Fighter pilots are a fraternal group and most of his surviving foes only regretted that Adolf Galland had not been on their side during the war.

■

WE HAVE RETURNED

THE LIBERATION OF THE PHILIPPINE ISLANDS WAS the first campaign in which corps-sized U.S. Army formations faced similar units of the Japanese Army. The campaign did not progress according to either side's plan, and the U.S. Army's return to the Philippines proved to be a much longer and bloodier process than its departure.

Douglas MacArthur's initial landing was at Leyte in the central Philippines, on October 10, 1944. The massive naval battles around Leyte diverted much of the U.S. Navy's carrier aviation capability, and an unusually heavy monsoon made airfield construction difficult. For the first time since Guadalcanal, the Japanese were able to contest mastery of the air over a battle-ground. Their forces fought a stubborn holding action on Break Neck Ridge, and even managed a parachute attack on American air installations.

The Japanese commander in the Philippines, Tomoyuki Yamashita, did not want a major battle for Leyte. He planned to concentrate his divisions on the main island of Luzon, where the Americans would have to fight on a field of his choosing. He was overruled by Tokyo, however, and fully half of Japan's transport shipping in the islands, most of its aviation assets, and more than 50,000 soldiers and sailors were lost in a Leyte campaign that lasted into 1945.

The invasion of Luzon exposed the American fleets to the full fury of Japan's newly organized kamikaze squadrons. The combat units of the invasion armada arrived first and bore the brunt of the suicide flights. Dozens of ships were damaged and several sunk by the time the last Japanese planes were destroyed. When the first battalions came ashore at Lingayen on January 9, the Japanese Army was nowhere to be found.

General Yamashita no longer had the strength to join the Americans in a battle of maneuver. He was withdrawing his remaining forces into strategic redoubts, where he hoped to deny the Americans strategic use of the island without having to defend its entire landmass. His divisions were hunkering down in the hills outside Manila, along the main north-south transportation routes and on the mountainsides that dominated the Clark Field airport. He presumed that his duty was to tie down the largest number of Americans for the longest period of time. If they were fighting his 14th Area Army in the Philippines, they could not be advancing on the home islands. True to his strategy, Yamashita did not surrender until Japan itself capitulated.

The Japanese naval commander ignored Yamashita's plans. Rear Admiral Sanji Iwabuchi served in a different chain of command, and he decided that Manila was the asset that should be denied to the Americans. He organized his 16,000 naval personnel for a fight to the death in the capital city.

The Americans split their forces on the central Luzon plain—one corps turned to contain the Japanese in Yamashita's mountain strongholds while the other moved south toward Manila. MacArthur used the Navy's amphibious capability to stage landings on both sides of Manila Bay, and approached the city from every direction. By early February, members of MacArthur's staff were planning their victory parade. On February 4, advancing elements of the 37th Division met the first of Admiral Iwabuchi's diehards.

There were nearly 700,000 civilians in greater Manila when the Americans arrived at the outskirts of the city. Thousands were fleeing by any means available, but the emplacements that the Japanese had constructed to keep the Americans out also served to keep the civilians in. In four years of occupation, the brotherly regard the Japanese had expressed for the inhabitants of their Greater Asian Co-Prosperity Sphere back in 1941 had entirely evaporated. Acts of violence against the trapped population became widespread. The wholesale demolition of military and transport installations began, and Manila was marked by towering columns of smoke and flame. American commanders considered sealing off the city, but escapees indicated that the Japanese troops were well supplied with food, medicine, and munitions. The civilian population would starve long before the defenders, and there were still thousands of Filipino and American hostages and prisoners in the city.

The first American forays into southern Manila were made with minimal use of artillery. Casualties in the initial assault groups were unacceptably high, and soon, long artillery barrages rolled up and down the streets leading to the Pasig River. The Japanese naval brigades and a few thousand army troops who had been trapped in the city fought door by door, block by block. The big government buildings were defended at every stairwell and corridor. Landmarks of prewar Manila crumbled, entire residential districts burned, and the people of the city died.

The Japanese made their last stand in the government plaza and the adjacent Intramuros district, the old walled quarter that had once been the Spanish capital. In front of the advancing Americans was 150 acres (60.6ha) of colonial history surrounded by a seventeenth-century fortress. Inside it, there were no more than 2,000 Japanese, but two or three times as many civilians. Behind the attackers were the ruins of Manila and the bodies of nearly an eighth of its residents. The Americans offered the Japanese a surrender with military honors, something that had been accepted by a Japanese commander at the city's Santo Tomas University compound early in February. They

offered a cease-fire during which the trapped civilians could be evacuated. There was no response, so the American artillery began a six-day bombardment.

Troops of the 37th attacked on February 23, working into the old city from the north and east. Hundreds of Japanese had died at their posts during the week of shelling, and the rest were deeply dug into the city's catacombs. In the midst of the fight, a Japanese officer ordered the release of 3,000 women and children who had been held hostage in the old city's churches. Their sons, husbands, and fathers had been murdered. Intramuros resistance ended on February 24, but the fight for the big government buildings across the park from the walls lasted for another week. The month-long fight for the city took the lives of nearly every Japanese defender, more than 1,000 attackers, and an estimated 100,000 civilians.

The painting on the following pages was done for the 37th Division Association. It commemorates the storming of City Hall in Manila. Soldiers of the division captured that building in a room-by-room assault, supported by artillery and point-blank tank fire.

■

BEACHHEAD

The American 8th Army's amphibious march through the central and southern Philippines is one of the most interesting and least-known campaigns of World War II. Before it was finished, General Robert Eichelberger's command grew to include five full American divisions and scores of supporting formations of all services.

On the road back to the Philippines, Douglas MacArthur employed a strategy of bypassing Japanese garrisons, freeing up U.S. forces for the invasion of the archipelago. Once MacArthur had returned, however, he felt that his promise to liberate the Philippines meant driving the Japanese out of all the islands, and that it was the 8th Army's job.

Eichelberger's troops staged dozens of landings in the islands south of Luzon, on the Visayans, and on Panay, Negros, Cebu, and Mindanao. The landings were nearly perfectly coordinated with the Navy, and with AAF and Marine Air Groups. In some cases, they had to fight their way ashore. In others, they landed to meet local guerillas, and once, a Marine Air Group supported a landing from an airstrip captured and defended by Filipino irregulars.

This painting was done for a book about the recapture of Corregidor, which was one of the few instances where Marine assault troops (who were primarily focused on the grim island trek to Tokyo) were involved in amphibious operations in the Philippines. The campaign to the Sulu Sea was an 8th Army show.

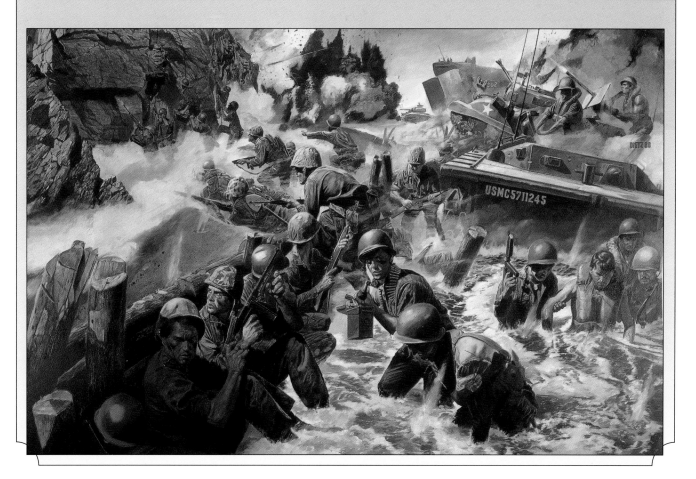

RECOMMENDED READING

A recommended reading list on a topic as vast as World War II could be book-length in itself. Every decade since the signing of the documents in Tokyo Bay has produced new scholarship, new information, and new perspectives on nearly every aspect of the war. A respectable bookcase could be filled with books on just the Battle of Britain, Stalingrad, D-Day, or the Bulge. One long shelf would only just hold the various works of Patton, McArthur, and Montgomery, while another shelf might barely contain the great fiction written by veterans.

This brief list was compiled by the artist and the author, and does not stray far from the subject matter of the paintings contained in *Portraits of Combat*. Some have been in print since the early 1950s, others are virtually brand new. It is a catholic reading list rather than a comprehensive one, and is presented with apologies to the dozens of other authors whose books could have been included.

Ambrose, Stephen E. *Band of Brothers*. New York: Simon & Schuster, 1992.
There have been many "Men of Company C"–style books. This one, about one company of the 101st Airborne, is one of the best.

Beevor, Anthony. *Stalingrad: The Fateful Siege 1942–1943*. New York: Penguin, 1999.
The battle to control the largest country on earth came down to a fight for a few square miles of rubble, and Beevor makes sense of it.

Blackburn, George. *Guns of Normandy*. Toronto, Ontario: Tundra Books, 1996.
Artillery books are few and far between. This one follows a Canadian battery from the beaches to the hedges to the breakout.

Buchheim, Lothar-Gunther. *Das Boot*. New York: Knopf, 1975; Distribooks, 1995 (reprint).
This is a classic look at the U-boat war shorn of nearly every trace of romanticism. If the book is not in stock, try Herbert A. Werner's Iron Coffins.

Carter, Ross S. *Those Devils in Baggy Pants*. Cutchogue, New York: Buccaneer Books, 1996 (reprint).
This book, the first of the paratrooper chronicles, originally appeared in 1951, when the war seemed like yesterday. It has seen innumerable printings since.

Cooper, Belton Y. *Death Traps*. San Francisco: Presidio Press, 1998.
It is amazing that a first-person narrative of the campaign across Europe, published fifty-three years after the last shot was fired, could be this original and compelling.

Douglas, Keith. *Alamein to Zem Zem*. New York: Bantam, 1975; London, England: Faber & Faber, 1994 (reprint).
This British tank commander's diary is a great addition to the long-out-of-print books of Robert Crisp and Cyril Joly.

Dugan, James, and Carroll Stewart. *Ploesti*. New York: Random House Publishers, 1962.
A colorful history of the Tidal Wave raid of August 1, 1943, on the Romanian oil refineries at Ploesti.

Dundas, Hugh. *Flying Start*. New York: St. Martins Press, 1989.
This elegant, humorous, and tragic testimony of a young Fighter Command pilot is a survivor's counterpoint to Richard Hillary's The Last Enemy.

Ethell, Jeff, and Alfred Price. *Target Berlin*. New York: Arms & Armor Press, 1981 (reprint).
Ethell and Price use one raid to exemplify the complexities of the entire 8th Air Force campaign.

Forbes, Gordon. *Goodbye to Some*. New York: Random House, 1961; Annapolis, Maryland: Naval Institute Press, 1997 (reprint).
This forty-year-old novel by a USN patrol bomber pilot is an excellent portrait of the endless long-range war in the Pacific.

Frank, Richard B. *Guadalcanal*. New York: Penguin, 1990.
This book completely delivers on its claim to be the "The Definitive Account of the Landmark Battle."

Fraser, George MacDonald. *Quartered Safe Out Here*. New York: HarperCollins, 1992.
A North Country regiment in the Indian Army's 17th Division was lucky to have a young corporal on strength who would grow up to be a journalist, novelist, screenwriter, and historian. We are lucky he wrote this book about one squad's war against the Japanese in Burma.

Guderian, Heinz. *Panzer Leader*. New York: DaCapo, 1996.
One of the first big books from a German general's point of view, this is still a good read and the only general's memoir on the list.

Hickey, Lawrence J. *Warpath Across the Pacific*. Boulder, Colorado: International Research and Publishing, 1984.
Hickey combined an unbelievable treasure trove of pictures with the grueling day-by-day diary of a B-25 group to produce a poignant view back through the looking glass.

Hynes, Samuel. *Flights of Passage*. Annapolis, Maryland: Naval Institute Press, 1988.
A Princeton English professor looked forty-five years into his past and unearthed this beautifully whole remembrance of his wartime career as a Marine Corps bomber pilot.

Irving, David. *Rommel: The Trail of the Fox*. New York: E.P. Dutton, 1977.
This clear-eyed portrait of the field marshal's career does not indulge in the adulation common to many such biographies of the Desert Fox.

Kaplan, Phillip, and Rex Alan Smith. *One Last Look*. New York: Abbeville Press, 1983.
This was one of the first "then and now" books, filled with 8th USAAF pictures and oral histories.

DIETZ

Lundstrom, John B. *The First Team.* Annapolis, Maryland: Naval Institute Press, 1984.
This book dissects the conflict between the Japanese and American carrier air arms through the Battle of Midway. A second volume deals with Guadalcanal aviation.

McCormick, Ken, and Hamilton Darby Perry. *Images of War.* London, England: Orion Books, 1990.
This is an excellent collection of art created during World War II, with an emphasis on the combat art projects.

McKee, Alexander. *Caen: Anvil of Victory.* New York: Dorset, 2001 (reprint).
This book helps answer the question, "How did the Germans hold on so long behind the beaches at Normandy?"

Monsarrat, Nicholas. *The Cruel Sea.* Springfield, New Jersey: Burford Books, 2000 (reprint).
Monsarrat's novel relies heavily on his experiences in the escort forces, and is true to its time and place.

Ryan, Cornelius. *A Bridge Too Far.* New York: Simon & Schuster, 1974.
One of Ryan's "big three" surveys of European battles, this is still one of the single most complete accounts of the airborne and armored stab into Holland.

Stafford, Edward Peary. *Little Ship, Big War.* Annapolis, Maryland: Naval Institute Press, 2000 (reprint).
One destroyer escort's story presents the Pacific naval conflict in microcosm.

Steinhoff, Johannes. *Messerschmitts Over Sicily.* Baltimore, Maryland: N&A, 1969.
First published as Straits of Messina, *this is an account of the demise of the German Air Force in North Africa and Italy, as told by one of the Luftwaffe's highest-scoring survivors.*

Townsend, Peter. *Duel of Eagles.* New York: Simon & Schuster, 1970.
A big book by a notable survivor of the Battle of Britain, Duel's *scope more than makes up for what might today be seen as "popular press" historiography.*

INDEX

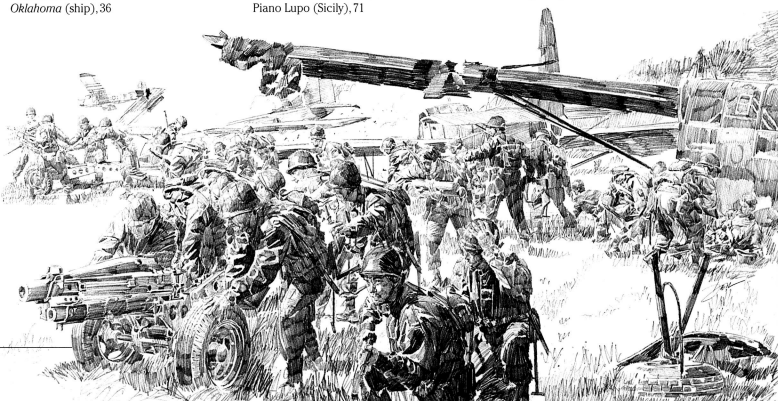

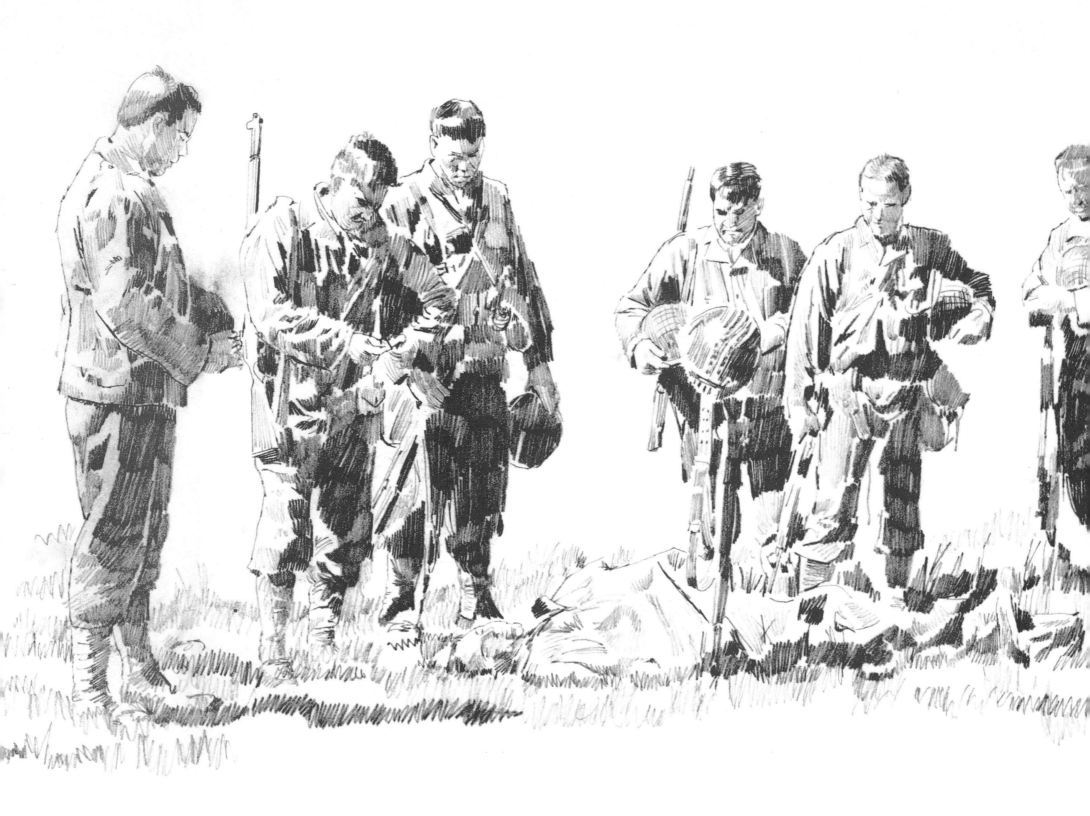